MANIPULATING
THE SACRED

AFRICAN AMERICAN LIFE SERIES

*A complete listing of the books in this series
can be found online at http://wsupress.wayne.edu*

SERIES EDITORS

MELBA JOYCE BOYD
*Department of Africana Studies,
Wayne State University*

RONALD BROWN
*Department of Political Science,
Wayne State University*

MANIPULATING THE SACRED

Yorùbá Art, Ritual, and
Resistance in Brazilian *Candomblé*

MIKELLE SMITH OMARI-TUNKARA

WAYNE STATE UNIVERSITY PRESS DETROIT

09 08 07 06 05 5 4 3 2 1

Library of Congress Cataloging-in-Publication Data

Omari-Tunkara, Mikelle Smith.
Manipulating the sacred : Yoruba art, ritual, and resistance
in Brazilian candomble / Mikelle Smith Omari-Tunkara.
p. cm. — (African American life series)
Includes bibliographical references and index.
ISBN 0-8143-2852-0 ((paper) : alk. paper)
1. Devotional objects—Brazil—Bahia (State) 2. Art, Yoruba—Influence.
3. Candomblâe (Religion)—Brazil—Bahia (State) 4. Bahia
(Brazil : State)—Religious life and customs. I. Title. II. Series.
NK1678.C34 O48 2002
299'.673'098142—dc21 2002012722

⊗ The paper used in this publication meets the minimum
requirements of the American National Standard for Information Sciences—
Permanence of Paper for Printed Library Materials,
ANSI Z39.48–1984.

To my mother,

Mrs. Evelyn B. Smith;

MY BROTHER

Malcolm B. Smith;

MY IYALORIXÁ,

Mãe Stella de Azevedo Santos;

MY DAUGHTER,

Evelyn Amma K. Omari;

AND HER FATHER,

Kwabena Omari;

MY HUSBAND,

Bakary Tunkara;

AND

TO THE MEMORIES OF MY FATHER,

Charles Louis Smith, Sr.;

MY BROTHER,

Charles Louis Smith, Jr.;

Ade M. U. Obayemi;

Arnold Gary Rubin;

AND *Roy Sieber*

Contents

Illustrations and Maps

Color Plates

Figures

Maps

Acknowledgments

Particular thanks to all the colleagues and friends who have helped me to make this book a reality. Special thanks are due to Bayo Ijagbemi, Babatunde Lawal, Kendra Gaines, and Judith Freeman for their close readings of the manuscript at different stages and their enthusiastic comments and suggestions; to Zabu Stewart for drawing the maps; to my daughter Amma and my husband Bakary Tunkara for their unflagging encouragement and love; to 'Wande Abimbola, Rowland Abiodun, Jacob Olupona, Helen Henderson, Maria José S. Barbosa, Salah Hassan, Roslyn Adele Walker, Roy Sieber, and Albert Boime for their intellectual generosity, and to Kathryn Wildfong, acquiring editor of the press, for her patience, team spirit, and belief in this project. I am grateful to Adela Garcia, Melba Joyce Boyd, and Ron Brown for their faith in this book.

I must offer a special tribute to the late Iyá Omileye, my Bahian mother Iyá Ode Kayode, my *ajibona* Thereza, my *irmã-de-esteira* Oyafuniṣemi, Madrinha Marinalva, Agbeni Cleo Martins, Egbomi Tomázia, Alapini Egún Domingo, Kabiyesi Efuntola, Iya Orite, Dona Hilda, Vovo and 'Dete of Ilê Aiyé, Bayo Akanbi, the late Esi Kinni Olusanyin, Olawole Famule, Annette and Seymour Bird, Ethel Tracey, Jeanne Pieper, Ruth M. Brown, Clyde and Lais Morgan, Baba Ẹfundeji, and to all the other warm and wonderful people who welcomed me into their spiritual and biological families in the United States, Brazil, and Nigeria.

Last but certainly not least, this research, which spans more than two decades, would have been impossible to undertake without generous financial support. I express my sincere gratitude to Fulbright-Hays, Ford

Foundation, Edward Dickson History of Art Fellowship, OSULB Professional Development, University of Arizona Provost's Author Support and Creative Achievement Awards, and the University of Arizona College of Fine Arts Dean's Fund for Excellence.

Notes on Orthography

The Yorùbá language is tonal. Vowels and syllabic nasals comprise three levels: a grave accent marks the low tone (e) while the mid tone remains unmarked. An acute accent signifies the high tone (e). Vowels are pronounced as follows: o (oh); e (ay); i (ee); a (ah); and u (oo). The vowels with subscripts ẹ (eh), ọ (aw), ṣ (sh) are pronounced as indicated in parentheses (Abiodun 1994a).

While the Yorùbá language as spoken in West Africa is distinguished by habitual shifts between these three tonal levels (Barber 1991, n.p.), this undulating organization is largely lost in the Yorùbá spoken within the sacred Yorùbá ritual centers in Bahia, Brazil, while the meanings remain similar. In Brazil the lilting shifts between tones characteristic of Yorùbá (and other African languages) has affected the overall mellifluous characters of Brazilian Portuguese and rendered it noticeably different from the more staccato version spoken in Portugal. In Brazilian Portuguese the subscripted ṣ is replaced by an x and pronounced sh. The vowels are pronounced the same as in Yorùbá.

I have followed the standard Yorùbá orthography, which is often referred to as "Òyó" style after the dialect spoken in the city of Òyó, Nigeria. I have followed the Portuguese rendering of the sounds of Yorùbá words. For example, the ṣ and sh of Yorùbá is rendered as x in Brazilian Portuguese, as illustrated in the Yorùbá orisha (òrìṣà) and the Brazilian orixā (both terms meaning deity). The sound that ṣ, sh, and x render is comparable to the English sh in shoe.

"Art is . . . an encounter with the visual that transforms."

bell hooks

Introduction

In key aspects, Yorùbá-descended sacred arts in "African" Brazil epitomize bell hooks's idea of transformation. Made and used in religious contexts,[1] these arts transmute their users and viewers by manipulating African memory and diasporic invention to create chronicles of historical intelligence and contemporary cultural meaning, even as these arts are recast by their human agents. One of my primary goals—a goal based on my experience and a review of existing scholarship—in this book is to highlight the agency of individuals and ceremonial objects in creating and manipulating religious and social intention. I argue that African Brazilian ritual arts conceptually based on Yorùbá models are media of empowerment that have an impact on Brazilians of both African and European descent.

My analysis explores Yorùbá-derived sacred art from the viewpoints of their African Brazilian creators, users, and consuming audiences as well as from the perspective of my own liminal status as an "outsider/within" initiate. The term "outsider/within" is borrowed from Patricia Hill Collins's 1991 essay, "Learning from the Outsider Within: The Sociological Significance of Black Feminist Thought."[2] Collins used the term to describe the dialectic presented by her liminal predicament as a scholar trained in "the academy" (with all the intellectual reconfiguration that positioning implies) and as someone who maintains close ties to "one of many Black communities" and their distinct epistemologies. The term resonates for me: I straddle many cultural fences and navigate multiple domains as a Ph.D.-educated African American woman who is a full professor and who maintains, among others, close ties to uninitiated African American Christian communities and to a global community of individuals who are initiated into the Yorùbá religion. I have participated in ritual ceremonies in Brazil and in Nigeria,

among religious communities that forbid the participation of uninitiated citizenry. From an ethnological standpoint, my peculiar situation raises interesting questions regarding the problematic situation of insiders/outsiders and about mobility between and within the shifting interstices of diverse societies. My "outsider/within" status has greatly influenced the way I conduct my research and write about it and has provided me with unusual experiences in the field.[3] Because I am at once both object and subject, it is difficult for me to write as a spectator, because I am and am not, simultaneously, a spectator. I am thus perhaps culpable of being overly conscious of the need to observe propriety and to avoid invasive and exoticising approaches in my research and scholarship.

I became an initiate of Yorùbá culture and religion quite by accident. I was a graduate student at the University of California, Los Angeles (UCLA), in the 1970s when the Black Power Movement and attendant views on nationalism were forefronted by many critical and progressive thinkers. In the winter quarter of early 1977, I was taking a Ph.D.-level field methods seminar from the late Arnold Rubin. Our requirements stipulated that students examine contemporary cultural manifestations in our own milieus. Ostensibly, this would prepare us for our fieldwork in Africa. I decided to research alternative lifestyles among African Americans and to focus on hair braiding, nose piercing, and multiple ear piercing. One day as I was driving down Vermont Avenue in south-central Los Angeles, I heard the sound of loud African drumming. My curiosity piqued, I parked my rickety old car and followed the sounds. I was led to a courtyard of the house owned by Chief Ajamu (a house which, I later learned, was constructed in a manner similar to those in southwestern Nigeria) where I encountered a *bembe*—as ritual ceremonies for Yorùbá deities are called in the United States. After observing for a while, I was invited by Babalorisha Efundeji to have a divination "reading," and soon after he gave me my first *ileke* (ee-leh-keh)—the beaded necklace that is emblematic of one's devotional relationship to the Yorùbá *òrìṣàs* (oh-ree-shahz [deities]). I became an avid learner of Yorùbá cosmology and ideations, and upon the advice of religious elders I became initiated as an *apetebi* Ifá (female official of Ifá divination—among the Yorùbás of Nigeria often considered the "wife" of an Ifá diviner). This took place in October 1977 in Òyó Túnjí, a village in South Carolina, and was performed by *Oba* Oseijeman Adefunmi Efuntola, the "king" of that settlement (fig. I.1), and witnessed by his head wife and minister of protocol, Ìyá Orite (fig. I.2). I have since main-

tained a very close connection with the religion, which over the years has included a blend of both spiritual and intellectual inquiry, much of which is represented in this study. Ọ̀yọ́ Túnjí—"Ọyọ Returns"—is also known as the African village (fig. I.3) and was founded by African Americans in 1970 as an autonomous cultural community based primarily on West African Yorùbá precepts but also incorporating Fon, Aṣante, and other elements (Omari 1991).[4]

Because it accents a single genre of art within a cross-cultural frame, this inquiry moves beyond the scope of most earlier African art diaspora studies.[5] Building on Griselda Pollock's observations regarding feminist art (1988, 1–17), we can say that most previous work on African Brazilian sacred arts has not looked at the objects as agents of social actions or aggregations of profuse affinities and resolutions, tensions, and borders as they reveal the dynamic, dialogical imbrication of African, Brazilian Indian, and European Portuguese societies. Of these studies published in the English language that concentrate specifically on the arts of one African diasporic culture, none has focused exclusively on a comprehensive, contextual examination of sacred African Brazilian, Yorùbá-derived ritual arts as processes that invent their subjects.[6]

Because studies concerning African-derived cultures that have been published in Brazil are written in Portuguese, they are largely inaccessible to most North American readers. Moreover, beginning with Raimundo Nina Rodrigues's pioneering late-nineteenth-century research, these studies have neglected art and visual documentation in favor of detailed inquiries into African Brazilian religions.[7] Still others (e.g., Bastide, Carneiro, Harding, Landes, Lody, Fontaine, Murphy, and Wafer) have highlighted ethnography, psychology, pathology, sociology, folklore, history, political science, and economy.

Of these, the two most popular and accessible studies among North American readers are ethnographies that do not deal specifically with art: *City of Women* (1947) by Ruth Landes and *The Taste of Blood: Spirit Possession in Brazilian Candomblé* (1991) by Jim Wafer. While both Landes and Wafer mention their photo-taking activities, they do not publish their photos in the first and most available editions of their books.[8] This dearth of photos renders their descriptions of objects and/or ritual contexts, which art or visual historians would consider artistic, of less value to readers who are also interested in visual documentation. While both these studies are richly detailed ethnographically, they foreground the authors' personal feelings and impressions

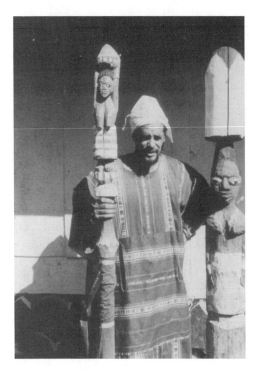

Fig. I.1. *Oba* Oseijeman Adefunmi I (Efuntola), head of Òyó Túnjí with two house posts carved in the West African Yorùbá style. Beaufort County, South Carolina, 1977. Photograph by author.

about the African Brazilians they have studied. Landes's and Wafer's data are also pervasively mediated through their assistants' interpretations: mulatto Brazilian scholar Edson Carneiro in Landes's case and his assistant/lover, and *candomblé* (cahn-domb-lay) priests/practitioners in Wafer's. Although they make significant contributions to our knowledge of African-based religious life in Brazil, neither of these widely read English-language texts achieves what *Manipulating the Sacred* aspires to accomplish.

Within the corpus of those few works published in Brazil specifically on Yorùbá-derived, African Brazilian ritual art,[9] most are inaccessible or inadequate for English-speaking readers not only because they are not written in English but also because they emphasize description, style, and other formal concerns, eliding altogether an analysis of the esoteric and metaphorical meanings of the art objects. They also

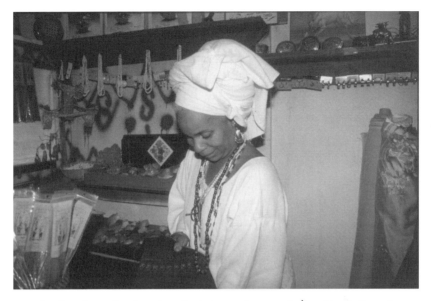

Fig. I.2. Iyá Orite, head wife and minister of protocol, Ọ̀yọ́ Túnjí, Beaufort County, South Carolina, 1989. Photograph by author.

usually overlook larger issues, such as the historical and contemporary sociopolitical contexts and the involvement of practitioners, consumers, and artists as agents of ritual production in their own rights.

Nina Rodrigues's 1904 "As Belas Artes nos Colonos Pretos no Brazil" (The Fine Arts in the Black Colonies in Brazil) remains the only study exclusively concerned with African Brazilian art in Bahia, where African influences are ubiquitous and, with respect to other Brazilian states, most salient. However, the work is limited to a description of wood and metal ritual objects Nina Rodrigues collected in Salvador, the capital city of the state of Bahia, in the northeastern region of Brazil, during his research on the "pathological nature" of African Brazilian religions. The primary value of the work lies in Nina Rodrigues's meticulous collection and the acquisition notation he provided for each object.

Roger Bastide (1968) and Iracy Carise (1975) undertook general studies of the forms and functions of African Brazilian ritual art. While Bastide presented a sketchy history of the art, which heavily referenced

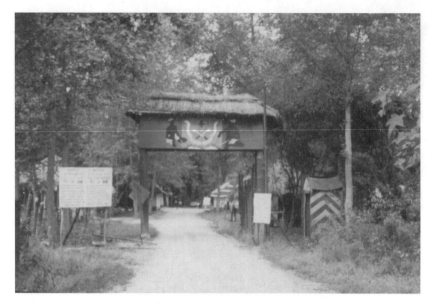

Fig. I.3. Entrance gates to Ọ̀yọ́ Túnjí, Beaufort County, South Carolina, 1977. Photograph by author.

Nina Rodrigues's work, he provided neither illustrations nor substantive discussion of context. And although Carise combined accessible historical data on Africa and Brazil with a consideration of art, the work's usefulness is compromised by its broad scope and its heavy reliance on secondary and tertiary data.

Barata (1941, 1957, 1966) and do Prado Valladares (1969a, 1969b, 1976) also applied formal, descriptive methodology, though neither author was concerned with ritual art from Bahia. Barata dealt with Macumba objects from Rio de Janeiro, while do Prado Valladares concerned himself with objects housed in the Instituto Historico of Alagoas in Maceio and from the ethnology department of the University of the state of Pará.[10] Although the general history and art history of African Brazilians are adumbrated in these papers, sufficient cultural, functional, and contextual data are not provided. Moreover, few of Barata's and do Prado Valladares's studies are grounded in field research, and most are articles rather than books. All except one are published in Portuguese.

Finally, none of the studies mentioned attempt to identify provenance with respect to a particular "nation," ethnic group, or region; instead, all rely on a rather facile and ideological notion of ritual homogeneity. In actuality, African Brazilian religion and ritual art are not monolithic totalities; rather, they reveal a resplendent assortment of regional variations, as in Africa (Apter 1992, 248–49). In Salvador there exist hundreds of different types of *terreiros* (temples), each reflecting different African ethnic models and exhibiting variegated art forms and religious characteristics.

A methodological interest in my analysis is how "practitioners" initiated in Yorùbá-derived, African Brazilian religions manipulate the "sacred" to encode, in art and ritual, vital knowledge about meaning, values, epistemologies, and history. Perhaps even more importantly, I examine the ways they proactively situate and maneuver themselves within dominant Portuguese Brazilian sociopolitical and economic domains.

After I was initiated as *apetebi* Ifá, I underwent other initiations in Bahia and Nigeria (fig. I.4). Although I must underscore the point that I am not yet a priestess who has the spiritual authority to initiate others, my initiate status has nonetheless yielded an extraordinary level of acceptance and privileges from disparate global regions where Yorùbá religious beliefs and practices exist (figs. I.5, I.6). By virtue of my initiate status, I am typically regarded as more an "insider" than a non-initiate indigene of a particular locale—an issue currently debated in the academy (see Kirin Narayan 1993, 671). I took note of this fact when I returned to Bahia during the summer and fall of 1998, from July to August 2000, and again from April through July 2001, to cross-check the accuracy of data collected during my previous research trips. Although my initial visits had been several years earlier, each time I returned I was enfolded seamlessly into the religious and social life of the *candomblés,* in which I was most active. I was struck by a sense of timelessness in terms of fundamental ritual processes and behaviors, although there were many dramatic changes in the city of Bahia and other changes in the *candomblés,* such as the existence of computers and a regularly maintained website for the community in Ilê Axé Opô Afonjá, the result of a community project funded by UNICEF for at-risk children.

The research for this book is based on my extensive, firsthand experience with Yorùbá religion in the United States, Brazil, and Nigeria from 1977 to 2001 and my sojourns in Brazil and Nigeria from 1980 to 2001. For ease of theoretical inquiry, I have organized the data (collected

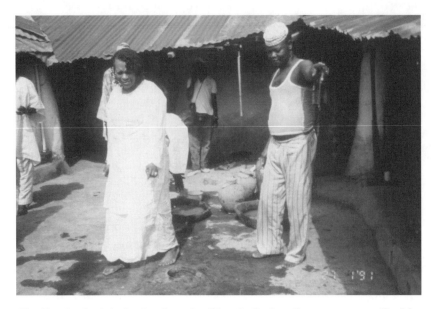

Fig. I.4. Author's induction into the Ọbàtálá Society, January 27, 1991. Ilé-Ifẹ̀, Nigeria. Photograph by author's assistant, Bayo Akanbi.

in the city of Bahia and the semirural island of Itaparica on several field trips between 1980 and 2000) into two separate, overarching clusters according to function and focus of the sacred manipulation: (1) art and ritual associated with the *orixás* (oh-ree-shahz [male or female deities who control and affect all aspects of life]) and (2) art and ritual identified with the deceased *egún* (ay-goon [genealogically chronicled male ancestors]). While art form and ritual praxis for the *egún* exhibit similarities to comparable complexes for the *egúngún* (ay-goon-goon [ancestors]) among the Yorùbá in Nigeria, artistic form and praxis for the *orixás* maintain a tense equilibrium between innovative African Brazilian inventions (Hobsbawm 1983) and those mimetic of similar Yorùbá practices.

These *orixá/egún* art and ritual clusters are pivotal activants in religious temples, which in Bahia are generally known as *candomblés*. For the initiates, *candomblés* are theorized as miniature "African" environments and sacred spaces demarcated in a number of ways from "nonsacred"

Fig. I.5. Thereza Christina Figueredo de Azevedo Santos (niece of Mãe Stella de Azevedo Santos and *ajibọna* of author) with author, August 2000. Photograph by author.

domains. Within the *candomblés*, as in Africa, clothing (and its permutations as dress or costume) is the most important two-dimensional art form. As a negotiator of spiritual and social meaning for individuals and groups of humans, deities, and ancestors, clothing clarifies identity and status within the sacred spaces of Yorùbá Brazilian religious communities. Such signifiers as distinctive clothing combinations and colors reveal an initiate's affiliation to a certain shrine or *orixá* (*òrìsà* in Yorùbá) and his or her status within the *candomblé* hierarchy. In fact, the initiate is required to don distinctive "Africanized" liturgical/ritual clothing immediately upon entering the precinct. This procedure signifies a conscious notation of proxemic transition and supports my hypothesis regarding cognitive demarcation of space within the *candomblés* (Omari 1984). Indeed, many *candomblés* physically emphasize the separation between sacred and nonsacred areas by fencing the precincts (Ilê Axé Opô Afonjá) or locating them amid dense vegetation in remote areas or on hills (Casa Branca).[11]

Fig. I.6. Author with Ọbàtálá Society female officials and devotees, Ọbàtálá Shrine, Ilê Ifẹ̀, Nigeria, 1991.

Within each art and ritual cluster, I am testing a conceptual framework that I provisionally designate with the Yorùbá idiom *abojúèjì* in order to attempt a more inclusive exegesis of the performance, interpretation, and formal qualities of African Brazilian ritual art as well as the simultaneously synthetic and reciprocally informative, interactive nature of African Brazilian/Portuguese Brazilian contact.[12] In Ògúnwande Abimbola's words, *abojúèjì* refers to "someone or [something] that participates in the culture for a while and goes somewhere else"—not a stranger in the sense of *alejo*, the Yorùbá term for visitor, but in the sense of having "eyes and mind in two places"—thus facilitating visualization and understanding in a number of places (personal communication with Abimbola, May 22, 1997). *Ojú* refers not just to sight but to "inner vision," a mechanism that is comparable to intuition in Western terms (Abiodun 1990, 63–89). Yorùbá-descended ritual arts and religious practices in Brazil and Nigeria illustrate the dialogical, interpenetrative

notion of *abojúèjì* as they negotiate and consciously select from non-African postcapitalist and African cultural influences.

In an earlier attempt to develop a conceptual framework to deal with this body of material, I used the term *meta* to define the process, but I did not use it in the sense that postmodernists use it to indicate the all-encompassing "umbrella" notion of a master narrative or metanarrative of modernism. My usage of "meta" intended to expand the idea of ethno-aesthetics developed by Philip Dark (1966).[13] Dark defined ethno-aesthetics as the "analysis of art as a cross-cultural phenomenon" and illustrated its operation with a comparative study between the art of the ancient African kingdom of Benin, in Nigeria, and the Kilenge of New Britain, in Oceania. He aimed to correlate complexes of contemporary art forms to appropriate complexes of contemporary culture in which the content is known, and then project these back in time, noting variations in form and meaning. Dark's method was progressive for its time in that he combined detailed ethnographies with a controlled (albeit morphological) artistic-trait analysis using computer punch cards. The deficiencies in Dark's ethno-aesthetic method include the absence of the indigenous voice and the lack of any indication of his own long-term involvement in the cultures he researched, beyond the roles of observer, document recorder, and reporter that most investigators customarily assume in the field.

My current methodology moves beyond Dark's model in that it reinscribes the indigenous voice (or emic perspective) and is multi-disciplinary. It also problematizes the insider/outsider status of a researcher/practitioner (with a doctorate), at least in the discipline of African/diasporic art history, by centering the investigator as a coparticipant on an ongoing, long-term level in the culture being researched.

The *abojúèjì* model is structurally the same as my earlier meta-ethno-aesthetic model, though the nomenclature has changed because I was persuaded by Yorùbá scholars Rowland Abiodun and Wande Abimbola to substitute an indigenous term for theoretical consistency. Thus the *abojúèjì* model blends diachronic and synchronic approaches and conjoins an indigenous African sensibility with the Euro-American analytic frames of social history, interpretive semiology, and art history. I build on the ideas posed by Umberto Eco in "How Culture Conditions the Colours We See," wherein he bases his definitions on linguistic analysis, extracting emic from phoneme and etic from phonetic. My use of emic implies the indigenous, "inside," viewpoints of the culture bearers,

while etic refers to Western, or outside, theoretical frameworks such as semiology, Marxism, functionalism, feminism, deconstruction, structuralism, and so on that are used to explain cultural phenomena. I blend emic and etic analyses yet foreground standpoints of self-identified indigenous makers and users of art objects. In this respect my approach approximates the ethno-scientific analytic model used by Warren and Andrews (1977, 5) in their work among the Akan peoples in Ghana. It is also similar in the emphasis on the voices of the culture bearers to the "ethno- aesthetic" paradigms employed first by Richard and Sally Price (1980, 8) in their research on the Maroon arts of Suriname and by David Brown for his study of Santeria arts in New York (Lindsay 1996). Many of the ideas and conclusions I reach here are based on my interpretation of data collected in the field but rendered in consultation with African and African Brazilian collaborators. My experience as an active devotee of traditional Yorùbá religion from 1977 through the present amplifies and clarifies my conclusions.

I am sensitive to the fact that my liminal presence as an "outsider/within" in Yorùbá-based African Brazilian ritual acts has inadvertently introduced variables that may have slightly altered perceptions, events, and relationships, as has my active participation in rituals or sojourns in the *candomblé* precincts; however, such disruption was not intended. Nevertheless, I do wholeheartedly agree with Bastide that "it is not sufficient to describe the rites or cite the names of the divinities; it is also necessary to understand the significance of the myths or the rites" (1961, 9).[14] In that respect, I believe it is precisely the experience of my ongoing participation in Yorùbá religion in three geographical regions—Nigeria, Brazil, and the United States—that adds a unique dimension to my critical understanding and interpretations. My initiate rank presented me with the rare opportunity to live in ritual communities for extended periods in Brazil and in Nigeria; many leaders and devotees opened their private homes and temples to me, as a member of a global religious community. This book, therefore, represents the first single-authored art historical study of sacred Yorùbá-descended, African Brazilian ritual art based on many years of sustained participation in and observation of many private and public ritual situations.[15]

I am concerned with the traces of Africa (in all their inflections) originating in precolonial Yorùbá-speaking societies and operative in African Brazilian domains. Therefore, in a dialogical procedure (Clifford 1988) involving many voices to analyze and explain the evidence, I

aim to inquire into the seldom considered African interstices that inform much Portuguese Brazilian/Westernized creativity and deportment. Finally, although this is the first book to date in English that concentrates entirely on sacred African-derived artistic objects, related ritual beliefs, behavior, and the meta-aesthetic/*abojúèjì* permutations of these practices operative in Bahia, Brazil, it is not conceived of as definitive in any sense.[16] Rather, it is offered humbly as a foundation and a stimulus for comparable African diaspora art studies in the future.

Chapter 1 situates the study of sacred art and resistance to Euro-Brazilian culture in Salvador as my geographical locus in Brazil. *Ilês axés* (ee-lays ah-shayz) is a plural religious term used by devotees to refer to African Brazilian residences (shrines) of sacred spiritual force and energy; it refers to temples used by initiates of both West African and New World "Yorùbá" religions. (*Ilês axés* are sometimes also referred to as *roça*, meaning, in Portuguese, the forest or rural area.) They are referred to in the literature and by non-adepts as *candomblés*, or temples. I begin by tracing the historical development of *ilês axés* in Brazil and discussing variables such as racial/ethnic membership, social class, economic status, language, and religious structure. Bahia was the point of disembarkation of the greatest numbers of enslaved Africans and remains the region where the highest degree of African influences can be seen. In this frame, *ilês axés* are theorized as tropes for "Africa" (a social construction of a projected notion of homeland) and thus as sites of conscious and unconscious resistance. The indigenous idea of *ilês axés* as insular environments that are conceptually and, often, physically separate from domains operative in mainstream Brazilian society is closely examined. *Ilês axés* can be understood as "microcosms" with unique values, deportment configurations, and epistemologies that are grounded in "Africa" and revealed in art and ritual.

A general overview of "traditional" patterns of Yorùbá history, culture, and art production is the focus of chapter 2. I pay special attention to critical contextual factors that are essential to a clear exegesis of the elements of continuity, change, exchange, and conceptual affinities between Africa and Brazil. This chapter considers slavery and ancillary issues and closes with a general analysis of the African contributions to the formation of Portuguese Brazilian culture. Chapter 3 examines the physical, historical, and cultural factors contextualizing African Brazilian ritual art and its religious matrix. I foreground the distinctive interrelatedness of African/Brazilian/Bahian art, religion, and ritual practices

and close by discussing the manipulation of art as sacrifice, prestige, display, competition/signifying, and resistance. A key concern is how clothing/costume/dress signifies identity and changes in status and power and how it is used to dress the spirits. Chapter 4 presents an in-depth case study of Yemọjá, the deity of the Ogun River in Abeokuta, Nigeria, and considers the disparate ritual and artistic ways she is honored by all economic classes in Bahia as the goddess Yemanjá and as the patron female saint of Bahia—Nossa Senhora de Conceição. Chapter 5 appraises the ideological male (*egún*) and female (*àxèxè*) ancestral ceremonies and offers an in-depth analysis of the origin, function, and organization of the society for male ancestors and its related art forms. I describe and analyze funerary rituals for female initiates and the art forms that operate as multivocal texts and circuits of dialogue between participants in and spectators of death rituals. In chapter 6 I examine the artistic impact the African/Bahian ritual has had on mainstream Brazilian/Bahian society, the Catholic religion, and popular culture. I first examine the ubiquitous transclass ritual and imagery for twins embodied in a largely domestic and pseudoreligious system of practices, looking at the historical background, ritual, and imagery originating with *ibejì* (twin veneration) in Nigeria and with Saints Cosmas (also Cosme) and Damian (also Damião) in Portugal. Their syncretized amalgamation in Bahia is analyzed in detail, and I hypothesize that differences in image choice and ritual procedure can be correlated with social class. While *Manipulating the Sacred* consists of predominantly new knowledge, I have included essential basic material from my out-of-print and largely inaccessible monograph *From the Inside to the Outside* (1984).

Ilês Axés

History, Agency,
and Sites of Resistance

Ilês axés originated in and were historically most prevalent from the 1700s in the state of Bahia, in northeastern Brazil. They also existed in other Brazilian regions, where they were assigned different names. *Ilês axés* have been documented in Rio de Janeiro since the late 1800s, where they are often called Macumbas—an expression describing the African Brazilian religions made up of an eclectic blend of Yorùbá, Bantu/Angola, Caboclo, Roman Catholic, and/or Kardecan Spiritist elements. Macumbas are sometimes confused by non-initiates (e.g., Bramly 1975) with Umbanda, religious orders encompassing European Kardecan Spiritist, Indian, and African modules. Macumbas differ from Umbandas with respect to the prominent role that blood sacrifice plays within Macumba private rituals.[1]

In the past two decades, *ilês axés* have radiated outward from their centers in Bahia and Rio de Janeiro to become established in the city of São Paulo as well (Prandi 1991). As complicated, polysemic complexes (i.e., institutions that negotiate multiple layers of meaning), *ilês axés* have moved beyond being primarily African in genealogical origin to being African-derived pan-Brazilian constructions whose exegeses preclude reductionist glosses. As Brazilian sociologist Beatriz Gois Dantas notes, the *ilê axé candomblé* is "a multi-faceted reality" (1988, 25).[2]

Building upon Dantas's view, this chapter examines the many meanings and values of the *ilês axés*. The plural term *ilês axés* refers

specifically to *candomblés* Nagô (abbreviated in Brazil from the Anago Yorùbá groups who lived during precolonial times in Dahomey). *Candomblés* Nagô most closely model Yorùbá religion as it is still practiced in nonurban areas of the West African countries of Nigeria and Dahomey—now the Republic of Benin. I shall review *candomblé* in general before focusing specifically on Yorùbá-derived religion (*Candomblé* Nagô). My first goal is to achieve as inclusive an exegesis as possible by conjoining the views of those who participate in *candomblé* with the opinions of those who study *candomblé*. In so doing, I hope to offer deep-seated analyses that neither exoticize nor objectify the initiates/agents of *candomblé*.

Defining *Candomblé*

Candomblé is the word Bahians use in popular language to refer generically to Brazilian religions that can trace their fundamental origins—in concept or practice—to Africa. The term originates from *Kandombele*,[3] a Bantu-language root word that has been translated by Yeda Castro (1976) to mean prayer meeting, festival, dance, or musical display. It has been incorporated as a loan word in the version of Portuguese spoken in Bahia, which differs in its lilting musical tones from the more staccato rendering spoken in Portugal or further inland in Brazil as a result of the impact of tonal African languages.

In the singular, *candomblé* denotes the general corpus or ensemble of ritual practices and beliefs brought to Brazil by enslaved Africans from the West and Central African countries of Nigeria, Dahomey, Angola, and Congo, among others. It currently serves as a trope for all Brazilian religions except relatively neosyncretic forms of Catholicism, Protestantism, Kardecan Spiritism, and Umbanda.[4] In the plural, *candomblés* refer to individual denominations of African Brazilian religion or to temples where sacred objects are sheltered, initiations take place, and private or restricted rituals are held. When referring to proxemics (notions of space), geography, or physical positioning, however, the adepts interchange the term *candomblé* with the term *terreiro;* Bahian initiates variously define *terreiro* as a Casa de Culto (a house of worship): the premises where a temple for the veneration of the *orixás* is situated (Pai Crispim 1981, personal communication, Bahia, Brazil; Povoas 1989, 1990, personal communication, Bahia, Brazil) or as "the assemblage of individuals who, under the leadership of a head priest or priestess, form a group of worship."[5] Both *candomblé* and *terreiro* connote

quasi-autonomous associations and corporations that possess their own esoteric belief systems, practices, and linguistic forms spoken internally by initiates.[6]

Prior to 1888, when all forms of slavery were abolished in Brazil, *candomblés* also referred to sizable jamborees and gatherings celebrated on the enslaved Africans' free days. They provided opportunities for the faithful to honor African deities cleverly disguised as Catholic saints and were one of the first concrete examples of African resistance and agency. Following Dipert's notion of the "action-theoretics" of agency (1993), I interpret agency as the conscious and empowering use of choice that enabled the enslaved Africans brought to Brazil to have a hand in molding their own destinies within the opportunities presented in their new surroundings. Thus the African deities were conjoined with Luso-Brazilian saints on the basis of visual signs or mythico-oral attributes,[7] a process also known variously as syncretization or amalgamation. These processes did not express themselves as fusion, in which no original elements of the other existed, but as hybridity, in which African, Portuguese, and Indian elements could coexist and even be interchanged. For example, the Yorùbá deity Ṣango (the deified king of old Ọ̀yọ́ and God of justice, thunder, and lightning, whose colors are red and white) was matched with Santa Barbara (who although female was a warrioress for justice whose colors were also red and white).[8] African symbols for Ṣango or other deities could coexist in the same shrine with a plaster statue of Santa Barbara with no conflict.

As it is used in contemporary Bahia, *candomblé* signifies the total aggregate of each group's ideology and "culture," including such factors as visual art forms, dance, music, myths, epistemologies, worldviews, mental constructs, values, rituals, appropriate deportment, and ethics. The popular, extended definition of *candomblé* (used in the singular) embraces the physical localities where deities are enshrined and the locus wherein ceremonies are held.

Where *candomblés* were once almost exclusively the cultural provenance of Bahia and its neighboring states where descendants of enslaved Africans were concentrated, their demographic following has now moved beyond a relatively homogenous racial membership to attract the white Portuguese Brazilian middle class. As a result, *candomblés* have increased in number from 67 (according to Carneiro's documentation in the 1930s) *terreiros* to 1,854, as registered by the Federação Baiana do Culto Afro-Brasileira in 1989 (Prandi 1991, 15). As Raul Lody (1987,

35) states: "Nowadays, *candomblé* has been discovered by the middle class and by tourists, important people, politicians and artists in search of prestige, exposing the *terreiro* as something fascinating and 'different' in addition to [serving as] not only a wellspring of religious and moral support, but mainly an aesthetic [attraction]."[9] This phenomenon is especially apparent in São Paulo, long the industrial center of Brazil. There, the tall buildings, the dominion of capitalism, the prevalence of salaried workers, and the dense, urban environment have decreased the mandatory sacred space of the forest and the beaten, dirt floors characteristic of many rural *candomblés* still found in Bahia.

Candomblés as Microsegments of "Africa"

Anthropological and sociological publications in Portuguese have largely dealt with *candomblés* as manifestations of African culture and of African-descended populations found in the northeastern region of Brazil—especially in Bahia. The *candomblés* of Bahia (although heavily persecuted in the early decades of the twentieth century, like the Xangos of Pernambuco, Alagoas and Sergipe, the Tambors-de-Mina of Maran-hao, and the Batuques of Rio Grande do Sul) have been interpreted and studied as preserved cultural constructions of ethnic groups—in this case, descendants of enslaved Africans (Carneiro [1948] 1967, 41–42; Dantas 1988, 20). *Candomblés* in Bahia have been heavily researched since the pioneering work of Nina Rodrigues, the Bahian medical doctor who from around 1896 until his death in 1906 sought to understand the African Brazilian mentality through close analyses of religious beliefs and practices (Bastide 1961, 7).

It was Nina Rodrigues's scholarship in 1896 that first advanced the concept of *pureza* (purity), or de-Catholization, conjoined with close adherence to "African" principles as a signifier of value and authentic-ity. His concerns with the notion of "purity" were shared by Melville Herskovits, an American trained in historical anthropology who inves-tigated "Africanisms" in North American black culture (Mintz 1992, 13). Nina Rodrigues concomitantly supported the tenuous viewpoint that the African Brazilian "was substandard and incompetent, and thus could not effectively merge into western civilization" (Bastide 1961, 7). Nina Rodrigues undertook his studies in the *candomblé* of Gantois when Priestess Mãe Pulcheria headed it. Gantois followed the "*nação nagô*" model, a type of ritual system founded upon the Yorùbá paradigm from the kingdom of Ketu, now in the Republic of Benin.[10] Subsequent

scholars, with very few exceptions (Dantas 1988; Prandi 1991), accepted the principle of "purity" uncritically and without firsthand knowledge supported by personal extended fieldwork in Africa (Bastide 1960, 1961, 1978a, 1978b; Carneiro 1948, 1981a, 1981b; Costa Lima 1967, 1977; Pierson 1942; Querino 1938; Ramos 1935, 1940, 1942; Rio 1906).

The Bahian *ilês axés* in which I participated, lived, or studied— from 1980 to 1983 and again in 1986, 1991, 1998, 1999, 2000 and 2001— were also concerned with maintaining "pure" African traditions and practices and, in my view, seemed to operate as sites of cultural resistance because their conceptual roots were lodged in continental Africa. The *ilês axés* I am familiar with include Ilê Axé Opô Afonjá in the suburb of São Gonçalo do Retiro (also studied by Bastide); Ilê Moroailaje in the urban area of Matatu de Brotas; Ilê Omolu/Xapanã in the suburb of Jardim Lobato; Ilê Obaluaiye in urban Curuzu, Liberdade; and the *terreiro* for male ancestors, Ilê Agboulá Egun on Ponto da Areia, the rural island of Itaparica, twenty kilometers by ferry from Salvador. I spent prolonged periods of time in Ilê Agboulá, either attending festivals or living as part of the extended family of Seu Domingo, the head official. *Terreiros* I researched less extensively include Casa Branca in Vasco da Gama, Terreiro de Balbino in Laura de Freitas, and Pilão da Prata in Boco do Rio (map 1).

Despite the strong ideological association with Africa that repeatedly surfaced during my field interviews in Bahia and Itaparica, Portuguese Brazilian scholars such as Dantas express the assimilationist conviction that seems to be characteristic of their intellectual, middle-class status—namely, that the African Brazilian's struggles to cultivate his or her African heritage "confine the black Brazilian to cultural ghetto[s] isolated from the flow of life and from [his/her] place in the structure of the society, protecting [him/her] from inequalities through the emphasis on symbolic forms of integration" (1988, 246).[11] Moreover, Dantas considers the idea of "Africa" solely as an abstraction constructed by Brazilian intellectuals in collusion with *candomblé* devotees in search of "Africa in Brazil."[12] In her opinion this construction was promoted by the advent of two prominently publicized national conferences on the topic (1934, 1937) that included renowned Luso-Brazilian scholars Gilberto Freyre and Edson Carneiro as well as African Brazilian participants such as scholar/Ifá divination priest Martiniano do Bomfim. These "Congressos' Afro-Brasileiros" received much popular support from the Brazilian "masses" and occurred precisely at the moment when

Map 1. Political map of Brazil drawn by Zabu Stewart.

the "legal status of full citizenship with all concomitant rights was extended toward the African-Brazilians" (Dantas 1988, 192–201). It is my opinion that Nina Rodrigues was simply crediting the agency and "voice" of his informants at the time he collected his data (shortly after the abolition of Brazilian slavery in 1888) regarding their impressions of "Africa." His attempt to position Yorùbá and other African-derived *candomblés* along an evolutionary continuum followed accepted "scientific" practices of that time. Nineteenth-century photographs (fig. 1.1) support my argument for African Brazilian agency and consciousness,

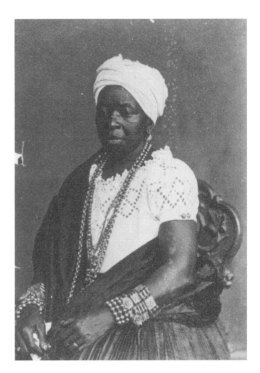

Fig. 1.1. African Brazilian
woman with clothing used in
contemporary Bahian
Candomblés. Nineteenth-
century albumen print by
unknown photographer.
Courtesy of the Schomburg
Library, New York.

as they provide evidence of adherence to African customs and signify the
conscious choosing of African dress over the many Portuguese or Brazil-
ian Indian options available. While the capped sleeves of the blouse may
be of European derivation, the mode of wrapping the head, gathering
the skirt, and draping the cloth about the shoulders resonates with il-
lustrations of local dress in Africa (fig. 1.2.).

 While I agree with Dantas that the African Brazilian idea of
Africa was socially reconstructed in a new environment and derived from
combined—perhaps eclectic—memories, my extended research in both
Africa and Brazil suggests that an element of African Brazilian agency
was involved, and Dantas fails to acknowledge this. One must be careful
not to confuse form and content. *Candomblé* was and is dynamic and
exhibits Brazilian contours fused with African nuclei. Emphasizing the

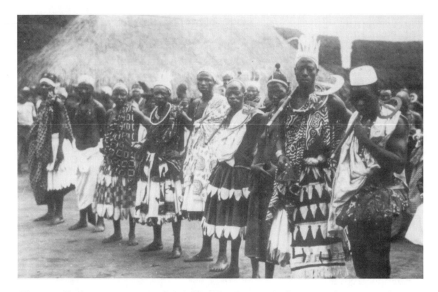

Fig. 1.2. Dahomean priests. Melville Herskovits Collection. Courtesy of the Schomburg Library, New York.

speaking of African languages and privileging verbal/nonverbal Yorùbá phraseology within the *candomblé* precincts (as opposed to Portuguese, the official language of Brazil) adds more weight to the argument for a conscious sense of defiance and selection on the part of *candomblé* participants. In order to understand the dynamic of resistance, it is necessary to review the socioeconomic matrix of the wider Luso-Brazilian society in which African Brazilian *candomblé* operates. Although new cultural forms were "invented"—and will continue to be—the cumulative cultural cognizance and worldviews of enslaved Africans transported from precolonial Africa to the New World during the transatlantic slave trade (1538–1888) also remain operative within the sacred spaces of *candomblés*. I regard *candomblés* as not only creative but also dynamic political entities in the sense that they directly or indirectly operate as centers of cultural resistance and power. Such resistance is based on African precepts and epistemological frames that remain active in the face of persistent, often elusive efforts by the wider Luso-Brazilian society to enforce the adoption of Western- or European-oriented ideas, values, and behavior

patterns. I use the term "political" not in the usual sense of governmental bureaucracy or administration but in the counterhegemonic sense of agency or resistance (whether covert or overt).[13]

Haitian scholar Pierre-Michel Fontaine (1985, 68) posits a theory of resistance and power for African Brazilian *candomblés* that supports my interpretation:

> The role of Afro-Brazilian religions [is] as power structures, considering not only the relationship between religion and politics at the conceptual level, but also the fact that inasmuch as the Afro-Brazilian religions constitute non-conformist and unorthodox structures, they are in a position of conflict and/or confrontation with the dominant culture and society. The power potential of Afro-Brazilian religions manifests itself, among other ways, in the frequent inclusion of attendance by or visits to the principal *iyalorixás* [priestesses][14] of Bahia in important public functions and ceremonies in that city, including audiences by the president of the Republic or the governor of the State. It was part of the process of *arbertura* underway in the 1980s. As the Brazilian state pursued the reestablishment of contact with what Brazilian social scientists call "civil society," it sought to take on a populist image, reinforced by the folksy, simple, and direct style of President João Figueiredo. The obverse side of this is, of course, cooptation and control; the possibility of Afro-Brazilian religions being used for purposes of social control. Nevertheless, the potential is also there for them to operate as centers of spiritual resistance.[15]

The Luso-Brazilian Mainstream

Although great care and attention are paid to fulfilling commitments to the nuclear and extended biological family, which constitute important values for Luso-Brazilians, emphasis is also placed on individual success. Good appearance, or *boa aparencia*—translated as European facial features and straight hair—postsecondary education, and wealth are some of the most important criteria used to assess success and social status, as well as to determine social mobility (fig. 1.3). *Branqueamento* (whitening) is a prevalent strategy used to achieve social mobility or increased status within successive generations. Establishing mixed-race relationships is the primary mode of attaining this goal of white or light skin color. In the mainstream, individuals may also achieve the status of "honorary" whites by the more restricted achievement of higher education and material wealth.

Fig. 1.3. Cleo Martins, Salvador, Bahia, Brazil, 2000. Photograph by author.

Class, economic status, education level, and ethnicity are closely entwined and socially constructed. The field studies of Charles Wagley (1952) and Harris (1956) documented the fact that in Brazil, impoverished, illiterate whites were considered *negros* in certain social circumstances, while very wealthy or famous African Brazilians were considered *brancos*. (My presence at private yacht club functions was usually overexplained by the fact that I was not an African Brazilian but an "Americana" and a "doutora"—doctor—even though at the time, I was only a Ph.D. student. Apparently it was necessary to situate me semiologically, especially since the only other persons of color present during those occasions were servants.) While some may assert that the term "doutor" or "doutora" is conferred on any educated person whether or not he or she has earned a doctorate of medicine or other doctorate, my investigations do not confirm this. Rather, terms such as "professora" (professor), "seu" (an abbreviation of the polite Senhor), "dona" (lady), and "senhora" (Mrs.) were more prevalent terms of respect. As

concluded from my observations and many conversations, African descent is evidenced by variations of extremely curly or wavy hair and dark to light brown skin color. I mention it here because "chromatism," or colorism, is extremely important in Brazil, where a detailed terminology for specific combinations of hair type, nose shape, and skin color exists. A person labeled *sarara*, for example, would have white skin but blond, tightly curled "negroid" hair, a generous nose, and very full lips (Harris 1958; Hildete 1982, personal communication, Bahia, Brazil; Ana Lucia 1982, personal communication, Bahia, Brazil; Yeda Maria 1998, personal communication, Bahia, Brazil). Brazilians also distinguish between a "Bahian white" and a white person from any other area in Brazil; many "white" Bahians would be considered "African Brazilian" by U.S. standards.

Candomblés as Centers of Resistance

While a limited number of individuals may be accepted into the mainstream, African Brazilians as a group are fully denied opportunities for advancement and participation in Brazilian society. Instead of agitating for integration into Luso-Brazilian sociopolitical structures as African Americans did through the nonviolent and militant phases of the Civil Rights movement, many African Brazilians elected to create and continue *candomblés* (as did the African American founders of Ọ̀yọ́ Túnjí). I regard these structures as minisocieties operating quasi-autonomously as microcosms and conceptually comparable in agency to Civil Rights groups. For many persons of African descent in Brazil, *candomblés* are critical and dynamic arenas of resistance that psychically balance their marginality in Luso-Brazilian circles. In contrast to the Brazilian mainstream, which economically, socially, and politically relegates most blacks to a peripheral underclass with few avenues for social mobility, organized African Brazilian religion offers viable, attainable goals and lifestyles. Each religious temple (*candomblé*) is viewed by its initiates as a separate, sacred, physical space, yet one ineluctably linked in a spiritually genealogical relationship to the earliest founding *candomblés*. Demarcation from the lay world is signified in many ways, the most salient of which I will discuss in chapter 3.

The main concern in these *candomblés*, where many members are female, is the maintenance and manipulation of *axé*—the sacred power and vital force inherent in all animate and inanimate entities (*àṣẹ* in Yorùbá)—and active and positive relationships with the *orixás*. But apart

from the religious focus, socially and psychologically, *candomblés* offer African Brazilians alternative channels by which to achieve some significant measure of self-esteem, social solidarity, prestige, and social status, because the system is founded on African values and behavior patterns. The research of Prandi (1991, 88) in São Paulo confirms my findings in Bahia:

> [*Candomblé*] constitutes not only the idea of progress which is not merely that of spiritual evolution, the mediumistic development of Umbanda. In the environment of *candomblé*, development involves access to elevated positions in the hierarchy, which can be attained through [the exemplary fulfillment of] ritual obligations. And this denotes prestige, because even outside of the sacred religious spaces, *candomblé* has been a religion recognized to a greater degree of legitimacy than [has] *umbanda*.[16]

Highly valued "African" attributes include proficiency in the Yorùbá language used in chants, songs, esoteric rituals, and daily conversation in the sacred space; the ability to dance well; familiarity with medicinal properties of herbs; and an ability to manipulate for various uses the spiritual force contained in the proper combinations of leaves. Other desirable connections to Africa include behavior patterns, African cornrows or braided hairstyles, dress, liturgical knowledge, and dance. Proficiency in all these determine social mobility within the spiritual or civil hierarchies of the religion. African Brazilian art forms and esoteric ritual are used dynamically to manipulate the sacred, thereby reinforcing and conserving the system.

Rather than focusing on individuals, the *candomblés* I studied concentrate on the welfare of the group members and religious communities as collective entities. Since they were group-oriented, they often functioned as mutual-aid organizations for their active members. The traditional West African economic principles of barter and redistribution—rather than those endemic to cash economy—were fundamental to the organization, as were group ownership and distribution of the land associated with the religious temples. (Comparisons may also be drawn with the reciprocal financial support many enslaved or free African Brazilian Catholic brotherhoods and sisterhoods offered their members.) Finally, the unifying rituals of initiation construct a bond of fealty that supersedes even the responsibilities that bind the individual to his or her biological family (Costa Lima 1967, 65–83; Oṣunlade 1982, personal

communication, Bahia, Brazil; Seu Domingo 2000, personal commu-
nication, Itaparica, Brazil).

The Role of Initiation

Conceptually, initiation is perceived as a rebirth—the death of the for-
mer individual and creation of a new being (plate 1). Aided by the creator
deity, Obatala, and the mother goddess, Yemanjá, the priest (*babalorixá*)
or priestess (*iyalorixá*) officiating over the initiation process is consid-
ered to function in a creative capacity that may be compared to the bio-
logical process of childbirth in women. The same analogy is made even
when the initiator is male. During the many initiation rituals in which I
participated, I frequently overheard congratulations given on the suc-
cessful *parto* (birth), much as would be extended a woman who had
physically delivered a healthy child. Initiation positions the initiate in
the comparable status of a newborn, and later, in a lifelong relationship
of "son" or "daughter" to the "mother/priestess" or "father/priest" who
conducted the initiation. The initiate into *candomblé* concurrently enters
an extended family relationship with all of the individuals who have been
initiated by the officiant, and the connection extends even more pro-
foundly to spiritually bind the new initiate to the priest or priestess who
initiated the officiant. Thus within *candomblé* lineage, relations com-
parable to those that trace daughter, son, mother, father, grandmother,
grandfather, and great-grandmother or great-grandfather connections
across the generations are established through the initiation process.
The experience further propels the individual into a contractual rela-
tionship with not only other *candomblé* members but also with the gods
that cannot be dissolved during one's lifetime. In fact, it is believed that
this connection supersedes death, so that the deceased officiant's "hand"
must be removed from the initiate's "head" by a special ceremony. Along
with membership into a new spiritual family, initiation carries with it not
only a new status but also a new set of duties or *obrigações* (obligations)
that must be fulfilled. An often heard adage, "O *Candomblé* e um saco
sem fundo" (*Candomblé* is a sack with no bottom), reflects the unending
cycle of *obrigações*, which, incidentally, members view as "privileges."

Typology of *Candomblés*

The numerous *naçãos* (ethnic "nations") initially formed during slavery
gave rise to diverse types of *candomblés* differentiated according to rit-
ual conventions and organizational formations. Gege (Jeje) *candomblés*

derive from the Ewe or Fon rituals brought from Dahomey.[17] Their deities (known as *vodun* or *vodu*), dances, languages, and rituals vary only slightly from Yorùbá-derived prototypes.[18] The similarity between the two can be partly explained by the socioreligious amalgamation and cultural exchange that occurred in Africa before and after the transatlantic slave trade. Another explanation emphasizes the frequent contacts and wars between the Yorùbá and the ancient kingdom of Dahomey (Mercier 1963, 210–34) that resulted in a massive Yorùbá influence on Fon culture and religion even during precolonial times (Akinjogbin 1967).

Angola and Congo *candomblés* are derived from Bantu-speaking slaves from Zaire, Cabinda, Angola, Mozambique, Zanzibar, and other Central and South African countries. Their ritual language is Bantu or a modification of Bantu, Portuguese, or Amerindian languages such as Tupi or Tupinamba. Deities in these *candomblés* have Bantu names, although many of their attributes and ritual paraphernalia (plate 2) are derived from Yorùbá models (Tata Lembaraji, Sept. 1998, personal communication, Bahia, Brazil; Carneiro n.d., 60, 77–78, 86–88, 97, 109). For example, the raffia fiber outfit decorated with cowrie shells used for the *inquice* Cavungo while in possession trance in the Bantu festivals is almost completely identical to the outfit used for the *orixá* Omulu in *candomblé* Nagô.

The style and organization of ritual dances and music in the public *festas* (festivals) I observed are unique to Angola and Congo *candomblés*, although they clearly pay homage to Yorùbá patterns. At every festival I attended in Bate Folha and Bogum (two very old, highly respected Angola [Bantu-derived] *candomblés*), during the final public ritual segment the entire Yorùbá pantheon was summoned, danced for, and dispatched before the festival was considered to have ended successfully. Angola *candomblés* are especially distinguished by the custom of allowing Exu (Èṣù in Yorùbá [the deity of the crossroads, risk, and unpredictability]) to publicly incorporate in the initiates' bodies. Although Èṣù publicly manifests in traditional Yorùbá religious ceremonies in Africa and the United States, Exu is never openly revealed in possession trance in orthodox Yorùbá-derived *candomblés* in Bahia because Exu is not regarded as an *orixá* per se, but as a divine messenger and mediator.[19]

Caboclo (Indian) *candomblés* are religious organizations wherein indigenous Amerindian spirits are honored in the sense that they are recognized as *donos da terra* (owners of the Brazilian soil). The Caboclo

spirits are celebrated as "mythical heroes" on *dois de julho*, July 2—Bahia's independence day (Lody 1987, 14)—and also on other dates as decided by divination (plate 3).

The rituals for these Brazilian energies are frequently mixed with Angola, Gege, or Yorùbá cosmology and ritual in certain Caboclo *candomblés*; according to Raul Lody, "uma etica africana permeando os rituais" ("an African ethic permeates the rituals") (1987, 17). They may also be honored as second- or third-tier deities in Angola and in nonorthodox Nagô *candomblés*. Caboclo divinities are variously *espiritos desencarnados* (disembodied human spirits or "ancestors") or forces from the forest or thickets. Prandi (1991, 245) distinguishes between Caboclos "de pena" or *indios* ("those wearing feathers" or Indians) and *boiadeiros* (cattle herders).

The deities in Caboclo *candomblés* are called *encantados* (enchanted or conjured ones), and all their ritual songs are in Portuguese. Not surprisingly, the dances performed in these *candomblés* are derivations of the samba, the national Brazilian dance and a Yorùbá word (Philip Taiwo Ijaola, Mar. 1981, personal communication, Salvador). In the *candomblés* I visited in Bahia (1981–83, July 2000), the Caboclo *encantados* were the only divinities who exhibited the non-Yorùbá traits of dancing with their eyes open, smoking cigars, drinking *cachaça* (sugar-cane brandy, said to be a favorite drink of Caboclos), and giving consultation and advice during public festivals with the intention of healing as they were corporealized during the initiates' possession trance. Brightly colored feathers and costumes of Amerindian derivation govern the aesthetic displays in the annual public festivals. The yellow and green colors of the Brazilian national flag predominate in liturgical garments and house decorations. Fruits and vegetables are sacrificed to Caboclo energies rather than the animals commonly offered to deities honored in other types of *candomblés*. These fruits and vegetables are abundantly displayed in the *barracão*—a building where large public festivals are held—during public ceremonies for Caboclos and are distributed to the spectators by the possessed Caboclos near the end of the celebrations.[20]

According to Carneiro (1948, 88–89), *encantados* are mere duplications of the Yorùbá *òrìsàs*. Carneiro cites, for example, the amalgamation of the Caboclo, Sultão das Matas (sultan of the forests) and Caboclo do Mato (pure-blooded Indian of the forest) with Oṣosi/Oxossi, the Yorùbá god of the forest and the hunt. The ceremonies I attended suggest, however, that Caboclos exhibit more original, possibly indigenous,

traits than Yorùbá ones and may therefore represent valid attempts at preserving, and respecting, aspects of indigenous Brazilian religion that have not yet been adequately studied. That this concern with respecting the Brazilian Indian ancestors in the Africans' new land is paramount is poignantly exemplified in the liturgical garments worn during the *egún* festivals for ancestors in Itaparica (plate 4).

Ilês axés: Candomblés Nagô in Bahia

Candomblés Nagô are religious associations structured according to Yorùbá models. They originated in the state of Bahia but expanded to Rio de Janeiro, Sergipe, and most recently São Paulo. Major portions of their ritual and cosmological systems and style of liturgical vestments have been adopted by the Gege, Angola, Congo, and to a lesser extent the Caboclo *candomblés*. For this reason many scholars have suggested their hegemonic influence. As noted earlier, the word *Nagô* is derived from *anago*, a term applied by the Fon-speaking peoples to Yorùbá-speaking peoples residing in the kingdom of Ketu of Dahomey. *Nagô* is now used in Brazil to designate all Yorùbá, their African Brazilian descendants, and Yorùbá myth, ritual, and cosmological patterns. However, distinct Yorùbá nations in Brazil such as the Òyó, Ketu, Egba, Jebu (Ìjẹbu), Jexa (Ìjẹ̀ṣà), and others from Lagos and Ibadan were noted by Nina Rodrigues as early as 1890, two years after the 1888 abolition of slavery (Nina Rodrigues [1896] 1935, 104), and are still discernible or operative today. Major Bahian *candomblés* Nagôs were heavily studied from 1890 until recently and are synonymous in many reports with *candomblés* Queto (Ketu). Despite the problems with attempting to evaluate authenticity in a pluricultural society, they are popularly regarded as the "purest" and "most authentic" African-derived *candomblés*. This view prevails among *candomblé* participants, although some have incorporated both Catholic and other African elements in their art forms and ritual practices from their inception. *Candomblés* Nagôs and *candomblés* Queto have ubiquitously served as the archetype of *candomblés* of the same *nação* (nation) newly founded outside of Bahia.

The first securely dated *candomblé* Nagô in Bahia was founded in 1830 in Barroquinha, an area now in the town center, by three African women: Iyá Deta, Iyá Kala, and Iyá Nassô (Carneiro [1948] 1967, 63–65). This *candomblé*, named Ilé Iyá Nassô (the house of mother Nasso), was moved sometime in the late nineteenth century to its present location in Vasco da Gama near the São Jorge gasoline station. It is currently called

Casa Branca, the white house. Quarrels over the leadership succession of two chief priestesses led to the subsequent formation of two additional houses: the *candomblé* of Gantois in Engenho Velho (the old sugar mill), where Nina Rodrigues conducted most of his research (fig. 1.4), and the Beneficent Society of São Jorge, more commonly known as Ilê Axé Opô Afonjá (the sacred force of the staff of the *orixá* Xango Afonjá). This latter *candomblé* was founded in approximately 1918 by Aninha in São Gonçalo do Retiro (fig. 1.5) and is the place where I conducted a significant portion of my field research in Bahia and where I was initiated as an Olorixá (olórìṣà).[21]

Although there still exist a few rural *candomblés* Nagôs (e.g., in Cachoeira, Santo Amaro, and Feira de Santana), they are now essentially urban or suburban phenomena. As we will see, however, a symbolic, ideological connection is maintained with rurality. An estimate of more than five hundred *candomblés* Nagôs existing in 1983 (Vicentio 1983, personal communication, Salvador, Bahia, Brazil) is probably conservative. This number contains those concentrated in the metropolitan area of Bahia and includes both the older, elite founding houses made famous by researchers since the late nineteenth and twentieth centuries, as well as the almost anonymous, proletarian neighborhood *candomblés*. Of the 1,854 *terreiros de candomblé* registered by the Bahia Federation of Afro-Brazilian Cults, 614 were self-named *queto* (a synonym for *keto* or *Nagô*).

The elite *candomblés* Nagôs command more prestige and attract more adherents than do the proletarian ones and therefore have a larger economic pool available for ritual expenses. I found that among these elite *candomblés,* the temple area, *terreiro,* usually encompassed numerous acres of land, including large areas of virgin forest and one or more streams. Elaborate separate buildings were built for each individual *orixá* honored in the *terreiro.* Each building (known as the *ilê orixá*—house of the deity) was constructed of mud and covered with cement or stucco. Roofs were composed of curved, elongated tiles, and both the interior and exterior were painted in the appropriate symbolic colors of the *orixá* owner of the shrine.

The basic plan of the entire structure consisted of a sacred, inner core room (plate 5) where the key objects and implements embodying the *axé—àṣẹ* in Yorùbá-derived Brazil—of the *orixá* were located and an outer room where sacrifices and other rituals were conducted. Among these *axé* were various types of ceramic and porcelain pots and dishes containing the stones, bits of iron, brass, silver, lead, or other

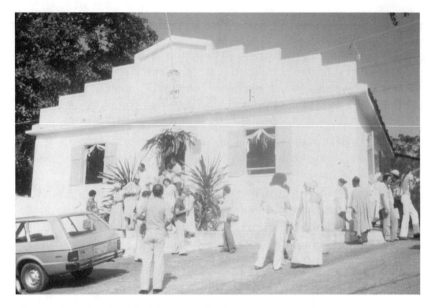

Fig. 1.4. Facade of Ilê Axé Gantois, Bahia, Brazil, 1983. Photograph by author.

metal representing the natural essence of the *orixá*. Next were liturgical implements, which are type motifs and specific to each separate *orixá*. Last were plates and dishes containing the remains of liquid and solid offerings considered be the preferred food and drink of the *orixá* during their former existence on earth. The natural elements and liturgical implements all received a portion of blood and food sacrifices, which were offered weekly, monthly, and annually. In the Ilê Axé Opô Afonjá, entrance into the inner core shrine room was forbidden except to the *iyalorixá* (chief priestess), *babalorixá* (chief priest), their top assistants, and *axogun* (male official charged with sacrificing animals), the incarnated *orixá*, or a very few senior, elderly individuals who were initiates of the specific *orixá* to which the shrine was dedicated. All others had to stay in the outer room of the shrine area during ceremonies. This outer area usually had liturgical implements displayed on the walls or photographs of the illustrious deceased dedicated to the *orixá*/owner of

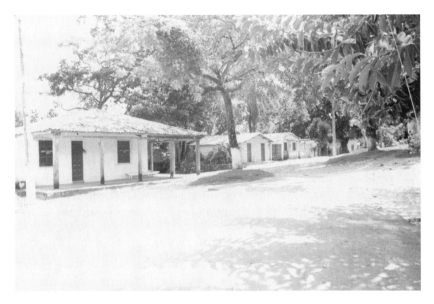

Fig. 1.5. View of grounds and Xango shrine, Ilê Axé Opô Afonjá, Bahia, Brazil, 1988. Photograph by author.

the shrine. Some of these outer areas contained normal furnishings one would find in any house, such as chairs, armoires, and so forth.

In contrast to the elaborate structures of the elite *candomblés*, I found that the proletarian ritual spaces usually consisted of only one or two tiny rooms in a small house. However, even in one of the *terreiros* in Jardim Lobato, where I lived, a separate area was used as an arena for the large, public annual festivals. These proletarian *candomblés* were frequently built near trees, shrubs, and other forms of vegetation. This choice in location was undoubtedly linked to the central role that leaves, herbs, and flowers play in rituals.

At Ilê Axé Opô Afonjá and Terreiro Omolu Xapana, where I also stayed, many of the initiates lived in the *candomblé* during the annual festival and initiation cycles, which lasted from three weeks to three months. Initiates slept in the *candomblé* overnight for the weekly or monthly rituals. They commonly referred to this residence as the

roça, a Portuguese term meaning country, rural region, or backwoods plantation. It was pointed out to me that this term is also colloquially used to refer to the "interior" of Brazil—the vast rural area outside any metropolitan area (Augustinho 1984, personal communication, Los Angeles, California; Tomázia 2001, Bahia, Brazil).[22]

During the ceremonial periods at Ilê Axé Opô Afonjá, when I first began this research, the chief priestess lived in Ribeira and moved to the *roça* where she was domiciled in the major shrine known as the *ilé Xango* (shrine of the *orixá* Xango Afonjá), patron of the *terreiro,* which included her special official living area. This building contained a basement museum until 2000. There is now a separate, large building for the museum. (She now lives permanently in the *roça* in a multilevel house located behind the *barracão.)*

The presence of the *iyalorixá* in the *roça* during the annual festivals signifies a heightened collective spiritual force that adds to the general excitement and sense of community. Located on the grounds is a school that teaches the resident and neighboring children the traditional history, music, dance, mythology, and songs of the gods. It is known as the *comunidade* (community) of Oba Biyi (the initiate name of Aninha, the founder of this *terreiro*).

The *roça* is permanently organized around older, committed initiates—usually *candomblé* officials—and devotees who are destitute or infirm. Each permanent resident is provided with at least a private room or, if means permit, a separate house. Rooms are equipped with all the basic accoutrements, though all washing and bathing and some cooking are done in communal areas. Sometimes rooms are shared by relatives, close friends, or members of the same initiation group, called a *barco* (literally, a small open boat). Temporary residents are given a separate room, or they share with someone else. My own residence at Afonjá was a sleeping room in the Casa de Oxalá, a large, long, rectangular building serving multiple purposes, where the shrine of this god was also located. In 1982 I shared my room with Ọṣunlade, an *iyalorixá* visiting from Brasilia. Although Ọṣunlade had been given her own room, she preferred to share with me, regarding my room as "better" possibly because it was closer to the entry door or because of the possibility of continued, close interaction with me—a foreigner.[23]

Most of the people participating in the *candomblé* Nagô *terreiros* that I investigated from 1980 through 1986 were of African descent. Devotees were primarily from the lower socioeconomic classes and were

generally laborers or held service-oriented jobs. In the last fifteen years, a small but slowly rising number of members hold skilled, managerial, or professional jobs, and a handful of initiates are white Brazilians. (Such examples are usually encountered in the older, wealthier, more prestigious ritual houses such as those of Menininha de Gantois, Axé Opô Afonjá, and Ilê Moroailaje.) Robert F. Thompson (1981, telephone conversation) has suggested that these *candomblés* occupy the apex in the hierarchy of *candomblés* and thus constitute an elite. It is my opinion that the "status" of some houses was achieved from the attention focused on them by scholars (e.g., Nina Rodrigues, Artur Ramos, Edison Carneiro, Pierre Verger, Melville Herskovits, Roger Bastide, and Ruth Landes). Jorge Amado (a writer) and Carybé (a famous artist during his lifetime) were celebrities of international importance who held prestigious civil positions in these houses (specifically Axé Opô Afonjá). They have contributed substantially to the reputation and renown of certain *candomblés*. Thus the ceremonies in these older, elite *terreiros* may sometimes attract huge numbers of tourists, eager to observe the "exotic" public rituals.

Values in *Ilês Axé*

Two canons of *candomblé* Nagô, henceforth referred to as *ilê axé*, are the preservation of "pure" African ideas and the meticulous maintenance of the esoteric religious ritual processes of the Yorùbá-speaking peoples of West Africa. The tropical climate in Brazil is so similar to that of the western coast of Africa that it is possible to find the same or similar vegetable substances that still play central roles in West Africa Yorùbá religion (Abimbola 1990, personal communication, Ilé-Ifẹ̀, Nigeria). *Candomblé* sacred herbology may have been further augmented by knowledge gleaned from Brazilian Indians. The transatlantic crossing led to some unavoidable alterations in other domains because of the oppressive conditions of slavery and the requirements and restrictions of a new sociopolitical environment. Many changes that occurred in art and religion were adaptive and defensive; the overlay of African gods with Catholic saints is just one example of this type of accommodation. The Bahian brand of Catholicism seems to feature an intense personal relationship and identification with a particular saint on the part of the believer. Specific saints are prayed to for specific requests: Santo Antonio for successful marriage; Cosme/Cosmas and Damião/Damian for jobs, luck, or removal of obstacles. The majority of

households appear to maintain separate altars for one or more saints and to regularly replenish them with lighted candles and fresh flowers. Thus it was an easy transition for enslaved Yorùbás to identify their *orixás* with a personalized saint possessing similar capabilities: Saint Lazarus, the saint of leprosy and oozing sores, for example, was conflated and syncretically associated with Omolu/Obaluaiye, the god of smallpox and other virulent diseases. (I noticed during the 1991 World Congress of Òrìṣà Tradition that Omolu's domain now extends to include AIDS, a clear indication of the adaptability that maintains a dialectical tension with keeping tradition.) Finally, in some *terreiros,* conflicts caused by the pressures to assimilate into modern Brazilian society led to the incorporation of Catholic altars into the ritual dancing space of the public *candomblé* area. (Casa Branca in Engenho Velho, for example, has a Catholic altar to the right of the entry of the *barracão*.)

In the *terreiros* I studied, only persons of clear African descent held the most important ritual posts, although this did not hold true for every house I visited briefly. For example, the *candomblé* of Menininha de Gantois was alleged to be a "house full of white and foreign initiates" (Ebomin Ọba Jẹsin of Xango 1982, personal communication, Salvador, Bahia, Brazil). Among the *terreiros* I researched, there were only two full initiates (*Olorixás*) who were white—Cleo and Djalma—both initiated to serve Yansan at Afonjá. Large numbers of whites and lighter-skinned Brazilians, however, did observe public ceremonies and participate in the secular aspects of the *candomblé* organization. The attraction of white Brazilians to *candomblé* was first noted in 1896, only eight years after slavery was abolished in Brazil (Nina Rodrigues [1896] 1935, 155).

Values and behaviors characteristic of the upper and middle classes (and mimicked in the lower classes) in Luso-Brazilian society at large are *inverted* in the African Brazilian religious realm, or *ilês axé.* Thus, some of the criteria that accelerate upward mobility in *candomblé* Nagô reflect the value placed on genealogy—dark or black skin and an ability to trace direct descent from Africans (especially the Yorùbá)—and the mastery of Yorùbá language used in chants, songs, esoteric rituals, and daily conversation in the sacred space. The ability to dance well and familiarity with medicinal properties of herbs, the spiritual force contained in leaves, and their proper combinations and uses are also highly rated.

While within mainstream Luso-Brazilian society it seems ideologically desirable to be as far away from the gods as possible (except when

asking for favors), closeness to the gods is desired and highly valued in the *ilê axé* culture. Proximity to the gods is achieved through the performance of certain tasks, a prodigious investment of time as an active member, and the experience of trance. Careful and consistent attention to one's *orixá*, willing performance of *tarefas* (ritual duties) necessary for the efficient maintenance of the temple, and active participation in the preparation for annual festivals also affect how rapidly one moves to the top of the *candomblé* hierarchy. Authority and permissible activity depend on length of initiation. Tasks associated with the initiatory rituals of novices, the collection and treatment of herbs and leaves for the diverse deities and rituals, and responsibilities in the shrines of specific gods are seen as privileges to be earned. In turn, performance of the tasks bestows substantial prestige and honor upon the recipient. Someone not permitted to work in the sacred space is relegated to the spiritually valueless status of a visitor. It is also deemed an honor to be able to offer a sacrifice—whether animal, vegetable, or material, including art—to an *orixá*.

In contrast to the Europeanized capitalistic sectors of Bahian society, which emphasize private property, individualism, and conspicuous consumption in the secular realms, *candomblé* emphasizes the welfare of the group as a whole. Capitalism has been defined as "an economic and social system" (Jameson 1994, xxi) characterized by private or corporate ownership of capital goods, by investments that are determined by private decision rather than state control, and by prices, production and the distribution of goods that are determined mainly by competition in a free market. The interpretation of capitalism herein emphasizes large-scale ownership and mass production of goods for profit in a "*world capitalist economy* which has its origins in the sixteenth and seventeenth centuries, and is integrated through commercial and manufacturing connections, not by a political centre" (Giddens, 183–84 in Williams 1994 [my emphasis]). I am not referring to capitalism in terms of its popular usage to describe the practices of conspicuous consumption. Although Lody (1987, 35) refers to some famous *terreiros* that operate like *empresas* (businesses), he is not specific regarding his data and I cannot verify his assertions. In a period of almost twenty-one years, I did not witness capitalistic operations, as defined by Giddens (1994) and others, in any *candomblé*. Concomitant with a capitalistic economy are Western values and consumption patterns, which generally extol private rather than communal property.

Material display and embellishment are a form of sacrifice to the *orixás*, who dispense spiritual (and, it is believed, material) rewards and benefits in return. Rituals and large public festivals are financed primarily by members and affiliates, although money for extraordinary expenditures, such as the repair or construction of a shrine or other structure, may be solicited from wealthy or famous secular, male officials and patrons of the *candomblé*, such as *ogans* or *obas* (see Costa Lima 1977). While there is no cost for initiation into Ilê Axé Opô Afonjá, clothing, animal, and vegetable sacrifices are provided by the novices. These items are usually obtained only after saving for years, through loans, or with the help of extended family, friends, and patrons. My observation of *candomblé* members revealed that their greatest expenditures were in the service of the gods, not their personal secular needs. In fact, the startling simplicity of their Western type of daily dress provided a dramatic contrast to the rich, often extravagant luxury of the public ritual dress of the *orixá*.

Land belonging to the *candomblé* Nagô is held in common and dispensed by the head priestess to those who need it to build houses, pending civil approval. This practice may have its roots in Yorùbá principles of land allocation and ownership. Food and economic aid are provided for devotees who experience unforeseen need, and in this respect *candomblé* Nagô functions as a mutual aid organization. During my stay I met some destitute initiates who had been given land, food, and money by the *candomblé*, usually in exchange for the performance of ritual duties.

The overriding focus of *candomblé* Nagô is communal rather than individual. Indeed, one of the highest compliments that can be paid to an initiate is that he or she is obedient, meaning that he or she places the interests of the group in the service of the *orixá* above him or herself. *Candomblé* Nagô also offers African Bahians avenues through which they can achieve self-pride, group solidarity, prestige, and social mobility within a system that celebrates African values, behavior patterns, ideas, and dark skin color. *Candomblé* provides an important alternative to the megacosm and fulfills a critical need for its members, who are otherwise denied participation in Luso-Brazilian society.

While we must acknowledge a contribution from the wider Luso-Brazilian society in the construction of intellectual and/or popular discourses on *candomblés* and other forms of African Brazilian religions, we must be careful not to discredit the cognitive element of African Brazilian agency in their formations and preservation. Ilês Axés must not be

viewed as reified and static but as dynamic and embodying conscious change—a process already evident in Africa before enslaved Africans were brought to Brazil. In the following chapter we will examine the legacies of *àṣẹ* and how it informs the religious organization and processes of the Yorùbá religion *candomblé,* the design, sequencing and signification of initiation, and the concept of *ẹbọ* (the trope of sacrifice in honoring the gods).

Legacies

Art, *Àṣẹ*, Cosmology, and Divination in Yorùbá Religion

More than twenty-five million Yorùbá-speaking peoples reside in the West African countries of Nigeria, the Republic of Benin, and Togo (map 2). Exhibiting diversity and organized into at least twenty-five discrete, semiautonomous monarchies, most Yorùbá speakers maintain a sense of unity by tracing a common descent through Odùduwà—a deity and an ancestor/ancestress who established an advanced culture, complex religion, and centralized system of government in the urban metropole of Ilé-Ifẹ̀, Nigeria, by 1100 A.D. (Lawal 1996, 19).

Before the 1800s the Yorùbás did not consider themselves the collective entity by which scholars refer to them today. Instead, they identified themselves by the names of their kingdoms and subgroups (Law 1977, 5)—an important consideration for the idea of nation in Bahia and other host countries of the Yorùbá diaspora. Anago, Ẹ̀gbá, Ifẹ̀, Ìjẹ̀sà, Ketu, and Ọ̀yọ́ are names of such kingdoms and subgroups kept alive in Bahia despite the hegemony of the term *nago* used popularly to describe Yorùbá-derived religion and art. Although minor regional, linguistic, and cultural variations exist, many southwestern Yorùbá kingdoms carefully preserve oral traditions that locate their origin in the town of Ilé-Ifẹ̀, in the state of Ọ̀sun, and regard the *ọni* of Ilé-Ifẹ̀ as their spiritual leader. The *ọni* (preeminent king) occupies the pinnacle of the religio-political pyramid and traces his descent directly from the founder *òrìṣà*, and ancestor Oduduwa, the first *ọni*. The kings whose prerogative is to

27

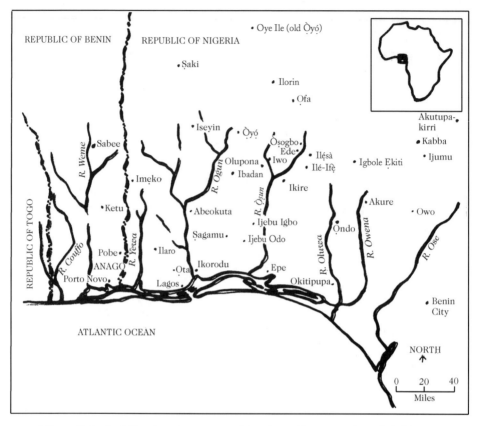

Map 2. Principal Yorùbá subgroups and localities. Drawn and modified by
Zabu Stewart (after Lawal 1996).

wear the *adé* (veiled, beaded crown) as an emblem of office are locally re-
ferred to as "crowned *obas*" and are able to trace their genealogy from the
sons and grandsons of Odùduwà. Considered "divine" kings and thus
èkéjì òrìṣà (second in power to the gods) these *obas* (town and division
chiefs, and patrilineal compound heads) (fig. 2.1) occupy the levels be-
neath the *oni* in the power hierarchy exemplified by the pyramid model.
Among the northeastern Yorùbá, women may rule as regents—though
they are called kings—when no suitable male is available. In such cases,
the women are treated as males, inherit and care for their predecessor's

wives, and wear male clothing while they perform their ritual or political duties as regents/kings (plate 6). Although they wear female clothing in their domestic compounds as they go about their duties as women and wives, their special rank is subtly signified by continuous wearing of a male cap atop their coiffures (fig. 2.2). After the rank of king, subsequent tiers were occupied by the *ògbóni* (wise elderly men and postmenopausal women) (plate 7) selected from each patrilineage and serving as an advisory council to the *oba* (Òjó 1966; Biobaku 1973).[1]

It is well documented that the Yorùbá are distinguished by profusely elegant artistic and cultural legacies operating within highly developed religious, social, and political systems. Whereas the Yorùbá lived (and many still live) primarily from agriculture, they also have jobs in local, regional, and international trade, politics, education, electronics, and other fields. Their historically urban culture remains based on the town as the fundamental settlement. Regions vary, but farmers typically envision their villages or farmhouses as provisional or even temporary abodes, while their real homes are located with patrilineal kinspeople in the towns. It is in the towns that the main households, palaces, local governments, markets, and most of the religious shrines are situated, and it is the towns that provide the geographical focus for Yorùbá artistic, religious, and cultural life. Much of the population in very small villages and towns in the northeast—such as Iffe Ijumu, Iffe Ikoyi, and Kabba—is still specialized by full- or part-time trades or professions. These include marketing, ironworking, brass-casting, woodcarving, weaving on the vertical or horizontal looms, bead-embroidery, potterymaking, cloth dyeing, leather work, calabash carving, hunting, fishing, and divining or other religious careers.

The Yorùbá cities, towns, and villages still reveal complicated stratified social and governmental formations. Salient practices for maintaining and proclaiming status have customarily been control of wealth and conspicuous display of art objects, hair designs, head coverings, clothing, and other adornments. (I observed these between 1980 and 2001 in Yorùbá-diaspora Brazilian communities and from 1981 to 1993 in Yorùbá communities in Africa.)

As underscored by anthropologist Andrew Apter, the Yorùbá actively participate in a postmodern world: "Today, Yorùbá language and culture is taught in Nigerian high schools and universities, 'traditional' herbalists are licensed by the state, and physics professors consult diviners, while business men, 'cashmadams,' army officers, and politicians

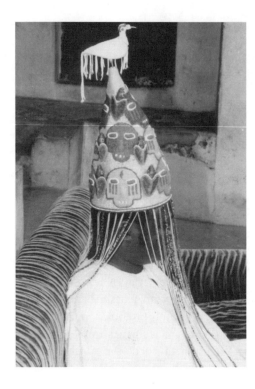

Fig. 2.1. The Obaro (king) of Kabba, Nigeria, with traditional beaded crown, 1991. Photograph by author.

protect themselves with [indigenous] medicine and educate their children abroad" (1992, 2). The Yorùbá worlds of tradition and postmodernism operate in tandem, alternately paralleling and intersecting. As we will see, this observation, like the foregoing description of Yorùbá society, pertains as well to the Yorùbá-derived African Brazilian worlds constructed during the transatlantic slave trade from approximately 1538 through 1808 and afterward, when Yorùbá culture and language were disseminated throughout the world by enslaved Africans who established important outposts of Yorùbá religion and ritual art in the Americas and the Caribbean.

The hub of traditional Yorùbá life was and remains religion (*isin òrìsà*), the frame within which much art production, social interaction, and political governance transpires; thus "In order for some aspects of Yorùbá life to be fully explained and satisfactorily understood,

Fig. 2.2. The female regent of Igbole dressed in female clothing for domestic duties. Ekiti, Nigeria, 1991. Photograph by author.

they must be interpreted mainly in terms of the religion" (Ọ̀jọ́ 1966, 158). Traditional Yorùbá religion has been recorded from the early visits of European adventurers and traders to the later extended sojourns of missionaries and colonizers. My research in the field has substantiated fairly consistent conceptual correspondences between Yorùbá religion in West Africa (especially in villages far from metropolitan areas, such as Akutupa-Kirri) and its inflections in Bahia. Yorùbá religion still resonates with practices in the *ilês axés* of the Yorùbá-based *candomblés* Nagô.

The Yorùbá conceptualize the physical world and the spiritual world (*ilé aiyé* and *ilé ọ̀run*) as two great halves of a calabash (*igba*) divided horizontally and simultaneously representing complementary male and female power and the power of nature *iyanla* (construed as feminine). The *igba* is an important element in all ceremonies of investiture (plate 8). Conceptually, the calabash represents the unbroken circle of life with no beginning and no end: the unborn, newly born,

children, adolescents, adults, elders, and the deceased blend together. An important idea is that death is not finite but rather a "change of address." While the container of the body disintegrates, the spirit lives on indefinitely and can be reincarnated into newborn children or accessed through art and ritual by the descendants. As noted by Yorùbá scholars (Abimbola 1971, 75; Ajuwon 1984, 89–98; Lawal 1996, 22;):

> The Yorùbá view the cosmos as a dynamic interplay of such opposites as heaven and earth, day and night, male and female, physical and metaphysical, body and soul, inner and outer, hot and cold, hard and soft, left and right. Life and death, success and failure, and so on. . . . This oppositional complementarity is evident in the popular saying: *Tibi, Tire la da ile aye* (the physical world evolved out of Good and Evil). Known as *ibo* (the worshiped), the benevolent forces comprise the *òrìsàs* and spirits of deified ancestors (*ara òrun*). If worshiped properly, these beings will ensure good health, long life, wealth, and happiness. The malevolent forces are the earthly calamities militating against human happiness and well being. Known as *ajogun* (warriors against humanity), these negative forces include death, paralysis, disasters, diseases, loss, trouble, barrenness, drought, curse and demons. (Lawal 1996, 22)

Òrúnmìlà (the principle of harmony) and Èsù (the principle of chaos) collaboratively regulate the dialectical powers embodied in the *ajogun* and the *òrìsàs*—malevolent and benevolent energies. Through the medium of Ifá divination, Òrúnmìlà enables others to detect and work out their difficulties and prophesy the outcomes of impending endeavors. In contrast, "Èsù is a paradigm for the 'opposites'" (Lawal 1996, 23). As bearer of information and offerings to advance equilibrium and harmony, Èsù negotiates among humans, the *ajogun*, and the *òrìsàs*. Many oral traditions in Nigeria and Brazil characterize Èsù as a catalyst who stirs up trouble to create situations that require offerings to him and mediations for him to take charge of, behavior Christians and Muslims associate with Satan (Lawal 1996; Wescott 1962; Abimbola 1976). Since Èsù is believed to instigate disagreements and conflicts, most compounds, shrines, and markets have *ojúbo* (altars) containing Èsù's energy where periodic offerings of "cooling" palm oil—one of Èsù's favorite foods—are placed.[2]

Within the circular scheme of the calabash, the Yorùbá attribute a pyramidal hierarchy to the spiritual energies they term *òrìsàs* and that

we define as deities. At the apex is Olódumàrè (also Olorun or Oluwa), regarded as the architect of all sentient beings and inanimate objects. As a supreme being, Olódumàrè is only venerated indirectly through the intervention of some 401 mediating gods and goddesses known as òrìsàs. The òrìsàs are still revered in the ilês axés of Bahia, where they are termed orixás. In the New World, their number has been reduced to seventeen. The most important of the òrìsàs in West Africa are Obàtálá (plate 9), the artist deity and father principle authorized by Olódumàrè to model the first mortal from primordial clay; Odùduwà, the deity charged with creating the earth by scattering sacred sand on the primeval waters to solidify into ilé aiyé—the physical world; Èsù, the messenger and mediator between humans and the gods, and the principle of unpredictability and change; Òrúnmìlà (Èsù's dialectical counterpart), the precept of predictability and stability achieved through the instrument of Ifá divination; Yemojá (plate 10), the mother principle and owner of the Ogun River in Abeokuta; and Ògún, the war/hunter precept, deity of iron, blacksmiths, and automobiles—who cuts with both sides of his highly honed knife blade; Sango, representing forces of thunder, lightning, and the deified king of Old Òyó; Òsun, goddess of the Òsun River and patron of Oshogbo; Oya, principle of severe windstorms, tornadoes, the Niger River, and favorite wife of Sango; Osanyin, god of curative medicine and herbs; and Sòpònna (Obaluaiye), deity of smallpox and healing.

The òrìsàs are humanized in both West Africa and Brazil. They are often interpreted as ancestors and are conjectured as possessing distinct personalities and tastes in food, music, and colors. They marry each other, divorce, bear children or suffer barrenness, and generally are seen as passionate energies involved in struggles, machinations, love affairs, and jealousies comparable to those experienced by mortals. As intermediaries between men and women and Olódumàrè, the òrìsàs are held directly responsible for human welfare when they are not preoccupied with their own affairs. They are

> receptive to pleas for intervention in life; their virtues or vanities are human attributes raised to godly stature; and they can be fallible, arbitrary, or whimsical in their attitudes and actions. If a human oba were to give way to the passion and fury frequently indulged in by Shango [Sango], it would not be well thought of; but since Shango is more than human, his violent outbursts are judged not so much as flaws of behavior but as phenomena in nature. . . . There is nowhere

> in oral literature any effort to play down the unpardonable side of an
> orisha's [òrìṣà's] character. The orisha does not have to be "good" to be
> worshipped. (Courlander 1973, 23)

Participants in Yorùbá religion have customarily interacted with their
orìṣàs on many levels, though they may concentrate on only one òrìṣà
at a time. Many local òrìṣàs demand the respect of every citizen in a
particular village, town, or state. An òrìṣà might be honored prescrip-
tively for a fleeting and specific interval to work out a single dilemma
or infirmity. In this case, the devotee would serve an òrìṣà until his or
her circumstances improved or, in order to display gratitude for the de-
ity's intervention, for an extended period of time. A specific example I
documented involved an older woman who had been infertile for many
years. She had unsuccessfully sought a solution until she arrived to seek
help from the main shrine for Yemọjá in Ibara quarters in Abeokuta. A
daughter was subsequently born, and as a fulfillment of her promise to
Yemọjá, the child was duly initiated and both mother and daughter par-
ticipated in private ceremonies and public festivals (Elegusi [Omileye],
head priestess of Yemọjá, Ilé Àṣẹ Yemọjá 1983, personal communication,
Ibara, Abeokuta, Nigeria). The relationships between devotees and their
òrìṣàs seem to have been fluid in other cases with frequent changes.

The traditional Yorùbá week (osse) is made up of five days; six
weeks are thus the equivalent of one month (osu). Each day is dedi-
cated to one or more òrìṣàs and marked by a special ritual, and there
are liturgies, rituals, or festivals weekly, monthly, and annually. The
days are named as follows: Ojo-Ako—first day; Ojo-Awo—"the day
of the secret," sacred to Ọrúnmìlà (the deity who presides over Ifá div-
ination); Ojo-Ògún—Ògún's day; Ojo-Jakuta—Ṣango's day; and Ojo-
Ọbàtálá—the day of the creator deity also known as Orishala (Ellis
1894, 145). In Brazil the Yorùbá influence is manifested in the custom
of assigning days to each deity; the entire candomblé initiate populace
observes Friday, the day assigned to Oxalá (the Portuguese version of
Oriṣala) by wearing white—his sacred color. In West Africa, Yorùbá
devotees may be chosen to worship an òrìṣà in one of four fundamental
ways: by possession trance during a ceremony for the deity; through
the declaration of the Ifá oracle—usually at birth or as a solution to se-
vere problems; through recurring dreams (Idowu 1962, 132; Verger 1957,
30; Omileye 1983, personal communication, Abeokuta, Nigeria); or by
virtue of hereditary. There appears to be no easily distinguished mode

of calling an individual to serve in the priesthood of an *òrìṣà,* and religious specialists occupy a liminal zone in society, being simultaneously esteemed and feared. Membership in certain priesthoods is hereditary in that almost every individual is nominally attached to certain *òrìṣàs* who are honored as founders.

The most important and sacred phenomenon to survive the transatlantic slave trade and to be shared among Yorùbá in West Africa, people who practice Yorùbá-derived religions in Brazil, and those from other sites in the global Yorùbá diaspora is the belief in the enigmatic and affecting presence of a worldwide energy called *àṣẹ* in Africa, *axé* in Brazil, and *ache* in Cuba. As I noted earlier, *àṣẹ* is conceptualized as residing in all living beings and inanimate things and operates on many levels—divine, metaphysical, social, and political. *Àṣẹ* as sacred energy and power is found in spiritual entities and human beings as well as in spoken words, secret names, thoughts, blood, animal fur, horns, and tails, bird feathers, art objects, crowns, beaded necklaces, ritually prepared clothing, earth, leaves, herbs, flowers, trees, rain, rivers, mountains, tornadoes, thunder, lightning, and other natural phenomena. *Àṣẹ* is used to establish and define shrine buildings or architectural complexes in some parts of Africa as well as in Bahia, where they are known as *ilés àṣẹ* and *ilês axés,* respectively. It is in this sense that shrines and the constitutive *àṣẹ* can be accrued, decreased, and otherwise manipulated for specific ends. As the quintessential commingling of tangible elements, spiritual ideas, and art forms to manipulate the sacred, *àṣẹ* actuates and channels energy or power with respect to sociopolitical, religious, and artistic processes and experiences. *Àṣẹ* informs the Yorùbá aesthetic at its deepest levels and is affective—often triggering an incomprehensible, fervent reaction. *Àṣẹ* is expressed outwardly through all the Yorùbá arts—performance, verbal, and visual; *àṣẹ* infuses words, music, song, space, and substance with sacred force designed to reconfigure existence, to manipulate the sacred by recasting and regulating the seen and unseen worlds. However, *àṣẹ* is an external as well as an internal resource, which emanates from the inside out. It is at once a signature of the divine as well as a product of one's own ethical comportment and relations with the world. The net effect of *àṣẹ* is the outward manifestation of inner power and the external award of inner force. In the words of Rowland Abiodun: "One cannot confer *àṣẹ* on oneself. It is for this reason that the Yorùbá say, 'A ki I fi ara eni joye' ('One does not install oneself as a chief or ruler over a community or group of people').

It is, therefore, not uncommon to hear a question such as 'Tani o fun o ni àṣẹ?' ('What/who is your sanctioning authority?')." So, too, the àṣẹ of each of the òrìṣàs represents this admixture of the human or socially constructed, and divine or essentially given. However, to manipulate àṣẹ is to deal in the metaphysical—and this is the province of the gods alone. All entities, including the òrìṣàs, are subject to the rules of hierarchical order when manipulating the sacred:

> Even an òrìṣà's àṣẹ can be queried. There are episodes in myth where powerful and charismatic figures like Ṣango and Ògún ignore traditional procedures to become an ọba (ruler, the highest position of sociopolitical authority [after the ọni of Ilé-Ifẹ̀]). The results are calamitous. Like a scepter, àṣẹ must be received from a source outside, and higher, than oneself, which in part explains the custom of consulting Ifá before approval can be given to install an ọba or an olori (community leader).(Abiodun 1994a, 74)

God-given àṣẹ is said to be physically manifest, and the recipient of àṣẹ both blessed and "marked": "the recipient of the àṣẹ must be correctly identified. Literally the sender 'shoots,' 'beams,' or 'aims,' his àṣẹ (that is ta àṣẹ) at a targeted person or thing . . . [i]n order to influence or change its state of being with instantaneous certainty" (Abiodun 1994a). As for all rituals wherein entreaties are made of the òrìṣàs, sacrifice, prayers and invocations, and behaviors sanctioned by the officiating priest or priestess are required. Procedures for requesting àṣẹ, however, vary:

> In some, the utterance of àṣẹ must be accompanied by chewing certain . . . peppers. . . . [or] the licking of . . . [s]pecially prepared medicines stuffed in an animal horn while [incanting]. Sometimes the sender must maintain a prescribed posture, such as standing on one leg, or kneeling, or in the case of women, holding or lifting up the breasts and/or remaining naked during the recitation. Other conditions may include facing east or west, or toward a hill, river, or a designated altar/shrine at a specified hour of the day or night. (Abiodun 1994a, 74)

In addition to manipulating àṣẹ, the Yorùbá and the Yorùbá diaspora are unified by continuing religious ritual activity especially in the arena of divination. The most esteemed type is known as Ifá divination and is performed by babaláwos (Ifá priests; priestesses are ìyánifás, or mother of Ifá), custodians of 256 groups of verses (odù) encompassing all of Yorùbá cosmology and epistemology. The odù include many incantations (ọfọ̀)

that are essential to activating Yorùbá medicine (*oogun*). Ifá is the dominant prognosticator among the Yorùbá in West Africa. Ifá priests (fig. 2.3) and priestesses (plate 11) memorize thousands of verses.

Divination consists of the selection of a single group of verses from this immense corpus by means of a methodical process performed by a priest or priestess who has been extensively trained in the procedure. Ifá divination is sought at the juncture of someone's life, a time when critical decisions must be made—at birth, marriage, or death, or during persistent ill fortune. Ifá is consulted by individuals on their own behalf or on behalf of social groups. Lineage heads, chiefs, and kings must consult Ifá at regular intervals and at times of uncertainty. Central to Ifá divination are the sixteen palm nuts (*ikin* Ifá) presented to each *babaláwo* or *ìyánifá* when he or she completes training (plate 12). The tray represents a miniature Yorùbá universe and signifies the circular *igba iwa* (calabash archetype of the world). The designs carved into the rim of the Ifá divination tray (*ikin* Ifá) are mnemonic and didactic devices that serve to invoke the *àṣẹ* Ọrúnmìlà and Èṣù. Other designs refer to significant events in the local or religious oral history and to powerful *babaláwos* in the officiant's patrilineage. The *ikin* Ifá are kept carefully by their owners in closed containers where they receive regular sacrifices from Ifá priests and priestesses as offerings to Ọrúnmìlà. The nuts are the most important means by which the diviner is able to communicate with Ọrúnmìlà through Ifá divination and thereby instruct his or her client by the chanting of a group of verses appropriate to the dilemma at hand. The palm nuts are used for momentous decisions. Diviners usually handle everyday problems with an *òpèlè*—a divining apparatus symbolizing the *ikin* Ifá and composed of halves of palm nuts joined by iron chain links.

The Ifá divination process involves several phases: the nuts are divided equally between two hands and shaken together, and all but one or two are extracted from the left hand (signifier of secrecy). If one nut remains, two marks are made with the right hand (signifier of revelation) in the camwood tree dust sprinkled on the surface of the divining tray; if two nuts remain, one mark is made in the dust. This procedure is repeated until there are eight sets of marks in the *opọn* Ifá, at which point they constitute the "signature" of one *odù*—that is, one Ifá verse of the possible 256 basic *odù*. The diviner is then able to chant the *odù* until he or she reaches one that applies to the client's problem. Finally, sacrifices are made (Ifátoogun 1991, personal communication, Ilé-Ifè, Nigeria).

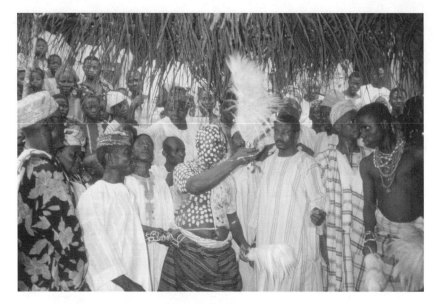

Fig. 2.3. Ceremony during installation rituals for the current *araba* (in center with small conical crown headgear, surrounded by other Ifá priests), Ilé-Ifè, Nigeria, 1991. Photograph by author.

While Ifá divination remains the preferred way of communicating with the gods among the traditional Yorùbá (Ifátoogun 1993, personal communication, Ilé-Ifè, Nigeria), the last known Bahian *babaláwo*, Martiniano de Bonfim, is recorded to have passed away in the 1940s (Verger 1981). In Brazil, a form of divination prevails that uses sixteen cowries (*erindinlogun*; or the extended *owo merindinlogun*). This method is used by Yorùbá priests and priestesses and healers in Nigeria and has become the preferred method of divination for the biological and spiritual descendants of the Yorùbá diaspora.

Erindinlogun is said to be less complex than Ifá divination and less revered among the Yorùbá in West Africa but more esteemed than Ifá in the Americas, where it is ubiquitous and more often used. This may be explained by its relative simplicity; the popularity of Ṣango, Yemojá, Òṣun, and other *òrìṣàs* with whom the sixteen cowries is associated; and that it can be practiced by both men and women. In contrast, during my

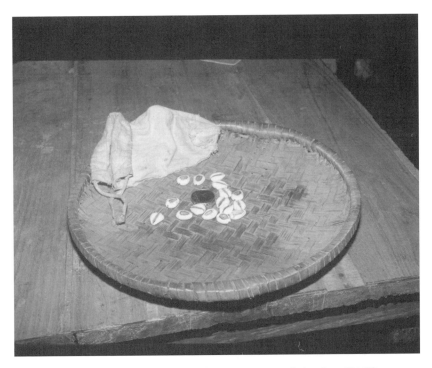

Fig. 2.4. Divining tray with cowries for *erindinlogun* divination, Ilé-Ifè, Nigeria, 1991. Photograph by author.

research on women and power in Nigeria from 1990–91, I documented only two women (*iyánifás*) who practiced Ifá divination professionally.

Divination using sixteen cowries is deployed in the priesthoods dedicated to the *orìsàs* Èsù, Obàtálá, Yemojá, Sango, Oya, Osun, Obá, Yewa, Nana Buruku, Ososi, and Soponna. When compared to Ifá divination with its manipulation of sixteen palm nuts or even the casting of the *opele* (divining chain), *erindinlogun* is uncomplicated. The cowries are cast on a basketry tray, and the shells facing mouth up are counted (fig. 2.4). There are only seventeen positions, or configurations, ranging from zero to sixteen (with a seventeenth arrangement signifying *èsù*), yet memorizing the verses is almost as difficult and time-consuming as learning those of Ifá. The cowrie shells used in divination are not

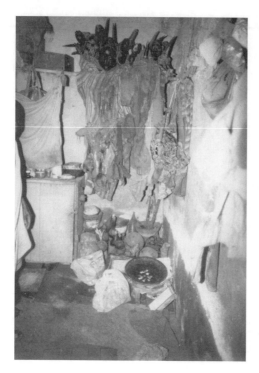

Fig. 2.5. Lineage shrine for *egúngúns* Paje Polobi and Olomonjagba. Located in the largest house in the compound, this shrine contains a palm tree switch *(iṣan)*, cowries for *ẹríndinlogun* divination, and wood and cloth masquerades. Idasa compound, Ilesa, Nigeria, 1982. Photograph by author.

the ones formerly used as money (*owo eyo*) but a smaller cowrie (*owo ero*). The basketry tray (*àtẹ*) is flat and of the type used to display beads, salt, and other small materials for sale at the traditional rotating, outdoor markets. The seventeen positions of sixteen-cowrie divination are designated by cognates of the *odù* of Ifá divination. When the *odù* has been determined by the first toss of the cowries, the diviner begins to recite the verses (*ẹsẹ*). The verses contain the recommended predictions and sacrifices based on the case of a mythological client who serves as a precedent. Unless stopped by a client, the diviner recites all the verses he or she has learned for that *odù*. As in Ifá divination, the client selects the verse applicable to his or her own circumstances. As in Ifá, more precise information to help clients choose between specific alternatives can be obtained by making additional casts of the cowries (*ibò*); (Bascom 1993, 3–8).

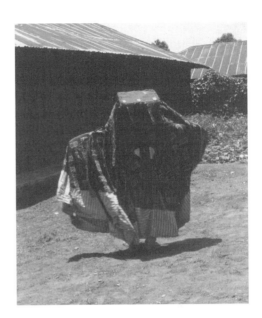

Fig. 2.6. *Egúngún,* Ketu, People's Republic of Benin, 1982. Photograph by author.

Finally, Yorùbá religion and art in West Africa is attentive to interaction with the energies of *egúngún* (ancestor)—known, departed, usually male, family members who have died a "good" death by avoiding suicide and lived a "good" life by exhibiting the admirable qualities of generosity, reliability, hard work, and the siring of many children. A main goal of Yorùbá religion is to establish a permanent foundation to ensure beneficial rewards for the extended family, lineage, or clan across several generations. Ancestral veneration is therefore limited to the compound or village—except in the instance of royal ancestors, whose veneration is national since they concern the entire state, town, or city. The unseen connection with and responsibility to the ancestors is nevertheless palpable. Yorùbá believe there will be abundance and prosperity if the ancestors are satisfied and catastrophes if they are neglected. The ancestors of individual households or compounds are honored at altars inside the living area (fig. 2.5).

All the ancestors of a village or town are collectively honored during annual or monthly public festivals for *egúngún* featuring elaborate,

expensive, and colorful artistic creations made of cloth (*aṣọ;* fig. 2.6) and other media. The *egúngún* strut and dance in processions throughout the town or city districts for days, attracting huge crowds by their vibrant displays and pulsating musical accompaniments. Since the *egúngún* are intended to represent named, deceased ancestors, the identity of the dancers is kept officially secret; they are believed to return to the earth from *ọ̀run* to visit their living relatives and to pray for them and the town or city as a whole. On this occasion, any outstanding dispute in the family or between families is settled by a committee of the ancestors adorned with cloth ensembles. *Egúngún* can be thought of as supernatural inquisitors who appear from time to time to inquire into the conduct of people and punish their misdeeds (Ellis 1894, 107; Lawal 1970, 8).

Ritual arrangements or relationships are more rigidly rule oriented in Ifá and in sixteen-cowrie divination than for the ancestors where, although there may be deep structural rules, there is always room for surface variations and even fairly radical improvisations and plays (Drewal 1992; Lawal 1996).

Inheritances

Innovations, Sacred Art, and *Axé* in *Candomblé* Nagô

Sacred art (ritually invested with *axé* and used in active ceremony) is essential for public and private ceremonies in the *ilês axés* of *candomblé* Nagô. It is as simultaneously innovative and African Brazilian as it is traditional and continental African, in that the art forms and their functions are conceptually based upon comparable art forms and functions that are indispensable to the effective operations of traditional Yorùbá religion in West Africa.[1] The most salient similarity between the roots of Yorùbá art and its African Brazilian branches is that the most important work that sacred art accomplishes is to revere the gods and ancestors. Sacred art is fundamental not only because of its role in aesthetic display and *beleza* (beauty) but also because of its embodiment and tangible expression of concealed power, ideas, values, and energies—the most conspicuous of which is the complex phenomenon of *axé*. Devotees of *candomblé* Nagô envision *axé* as both the dialectic of creative force and destructive power and as a tangible, magnetic energy capable of manipulating the sacred, commanding the animate and inanimate, achieving the desired objectives of those controlling *axé,* and making deeds and events happen, or not, and taking place smoothly, or not. *Axé* can be accrued and decreased and is ubiquitous (Dona Hilda and Pai Crispim 1982, 1986, and 1991, personal communication, Salvador, Bahia and Itaparica, Brazil; 1999, 2000, personal communication, Seu Domingo, Itaparica, Brazil).

43

Abiodun introduces astute ideas of the connotations and capacities of *àṣẹ* as it relates to Yorùbá art in West Africa—ideas that resonate incisively with the African Brazilian understanding of the relationship between sacred art and *axé:*

> In Yorùbáland, depending on the context, the word *àṣẹ* is variously translated and understood as "power," "authority," "command," "scepter"; the "vital force" in all living and non-living things; or "a coming-to-pass of an utterance." . . . To devotees of the *òrìṣà* (deities), however, the concept of *àṣẹ* is more practical and immediate. *Àṣẹ* inhabits and energizes the awe-inspiring space of the *òrìṣà*, their altars (*ojú-ibọ*), and all their objects, utensils, and offerings, including the air around them. Religious artifacts are thus frequently kept on the altars of the various *òrìṣà* when not being used in public ceremonies. There they contribute to and share in the power of the sacred space, the architectural space where priests and devotees may be recharged with *àṣẹ* before undertaking a major task (Abiodun 1994a, 72; see Ruy do Carmo Povoas 1989, 39–42.)

Within the *ilê axé*, art does not operate to manipulate the sacred in isolation but is part of a complex aesthetic and religious symbolic system that includes exalted words (*ọfọ̀*) and other speech, dance, music, the human body, songs, food, deities, ancestors, and the organic, non-manufactured environment (*natureza*, or nature).[2]

As in West Africa, the devotees in the *ilê axé* concretize in many ways the intangible *axé* of each *orixá* and *egun*. Localized in organic materials occurring in nature, *axé* is also anchored in ritual materials: individuated multimedia or wooden sculptures; rattles, staffs, axes, crowns, fans, and other ritual implements; color-coded and ceremonial clothing; and in special circumstances, even the human body. All are regarded to be infused with *força*, the concealed power of the gods or ancestors (Ìyá Omilêye Yemọjá, Abeokuta; Oluwo Ifá, Ibara Abeokuta; Sanu Fakorede 1982, personal communication, Ọ̀yọ́, Nigeria; Seu Domingo, Itaparica; Babalaxé Crispim, Jardim Lobato; Dona Hilda Curuzu 1981, personal communication, Liberdade, Brazil). The deities and ancestors are honored and invited to be present, not only by artistic forms but by music and performance as well. Each spiritual power has his or her own precisely individuated melodies, songs, intonations, drum rhythms, performance sequences, and series of hand claps that are distinctive only to that particular force. Some or all of the above are utilized on a habitual basis in private rituals that take place daily

and weekly (depending on the function) in the very early morning as ongoing prayers and praises. They may also occur early in the morning and mid-afternoon in preparation for the great annual festivals that take place in the evening, beginning at 7:30 or 8:00. These galas are popularly known as *festas* or *xires* (shee-rays, plural). The latter term is derived from the Yorùbá *șire* contracted from *șe ire,* meaning to do, act, cause goodness, blessing, favors, benefits. Because of their misplacement of the tonal accents, some scholars have translated *șire* to mean "to play," that is, "have fun," whereas the Yorùbá *șeré* actually means "to play" (Lawal, January 2000, telephone conversation).

Xires are elaborate multimedia events honoring *orixás* and involving several categories of artistic creativity—apparel, sculpture, drumming, dancing, singing, performance, and food—often transpiring at the same time. *Xires* are public and open to anyone—for certain *candomblés,* they are even publicized by Bahia Tursa (the official tourist agency of the state of Bahia). The *iyálorixá* or *babalorixá* (mother or father of the deity) who heads a specific *ilê axé candomblé* Nagô draws the attention of an *orixá* by reciting the appropriate prayers or accolades (*oríki*) on bent knees, accompanied by hand claps, rattles, *agogos* (metal bells), or gourds. It is only after these early morning private preliminaries—during which sacrifices are offered—that a semiprivate dance ritual for Exu, which takes place in the afternoon during the annual ceremonial season, is performed by the senior initiates.

Sacred art in *ilê axé candomblé* Nagô thus embodies both meaningful experience as well as experienced meaning. As it accrues layers of meaning, sacred art may be theorized as visible poetics or as *oríki.* *Oríki* in the singular is defined by Yorùbá scholar Olabiyi Yai as "a concept and discursive practice . . . [that is] by its nature . . . an unfinished and generative art enterprise" that allows for subtle change, radical innovation, stable tradition, and conventional predictability all at the same time (Olabiyi Yai 1994, 107). The fluidity of *oríki* verbal art forms corresponds to my understanding of African Brazilian sacred visual art. Both art forms exemplify the principle of *abojúèjì* in that they are both "inside as well as outside." They reconcile or negotiate the multiple artistic forms and stylistic elements presented by African heritage and the heritage belonging to the Portuguese and local Brazilian Indians encountered by the newly arrived enslaved Africans. The type of clothing ensembles worn daily inside the precincts of the *ilê axé,* for example, are African Brazilian inventions known as *roupa de axé* and *roupa de ração* (clothing

of axé and clothing of ration). *Roupa de ração* (fig. 5.6 and plate 13) may semiotically reference Africanness, the African-Brazilian, slave clothing rations, ritual purity, and religious power while simultaneously blending inside and outside elements (Anibal Mejia, October 1995, personal communication, Tucson, Az.; Ebomin Tomâzia 2001, Salvador da Bahia).

Roupa de axé manifest a "double-voiced" system of figuration with African and European components that are innovatively recombined.[3] The ubiquitous, generic form of *roupa de axé* is mandatory for all women who hold some level of initiate status, and each devotee who enters the sacred space must immediately exchange her Western street clothing for the prescribed *roupa de axé*. Those who live in *candomblé* Nagô permanently must wear this ensemble daily whenever they participate in rituals. When they go outside the *ilê axé* precincts, it is permissible to wear Western-style contemporary clothing. The decreed usage of the *roupa de axé* is strictly enforced and may thus be regarded as a marker of the wearer's presence in the sacred space.

Roupa de axé may also serve as a badge of identity—a self-determined and inventive African Brazilian aesthetic that concomitantly exhibits heuristic, conceptual aesthetic links with the root art practices of the Yorùbá. As a contrapuntal ensemble—a ritual uniform marking a new cultural identity by combining antithetical elements of older European and African models into one ensemble—the African Brazilian *roupa de axé* underscores the point so forcefully made by Edward Said that "no identity can ever exist by itself . . . without an array of opposites, negatives, oppositions" (1994, 52). The *roupa de axé* visually oppose the Western clothing worn in Brazil; it is made up of seven semantically coded elements, the last two of which are restricted according to the wearer's rank. These last two elements underscore the hypothesis that the *roupa de axé* is a self-contained system of visual communication allowing the signification of social prerogatives and behaviors. The seven elements are the *camizu, saia, ojá, ilêke, mocá, bata,* and *pano da costa;* all may be deciphered as signs in the same way that languages are deciphered and understood (Bogatyrev 1971, 83). *Roupa de axé* are made of white cloth if they are used in the ceremonial cycle of oxalá or initiation. They are otherwise color coded to signal the wearer's spiritual connection to a specific *orixá.* For example, although codes vary from *ilê* to *ilê* (diminutive for *ilê axé*), initiates of Yemanjá may wear skirts in which the light blue or pastel green colors (as seen in plate 13) dominate because those colors are referents to the *axé* of the goddess who

derives her powers from river and seawater. Initiates of Oxum, on the other hand, wear yellow or pink skirts to signify that deity's love of gold and brass. In contrast, the *roupa de axé* must be completely white and made of 100 percent pure cotton muslin during the Aguas de Oxalá—the ritual cycle for the creator/father deity Oxalá that begins the annual series of private ceremonies and public festivals for the *orixás,* during the *axéxe*—funeral rituals for initiates, and during most phases of the initiation sequence of rituals and ceremonies. White cotton muslin is also referred to as *roupa de ração*—clothing of the ration or restricted clothing.

The *camizu* consists of a usually white short-sleeved blouse trimmed in lace and sewn to a half-slip. The term *camizu* is derived from the word for the Muslim burial tunic and was probably borrowed from the language spoken by the "malés," as enslaved Muslims were referred to (Nina Rodrigues [1886] 1935, 152). While I exercise the necessary caution when undertaking comparisons drawn from both the historical record and my own field research (Mintz 1992, 12), in my estimation, the top blouse—like the top section of the *camizu*—exhibits many stylistic similarities with the blouses considered traditional and worn by many West African women in Nigeria, Senegal, Ghana, Cameroon, and other locales in the eighteenth, nineteenth, and early twentieth centuries.[4] In this framework, the *camizu* operates as an icon consciously invoking Africa. The *camizu* is often embellished with *renda* (delicate lace), which the Portuguese introduced in the 1600s to Brazil, where it continues to be handmade by Brazilian women (La Duke 1985, 106), evoking a European element.[5] Like other parts of the *roupa de axé,* the *camizu* exemplifies the selective combination of European and African components to create a new African Brazilian artistic form while maintaining West African Yorùbá functions.

The *saia* is a full ankle-length skirt gathered at the waist and fastened by long ties extending from a narrow waistband. It has often been attributed to the long, full colonial Portuguese-derived skirts worn by the mistresses on plantations, but there are several possible African prototypes of this skirt, including the full skirts worn by the male—and some female—rulers of the former kingdoms of Dahomey and the Yorùbá kingdom of Owo. As illustrated in Eyo and Willet (1980) the *olowo* (king) of Owo, Nigeria, wears traditional royal regalia largely made of coral beadwork. The king also wears the full, gathered "skirt" of coral instead of trousers. The literature abounds with such examples

of African rulers wearing full or gathered skirts (see fig. 1.2)—a fact first brought to my attention by Thompson (1991, telephone conversation).

The *ojá* (or *torço*) is a long narrow piece of cloth (approximately 12 inches by 72 inches) that serves as a baby sash among the contemporary Yorùbá where it is called *òjá*. It is used by African Brazilians in the same way as the Yorùbá head tie (*gèlè*) and is wrapped in the African fashion when the initiate (*iyawô*) is in a normal state of consciousness. Enslaved Africans in the United States, Cuba, and Brazil wore the *òjá* on their heads, and it remains an important element of appropriate dress for married women in many West African countries. In Brazil in the nineteenth century and earlier, when the *ojá* was used as a head wrap, it was an important marker of Africanness.[6] Because it remains so, the *ojá* is another important icon of Africa manifested in the *roupa de axé*.

When worn to perform the seemingly endless caretaking tasks usually assigned to the *abiãns* and *iyawôs* in the sacred space, the *camizu, saia,* and *ojá* are made of the least expensive grade of white pure cotton muslin. However, these articles may also include other kinds of fabrics and laces that vary in quality and elegance depending on the rank of the wearer and the type of ceremonies or other activities to be performed. The *camizu, saia,* and *ojá* serve not only as the ubiquitous, unadorned work "ritual uniform" but also as phonemes in the visual lexicon of specific *orixás* in the *ilê axé* when fabricated in colors and other materials.

Male initiates also wear *roupa de axé*. Their special uniforms consist of a white tunic, white trousers (*sokoto;* plate 14), and optional head coverings. The men who perform animal sacrifice—identified by their title of *axogun*—wear special white caps (*fila*). Curiously, I have not seen men wear colors except during *xiré,* after the deep-possession trance of the *orixá* incarnate descends on the initiates. At that juncture, both male and female initiates are removed from the dance arena to be dressed in the back room; they return wearing the formal ensembles that signal their altered states of being (fig. 3.1).

As a physical site the *ilê axé* usually encompasses many acres of land and, ideally, includes an area of virgin forest and one or more brooks or streams—symbolic referents to the forest domains in West Africa that remain conceptually prevalent in the composite idea of Africa in the sacred space. Conceptualized as a sacred space or microarena physically distinguished from the *ilê aiye*—the nonsacred locales outside—the *terreiros* (the demarcation of the *ilês axés*) is often tangibly signalled by a tall cement, stone, or stucco fence that entirely surrounds and protects

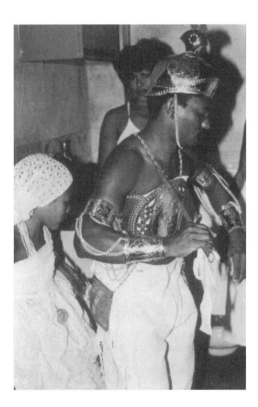

Fig. 3.1. *Orixás* Ogum and
Xango Aira dancing during
the *xire* in the *barracão,* Ilê
Axé Babaluaiye of Dona
Hilda, Curuzu, Salvador,
Bahia, Brazil, 1981.
Photograph by author.

the grounds, as, for example, in the Ilê Axé Opô Afonjá in São Gonçalo
do Retiro (fig. 3.2). Inside the gates are separate cement-covered mud
buildings that can be quite elaborate. These constructions are built for
each individual *orixá* venerated in the *ilê axé* and mirror the structure
of Yorùbá shrines in West Africa. That is, they are made up of both
an inner core shrine room where key objects and costumes embodying
the sacred force of the deity are kept and where only the head priest,
priestess, or select eldest adepts may enter, and an outer area for prayers
and rituals that is accessible to lower-ranked initiates. In those active
sanctuaries I have entered, the sculptures, rattles, and porcelain or clay
containers housing the *orixá*'s *axé,* fresh water, flowers, preferred foods,
and other ritual items or offerings occupy the entire space of the room.

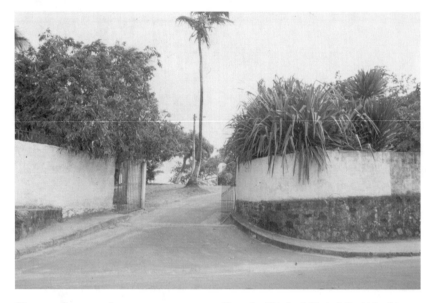

Fig. 3.2. Stone and stucco gates surrounding the Ilê Axé Opô Afonjá in São Gonçalo do Retiro, Salvador, Bahia, Brazil, 1988. Such gates demarcate the outside environs from the sacred grounds of the *ilê axé*. Photograph by author.

These items are aesthetically arranged on a multitiered *ojubo* (interchanged with *peji*). The *ojubo* extends the entire horizontal length of the wall directly in front of or to the right of the shrine's entrance door. The *orixá* to whom the shrine is dedicated is customarily situated in the center of the arrangement, with other mythologically related deities flanking both sides. In plate 5, for example, the figures of shoemaker saints Crispim and Crispiniano, referred to affectionately as *beje* (a diminutive of *íbejì*, the Yorùbá term for sacred twins) by Pai Crispim, head of an *ilê axé* in Jardim Lobato, are two of the shrine *orixás*/owners. The figures are placed in the center of the lower level of the arrangement on a raised structure covered with a white cloth, in front of a vertical pole. As with sacred sculptures among the Yorùbá in West Africa, these wooden carvings have been ritually activated to serve as containers for the *axé* of *ìbejì* and thus as foci of devotion to those *orixás*. Pai Crispim continued the practice of using Catholic saints to camouflage African gods—a practice

instituted in the early 1700s because of the Catholic priests' unrelenting efforts to eliminate all vestiges of the African religions, beliefs, and behaviors the enslaved Africans struggled so ingeniously to retain. One solution to the problem of continuing the African songs and dances was to conceal African gods behind Catholic saints and feign ignorance. From Herskovits's work (1966, 78–79), this example of African Brazilian manipulation of the sacred has come to be known as syncretism—a complex and often misunderstood mechanism of conceptual and material coexistence operative in colonial or imperialist arenas in which two or more unlike cultures affect one another. Syncretism has as its objective the reconciliation or negotiation of dissimilar or opposing precepts, procedures, or artistic forms. It is more appropriately understood as the process of camouflaging or layering than as fusing, hybridizing, or juxtaposing, which are understood either as merging or placing side by side (Droogers and Greenfield: 2001). Although there exist actual wooden sculptures called *ìbejì* that are similar in form to *ère ìbejì* (wooden twin sculptures) used by the Yorùbá in West Africa and housed on the altar in Ilê Axé Opô Afonjá and other *ilês axés*—there also exist *ilês axés*, such as that headed by Pai Crispim and those of Casa Branca and Gantois, where Catholic saints are called by Yorùbá deities' names and treated the same as *orixás* in rituals. Understanding the principle of *abojúèjì* is critical if one wishes to understand the dynamics of *axé* in manipulating the sacred. The same beliefs and practices that credential a plastic doll carried on the back of a surviving twin (fig. 3.3) or a photograph to function as an *ère ìbejì* when ritually prepared in special circumstances in West Africa also empower Pai Crispim's wooden statues of Saints Crispim and Crispiniano to perform as the *axé* of the *orixá* for *ìbejì*.

Initiates usually refer to the physical site of *candomblé* Nagô as the *roça*, a Portuguese term that translates as country, rural region, or backwoods plantation. The frequent reference to the *ilê axé* as the *roça* when discussing *candomblé* activities, and the wearing of a special uniform in the sacred space, suggests that for the initiates *candomblé* Nagô is a separate universe or microcosm. Whenever I disembarked from the public transportation that brought me to the gates of Ilê Axé Opô Afonjá in São Gonçalo, one of the sites where I lived and researched, I felt a profound sense of crossing boundaries and of leaving the nonsacred, urban openness for the rural, cloistered, sacred physical and spiritual space where different norms prevail, an experience other initiates told me they shared.

Fig. 3.3. *Ìbejì* with blue plastic doll on her back representing her deceased twin sister. Akutupa Kirri, Nigeria, 1991. Plastic dolls are often consecrated and used as *èrè ìbejì* by Western-educated Christian or Muslim Yorùbás in place of the traditional wooden sculptures for sacred twins. Photograph by author.

Following the linguistic model Bogatyrev used in his study of costume in Moravian Slovakia, clothing and other objects in the *ilê axé* may be theorized as sign carriers. They perform communicative functions according to "grammatical" rules developed to convey distinct ideas or activities related to secular or spiritual status and states of being of the community members. These meanings are learned by initiates during the long period of seclusion from their biological family and the rest of the outside world, as well as from the other members of the *candomblé*. Such an interpretation is further supported by Bogatyrev's discussion of clothing as a semantic system operating according to learned grammatical rules (1971, 10–19):

> Dress usage . . . is . . . simply a system with a semantic function in which clothing is the sign-carrier . . . [that] phrases "grammatical rules" underlying the . . . [rules of usage]. . . . [C]ostume signs in order to be correctly understood must be learned in the same way that languages must be learned. . . . Functions [are] . . . divided with respect to the role the linguistic sign served . . . whether its orientation was to its referent ("communicative" function) or to the sign itself (referential function). . . . In the focusing of the sign on being itself, or to the various aspects of life which the sign is indicative of the main emphasis is the relation between the costume and the external world. . . . [A]s in the case of the linguistic sign, it is the orientation of the sign, which the users of the sign may change along with the sign's structure and form, that is of predominant importance. . . . [F]unctions are roles/tasks fulfilled by the costumes or their parts. . . . [T]hey confer [the] value of signs upon objects . . . [the] same as [the] roles played in speech [which] confer upon sounds the value of phonemes.

Among other examples of the communicative function of *candomblé* clothing, I have observed that whenever possession trance occurs, the *ojá* is immediately taken off the *iyawô*'s head and placed on another part of the body not only to signify the changed state of being but also to signal the gender and identity of the *orixá* possessing the initiate. The gender of the mounting deity is communicated by the way the *ojá* is arranged. For instance, incarnated female *orixás* (often referred to as *ayabás*, or queens), including Yansan, Yemanjá, and Oxum, are identified by an *ojá* tied over the entranced *iyawô*'s breasts and under her armpits in a big bow that terminates at the small of the back. For the seven years before they undergo the initiation to ebomin, *iyawôs* wear an *ojá* on their heads and another *ojá* tied around the top part of their bodies to end in a large bow on their breasts. In contrast, Oxossi, a male *orixá*, is identified by two *ojás* crisscrossed over the front and back of the initiate's body and tied to end in bows at each side of the waist. Oxalá, another male *orixá*, is designated by two *ojás* crisscrossed in the manner of Oxossi, but ending in bows at each shoulder (fig. 3.4).[7] Finally, *ere*—the transitional state of mild trance that follows the forceful trance indicating full possession of the initiate by the *orixá*—is characterized by mischievous, often boisterously childish behavior and is signaled by an uncovered head and the initiate's *saia* tied over one shoulder (fig. 3.5).

Beaded necklaces (*ilêke* or *eleke*) form another important component of the *roupa de axé* because the color(s) and sequential arrangement

Fig. 3.4. Incarnated *orixás* Yansan 'Bale *(front)* and Oxalá dancing during the *xire* in the *barracão,* Ilê Axé Babaluaiye of Dona Hilda, Curuzu, Salvador, Bahia, Brazil, 1981. Photograph by author.

of individual beads communicate the identity of the *orixá.* Blue, clear, or green crystal beads signify the cool water qualities of Yemanjá, while crystal amber or opaque yellow refer to the warm brass or gold of Oxum. In addition, the specific type of bead and number of strands of beads signify whether the wearer has undergone full or partial initiation, is still a novice, or holds non-initiate status (plate 13).

For example, during their initiation confinement and to signal their special liminal condition—halfway between the supernatural world and the mundane world—*iyawôs* wear a special necklace called a *kelé* or *quelé* (plate 1) that consists of large tubular beads alternating with multiple strands of tiny beads and is tied closely around their necks. After the initiates "graduate," the *kelé* is kept in the shrine where their individual *Orixá's axé* resides. The *kelé* is worn once more during the seclusion

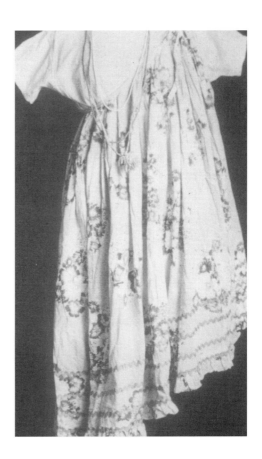

Fig. 3.5. *Roupa de axé.* The skirt worn over the left shoulder communicates the state of infantile trance *(ere).* Photograph courtesy of the Fowler Museum of Cultural History, University of California, Los Angeles.

necessary for the transition ritual from the rank of *iyawô* to *ebomin*—generally performed seven years after the first initiation. The color(s) and materials of the *kelé* signal the type of *orixá* who governs the new initiate's head. The name *kelé* and its form seem to have been appropriated from a similar necklace associated with the *òrìsà* Sango among Yorùbá-speaking peoples in West Africa. There, the *kelé* is also a choker type of necklace (fig. 3.6) made of large round or tubular beads that are often in red and/or white (the sacred colors of Sango) (Mogba Sango 1982, personal communication, Ibadan, Nigeria; Baba Sango, Apr. 1981, personal communication, Ketu, Benin). Within the *candomblé* Nagô

Fig. 3.6. *Elẹgun* Ṣango wearing *kele*, beaded choker embodying *àṣẹ* of the deity Ṣango. The *kele* and special coiffure are markers of sacred status. Ketu, Republic of Benin, 1982. Photograph by author.

the *kelé* is a visual sign of submission that links the wearer to his or her specific *orixá;* it cannot be removed until after the initiate's first public appearance (*dia de orunko*), which is also the first day he or she utters his or her new, sacred initiate name. The removal of the *kelé* marks the end of the strict ritual seclusion and the passive, childlike phase of submission to the *orixá* and the initiating officials (Pai Crispim 1982, personal communication, Bahia, Brazil). The removal of the *kelé* may also signify the initiate's newly acquired sense of power and self-control. A major portion of the initiation process is concerned with instilling techniques that ensure the individual's ability to control the experience of possession trance and the appearance of his or her *orixá* to only specific rituals and only in response to definite "signals" or "summons." Once the *kelé* is removed, the *iyawô* stores it in his or her ritual core

of sacred objects along with the stone (*okuta* or *ọta*) in which his or her *orixá* is localized and consecrated.[8] As Bogatyrev found in his study of costume in Moravian Slovakia, the symbolic system of clothing and ritual implements in the African Brazilian *ilê axé* allows the participants and audience members to immediately identify the *orixá* and quality of trance possessing the initiate. He determined that the process is learned in much the same way as spoken languages are learned.

Because the collective is more important than the self, the most compliant initiate is the most trusted and esteemed. For those who are able to obey and submit (the overwhelming majority of whom are the African Brazilian women or homosexual men) to *obedecer*—the higher spiritual authority—the *ilê axé* extends many important opportunities to achieve self-esteem, prestige, power, and social mobility within a system that celebrates African values, ideas, behavior patterns, modes of dress, and (often) dark skin color. Authority and permissible projects are in-dependent of actual chronological age, depending rather on length of time since the individual's full initiation into the religion and his or her willingness to conform to the strict codes of protocol. Each level in the *candomblé* hierarchy is distinguished by a special mode of social behavior and distinctive behavioral and sumptuary restrictions (*ewọ̀*), as well as a distinctive dress code.

Each status is denoted by the combination of elements of the *roupa de axé*, and each status has a set of appropriate etiquette within the *ilê axé*. Thus the initiate and other observers learn status positions and pro-tocol or find familiar ones reinforced and concretized. The highest status level is that of the *babalorixá* (plate 14) or *iyalorixá* (fig. 3.7). He or she is chosen by divination from the class of the eldest initiates (*ebomi*). Even though he or she may belong to the lower socioeconomic class in the *ilê aiye* (outside of the *ilê axé* walls) and wield little power in that context, within the sacred space the *iyalorixá* or *babalorixá* is the most powerful person and highest in authority after the deities. They derive their great-est and unquestioned leverage from their positions as *alaxé*—owners or managers of *axé* (Braga 1988).

Protocol in the *ilê axé* dictates that initiates may only address the *iyalorixá* or *babalorixá* after prostrating full-length on the floor (*dobale* or *iká*), with heads bared. They must speak with their heads lowered and their eyes cast downward (fig. 3.8). I have often observed both initiates and non-initiates pay deference to the *babalorixá* or *iyalorixá*, most often by kissing one or both of his or her hands. Because he or she is the

Fig. 3.7. Mãe Bida, *iyalorixá* of Yemanjá from Rio de Janeiro, at the International Òrìsà Congress, Salvador, Bahia, Brazil, 1983. She wears *aṣọ oke,* the strip-woven cloth imported from Nigeria used as an insignia of her rank. Photograph by author.

earthly custodian of the deities' *axé*, only the *babalorixá* or *iyalorixá* can officially enter into direct spiritual dialogue with *orixás* on the behalf of others. He or she derives abundant control from this privilege as well as from the position of *alaxé*.

The *iyalorixá* or *babalorixá* is responsible for the spiritual and practical administration of the *candomblé*, and his or her job entails many duties, such as divining for those he or she has initiated, as well as for the many outsiders who regularly seek spiritual or psychological therapy. Through divination, he or she decides when initiation and other ritual cycles begin and end and then supervises all preparations for these events. Especially crucial is the administration of the large annual festivals that bring visitors from other *candomblés*, as these require the management of food and money.

Art forms and other objects validate the *babalorixá* and *iyalorixá*'s entitlement to manipulate the sacred and, again, seem to speak in double or multiple voices. For example, Iyá Ode Kayode (also known as Mãe Stella) lives in the largest, most well appointed house in Ilê Axé Opô Afonjá. She presides over this house, and only she is entitled to use fine china, crystal, silver, or chrome utensils for eating and drinking in public. These prerogatives do not simply mirror the material markers of status or conspicuous consumption found in the Westernized Portuguese Brazilian *ilê aiyé;* the manner in which rank is conveyed may have clear historical precedents in architecture, clothing, and regalia among the Yorùbá (fig. 2.1, plate 6).[9]

The elaborate clothing worn by the *babalorixá* and *iyalorixá* (plate 14 and fig. 3.7) signifies their powerful roles, and for women in the way the *iyalorixá* wears and arranges the textiles and laces. Only the chief priestess may wear an African-derived cloth (*aṣo oke*) folded on her right shoulder (fig. 3.7). *Aṣo oke* contains many prestigious and costly strips of cloth traditionally woven by Yorùbá men on a treadle loom and then sewn together. It is still worn by Yorùbá kings, chiefs, and high officials or by others for special occasions such as weddings and funerals. *Aṣo oke* was regularly supplied by the *negros de ganho* (enslaved Africans hired out by their owners as sailors, metalsmiths, and other specialized, skilled labor) who traveled between Bahia, Nigeria and then-Dahomey from the seventeenth through the nineteenth centuries. *Aṣo oke* has been substituted by cotton cloth of striped patterns by some individuals in the twentieth century and has also been referred to as *pano da costa* (cloth from the African coast).

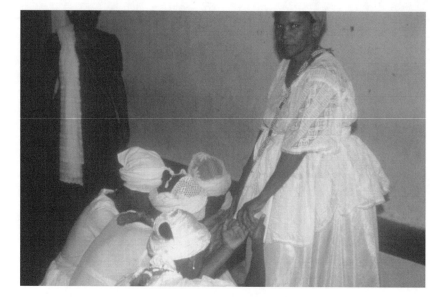

Fig. 3.8. Standing *iyalorixá* (head priestess) receiving respect from her initiates, Feira de Santana, Brazil, 1983. She wears the *bata*. Photograph by Ndolamb Ngokwey.

The *iyalorixá* wears a special necklace symbolizing her position as keeper, manipulator, and activator of *axé* (fig. 3.8). By virtue of her status as *ebomin*—elder relative or initiate who has performed *deka*, the level of initiation commemorating seven years of investiture—she is also entitled to a lacy overblouse, stylistically derived from Africa and known as a *bata*. A traditional African head tie (*ojá*), the full skirt, and one or more bracelets complete her costume. Only the *iyalorixá* is authorized to use the most expensive, luxurious brocades, silks, laces, or velvets in her daily clothing, and these, combined with her distinctive elements of costume, communicate her role of authority and influence (plate 15).

The next posts in the hierarchy of internal power within the *ilê axé* are those held by women who are the assistants to the chief priest or priestess: *iya kekere* (little mothers). Their duties include supervising the food sacrifices to the deities, caring for the shrines, and leading songs during daily prayers, weekly ceremonies, and major festivals in public

and private ritual contexts. The *iya kekere*'s formal clothing consists of the *bata*, an *ojá, saia,* and the *pano da costa* worn around the waist. Lower initiates must prostrate before addressing this class of officials but afterward may speak to them on bended knees. (The chief priestess and her assistants are always recruited from the *ebomin,* who receive the *deka* seven-year initiation.) All *ebomin* are entitled to wear the *bata,* and only they may use it. The *iya kekere* are entitled to materials that are slightly less sumptuous than those owned by the chief priestess, thereby visually marking their lower status in the hierarchy.

The *iyawô* (or *olorixá,* wives of the gods) make up the next generic class in the *candomblé* Nagô hierarchy.[10] Whether they are men or women, they are known by that term because of their close relationship with their deities, a relationship often compared in the *ilê axé*—as also among the Yorùbá—with that of husband and wife/wives (Pai Crispim 1982, personal communication, Salvador, Bahia). The most meaningful function of the *iyawôs* is to incorporate in their bodies, by means of possession trance, each of the *orixás* venerated by the *candomblé.* Each man or woman is prepared for this role through an initiation lasting a minimum of three months with up to a year of ritual seclusion in a special building or room separated from the rest of the members. When they successfully receive their possession trances during public *xires* and are selected by the presiding priest or priestess, the *iyawôs* are the class of initiates who are regularly permitted to wear the *axo orixá.* The entranced *iyawôs* are dressed by their *ekedes* in the *barracão.* They then reemerge in the public space, dancing the elaborate, liturgical ensembles of their respective *orixás.* On special occasions, the presiding ritual leaders or *ebomin* may receive possession trance and often may also be dressed in *axo orixá.* Each man or woman is dedicated to a specific god or goddess and performs an indispensable spiritual role. Without a human vessel in whom to incorporate, African Brazilian devotees believe that contact with the particular god will be actively dissolved (although the deity may remain quiescent in the sacred shrine symbols).

The ritual uniform of this level of the hierarchy consists of the basic *roupa de axé* (plate 13). The major exceptions are that while males always wear white in the *xire* unless in trance, the women tend to wear the colors associated with their deities, when not required to wear all white, and are further signified by a large sacred bead worn on their *ilêke* symbolizing the completion of their initiation process and sanctified by the *axé* of their specific *orixá.* Only when "possessed" by the *orixá* during

the public ceremonies will the *iyawôs* put on *roupa de orixá* (special, elaborate costumes signifying sacred attributes and type-motifs particular to each deity; plate 16). Because these ritual garments are viewed as sacrifices to the deities and believed to contain, manipulate, and distribute *axé*, when they are not being used in the *xire* they are stored in large trunks in the back rooms of the *barracão* or in the inner rooms of the shrines of the respective *orixás*. Those with the rank of *iyawô* are constrained to eat with their hands and use white enameled metal plates and cups, in keeping with their lower position in the hierarchy. But even at this level, the consciousness of having power over another individual is always present; because of the nature of initiation, someone initiated even a few minutes earlier than another is entitled to some special privilege or behavior acknowledging this position. This concern with rank as it relates to seniority and concomitant privilege is also observable in contemporary Yorùbá society in Nigeria. An important example can be seen in the institution of polygamous marriage in which the *ìyálé* (senior or head wife) administers and directs the wives who came into the household after her. Even the title *ebomin* for the second class of initiates in *candomblé* Nagô signifies this concern for rank and privilege, translating in the Yorùbá language as *egbon mi* (my elder relative). (*Aburo* is the term used to refer to someone younger.)

The lowest rung of the hierarchy belongs to the *abiãn*, those dedicated to the gods but not yet initiated. These individuals generally wear plain white muslin costumes, without head ties, and with only a single strand of tiny beads in the color of their specific deities.

As the foregoing suggests, a strict socioreligious hierarchy is codified by liturgical accoutrements. These outfits not only signal the degree of power the wearer possesses but also communicate the individual's prerogatives and the appropriate behavior expected of others lower on the hierarchical scale. Costumes of the gods serve tripartite functions as offerings, aesthetic displays, and perpetuation of the religion. By extension, they also serve to sustain the power of the African Brazilian women and men who are caretakers of this religion. Ilê Axé *candomblé* Nagô offers resolutions to the problem of the African Brazilian's lack of power in the wider society, and the sacred art forms we have discussed reinforce these resolutions. Ritual clothing, implements, and other art objects are conceptualized as sacrificial offerings to the *orixás*. Because of the satisfaction art provides in the form of beautiful containers for and activators of *axé*, art plays an essential role in manipulating the sacred. Separately

and in combination, these African Brazilian art forms operate as multi-voiced systems of figuration that signify mythology, values, history, and ideas originating both in Africa and Brazil. In the latter, they operate dynamically in the *ilê axé*, not as static retentions but as products of agency, independent development, and innovation, within historically related and overlapping sets of broad aesthetic ideas.

Yemanjá/Yemọjá

Mother, Water, Ruler, River, Àjẹ́

Yemanjá (also known as Yemọjá and Iemanjá) was one of the most influential òrìsàs accompanying the enslaved Yorùbás in their forced migrations to the former Dahomey and to Brazil from about 1538 through 1850 from southwestern Nigeria. There she was and remains known as Yemọjá (the goddess of the Ogun River), one of 401 members of the Yorùbá pantheon.[1] Art forms and ritual practices honoring her were and still are some of the most pervasive constituents of Yorùbá-derived religious systems in other parts of South America, the United States, and the Caribbean. In this respect the veneration of Yemanjá/Yemọjá is transcultural and international. In Brazil and beyond, Yemanjá/Yemọjá's charisma has surpassed the borders that demarcate class, ethnicity, and race to embrace everyone.

Yemọjá in West Africa

In Africa, Yemọjá is venerated as queen, mother, protectress, provider of fertility, and àjé. Her many ritual and mythological roles are addressed in a rich variety of daily, weekly, and annual ceremonies and discourses, with their attendant visual lexicons. Yemọjá's name is derived from Yeye Ọmọ Ẹja (the mother of fish children) and is a metaphor for bodies of water where fish abide, including ponds, lakes, and the ocean. She can be historically traced to the Ẹgba polity of the Yorùbá people, located in the region between the town of Ilé-Ifẹ̀ and the city of Ibadan. There, she

65

was the goddess of the river Yemọjá, which no longer exists. In the early nineteenth century, internecine wars between diverse Yorùbá kingdoms compelled the Ẹgba to migrate west to the city of Abeokuta. With them, the Ẹgbas transported the *aṣẹ* Yemọjá (sacred objects and foundation of Yemọjá) and transformed the Ogun River—now situated in Ogun State, Nigeria, into the new abode of Yemọjá.[2]

Although her worship extends to many major sites throughout Nigeria, Ṣaki and Abeokuta are the Yorùbá towns where the power of Yemọjá is most salient. In Ṣaki (Shaki), in the interior of Yorùbá territory, Yemọjá is still regarded as "'Mọjẹlẹwu," the "wife" of the *okẹre* (king) of Shaki, and the Ifá divination verse, *ogbe-eje ogunda*, preserves her royal role as Queen:[3]

> Pon is the *awo* of Aro, *òrìṣà* is the *awo* of outside. Ifá divination was performed for Ifin. Ifin was in want of a child. By the time she was to give birth, she gave birth to 'Mọjẹlẹwu, a female. Ifin was asked to make sacrifice to Ifá, Ifin made sacrifice. The husband also was asked to make sacrifice, only the wife did make the sacrifice, the husband did not. When Ifin was to give birth to the child, she gave birth to a female child. The time came when the child was to be given her name. The parents said, well, there is no other name we can give to it than to say—Omọ jọ elewu, Omọ jọ elewu ('Mọjẹlẹwu) and that is why the child's name is Ọmọjẹlẹwu. 'Mọjẹlẹwu became of age. My right hand performed divination for Ọsun, the *awo* of Aso-Oke, divined divination for *oke* (hill). Tell me your don'ts [forbidden words or behaviors], I'll tell you my don'ts. Performed divination for 'Mọjẹlẹwu, wife of Okere. Okere was to give marriage to 'Mọjẹlẹwu. Okere called 'Mọjẹlẹwu. He told the wife, look, sit down. It is better for us to know our don'ts and I know your don'ts as you will know mine, that we will not offend one another. The wife said to the husband first: "Well, you see me as I am, I have very fat breasts. Should you never abuse me with it." And that's what we call Yemọjá. Ọmọjẹlẹwu was a dyer. Okere was *oniṣegun* (a native medicine man) and a hunter, a bold hunter. He had many medicines. The husband told the wife—"Look at this small house, should you ever enter it, don't enter into this room, NEVER!"
>
> Okere also cared for pigeons. (As you know, some people have an interest in keeping chickens; instead of keeping chickens, this Okere keeps pigeons). One day, one of the pigeons of Okere went out to spread the remains of the dye material of 'Mọjẹlẹwu, what 'Mọjẹlẹwu used to dye cloths. One of the pigeons went out just to scatter them. 'Mọjẹlẹwu took up a stone and threw it at the pigeon. As Okere saw the action of the woman, he said, "Aah! 'Mọjẹlẹwu, and you did this?" Before he finished the sentence, he remembered what the wife had told him—her don't. He stopped, Okere stopped, Okere stopped,

maybe he wanted to abuse the wife. Immediately he stopped, he didn't pronounce what he wanted to say. The wife was not happy about it, she knew fully well what he wanted to say, but she kept it within herself.

The time came when the Okẹre went to war, but before he went to war . . . he spread out all his medicines outside to dry them. . . . He put them in the sun. Later, there was evidence that there would be rain. The medicines of the Okẹre were outside . . . in the sun, just to have them dried. . . .'Mọjẹlẹwu was at home, doing her dyeing work. Then she realized that, "Aah! If this rain has to fall, these medicines will be spoiled and will become bad." She began to think on what to do, thinking, remembering the "don'ts," that she should never touch or go to the one inner room. She began to pack all the medicines. Okẹre also had realized that there would be rain (there were some people in the old days who had the power of getting to any place they would want to touch anytime). So Okẹre seeing that "Aah!" he had put those things in the sun. If this rain had to fall, there is no alternative, all those things have to spoil. Then he immediately realized it and got all things together, trying to come back home.

Then he saw 'Mọjẹlẹwu, as she was trying to pack all those medicines inside. Then a far off, he said: "'Mọjẹlẹwu, as I've told you, you should NEVER enter this small room or even touch any of the medicines, YOU, THIS FAT BREASTED WOMAN!" 'Mọjẹlẹwu became annoyed, and what she did was to begin to pack all her belongings. This is the story of how Yemọjá became the River Ogun—and became Yemọjá is what we are narrating—So, 'Mọjẹlẹwu got all of her properties, everything she had and she began to walk away with them. Then Okẹre said, "Hah! There is no need of deceiving yourself! There is no place where you can go, you cannot go ANYWHERE!"

Okẹre was a good medicine man, somebody who knew a lot of medicines. He was a powerful man in medicines. 'Mọjẹlẹwu began to run, she was just going away from the husband's house. Then the Okẹre began to pursue the wife. As soon as they got to a tall hill, he said, "Oh, you people, Agbele is the *awo* of Aro that he called Iyere, *òrìsà* is the *awo* of outside. He performed divination for Ifin who was in want of children, she was to give birth, she gave birth to 'Mọjẹlẹwu as a child . . . of my right hand, *awo* of Otun, performed divination for Osun, the *awo* of Ese Oke (that is the foot of a hill) performed divination for a hill. Tell me what you don't like, I tell you what I don't like. [*Awo* Ese Oke] performed divination for 'Mọjẹlẹwu, wife of Okẹre, performed divination for Okẹre who was to give marriage to 'Mọjẹlẹwu as wife, YOU BIG HILL, STOP 'MỌJẸLẸWU FOR *AWO*, CROSS HER, DON'T LET HER TO GO TO THE PLACE SHE WANTS TO GO, BIG HILL! STOP 'MỌJẸLẸWU FOR *AWO*" (that is, for Okẹre). . . . Oke (hill) heard this and it rose, it rose higher than it was before. . . . There was no way for 'Mọjẹlẹwu to go, she had been crossed, and so 'Mọjẹlẹwu

fell down. 'Mojelewu, too, became very tall but when there was no other way for her, she, too, just went down, like that, flatly (men and women of old days had such powers . . . supernatural powers that very few people have now).

So, 'Mojelewu, after falling down, became a river, but broke the hill into two . . . it broke the hill into two and through it there was water, 'MOJELEWU BECAME WATER, RIGHT FROM THAT PLACE . . . Yes, Agbele is the *awo* of Aro, *òrìsà* is the *awo* of outside, performed divination for Ifin who was in want of a child, when she was to give birth, she gave birth to 'Mojelewu as a child . . . IGBORIMIRIMI . . . of my right hand, the *awo* of Osun performed divination for Osùn . . . IGBORIMIRIMI . . . the *awo* of a foot of a hill, performed divination for a hill, tell me your don't I'll tell you my don't, performed divination for 'Mojelewu, wife of Okere of Saki . . . and that's how 'Mojelewu became the river Ogun and became known as Yemojá.

Now . . . her children began to worship her, just to appeal for her love, so she will be able to give them all they think they need. That is the beginning of the worship. Because Yemojá, that is, 'Mojelewu, had to call on her children . . . she said that anytime they would want a place of call in the river (a place of worship, it can be called also, as in *ojúori* for a departed father or mother, where they are buried, you can go to that place if you want something, call on him or her and make some *ebo* or some sacrifice). . . . That is the beginning of the [Yemojá] worship. ('Fayinka, *babaláwo*, chief, Gbajura quarter 1983, personal communication, Abeokuta, Nigeria [trans. Bayo Akanbi, 1983, Ife, Nigeria])

Although the *okere* is a Muslim, he is still careful to pay special ritual attention to Yemojá in the ceremonies associated with his office. For example, Yemojá must be invoked during the coronation ceremonies before the king of Saki can be considered to be properly installed in office. This spiritual requirement was honored by the current *okere* and his officials despite the strong Muslim contingent connected with the palace.

In Abeokuta the devotion to Yemojá was still active and was also associated with a royal context when I conducted my research in 1983 and when I returned in 1991. Yemojá's major shrine is located in the Ibara district close to the palace of the paramount chief (also king), known as the *olubara*. In Ibara, Yemojá is seen as not only a queen but as the mother of many other gods and goddesses and as an àjé. She is believed capable of controlling and facilitating fertility and procreation on a human as well as a generic biological level, and her power is believed to encompass even some aspects of nature. While I was there in 1983, Abeokuta and

the general area had been experiencing an unseasonable dry spell that caused quite a lot of hardship for the farmers. This minidrought was a frequent topic of conversation at the *afin* Ibara (palace). The *olubara* and his Ifá diviners and other priests finally decided that Yemọjá must be the cause of all the water drying up. When they divined, they found that she wanted a major sacrifice—a cow. Once this was accomplished, miraculously or coincidentally (however we may look at it) the rains came and the dry spell was ended. I was surprised to note the king's high respect for traditional Yorùbá religion and for the worship of Yemọjá, despite the fact that he was Western-educated and a professed, devout Christian.

There are several references in the literature about the Yorùbá in West Africa to Yemọjá's role as àjẹ́ or *iyami*—our mother (or witch in Westernized thinking). According to Peter Morton-Williams (1960), Yemọjá is the mother of witchcraft. In his classic study, *Black Gods and Kings,* Thompson quotes two high-ranking priests who emphasize the close connection with Yemọjá and Gẹ̀lẹ̀dé, a society devoted to placating *iyami:* "Gelede is the worship of Yemọjá, goddess of the sea and river. The masks of Gẹ̀lẹ̀dé represent her and her female descendants," and "Yemọjá is owner of Gẹ̀lẹ̀dé."[4]

In Ibara, Yemọjá is thought to reside in the various tributaries of the Ogun River, which are located in the precinct, and she may be invoked by speaking the different names that recall these distinct watery dwellings. She is worshiped through blood and food sacrifices, *ọfọ̀ àṣẹ* (words charged with spiritual power through ritual chanting), and other means in two major shrines located near the tributaries (fig. 4.1). Although Yemọjá is honored regularly in daily, weekly, and monthly ceremonies, the most elaborate ceremonies are the annual festivals beginning in late April or early May that usually last nineteen days.

During the annual festivals all the images of Yemọjá are taken from their individual household or compound shrines and brought to the major shrine in the royal Ibara district shrine. Here, they are lined up on the long veranda of the interior shrine courtyard (plate 17) in front of the secret, sacred precinct where the most powerful symbols of Yemọjá are housed. These images—*ère* Yemọjá—receive a portion of all food and animal sacrifices and are believed to be reactivated during this period. Contemporary images are enamel-painted wooden carvings that usually depict a female with very large breasts suckling one or more children and often surrounded by other children. The carvings signify the role of Yemọjá as nurturing mother, vigilant protectress, and agent

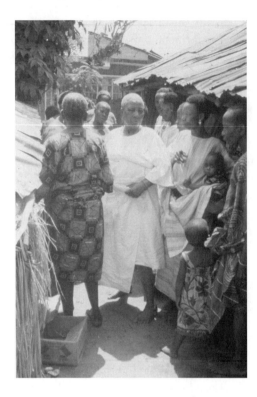

Fig. 4.1. Ìyálòrìṣà Omileye, the head priestess of the Yemọjá Shrine uttering sacred words during a ritual, Ibara district, Abeokuta, Nigeria, 1983. Photograph by author.

of fertility. A special necklace consisting of multiple strands of tiny clear crystal beads secured by two or three larger red, white, and blue Venetian trade beads serves as a symbol of Yemọjá in Ibara and is represented on the sculptures that conform in style to the typical Yorùbá canon.

The most important events of the annual festivals in the Ibara district in Abeokuta, besides the private sacrifices, involve the public processions from the major shrines to the Ogun River tributaries to retrieve the sacred water necessary to replenish the *aṣẹ* of Yemọjá. The consecrated pots in the shrines are carried to the river on the heads of devotees designated by divination (fig. 4.2). Later, in the evening, the Yemọjá images are paraded throughout the district on the heads of initiates. The images are taken to visit each of the individual houses, market stalls

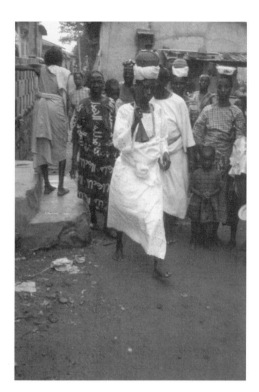

Fig. 4.2. Priestess of Yemọjá
leading a procession to the
Ogun River in order to
replenish sacred water for the
shrine, Ibara district,
Abeokuta, Nigeria, 1983.
Photograph by author.

(plate 18), and the palace in Ibara for the collecting of gifts of food,
drink, or money. Yemọjá expresses her pleasure and bestows her bless-
ings by incarnating one or more of the devotees during these processions
(plate 19). The possession trance is an extremely important element in
these processions. The festival ends at dusk and everyone returns to the
main shrine where the possessed devotees have their trances lifted by
the priestess.

In the town of Ilé-Ifẹ̀ in Nigeria, Yemọjá is regarded as a daughter
of Olokun, the goddess of wealth, and as the personification of the sea.
She is accessible to her devotees because of their understanding of her
behavior and feelings as comparable to that of earthly women: Yemọjá's
first husband was Ọrúnmìlà—the òrìṣà governing divination. She later

married Olofin, the ọni of Ifẹ̀, with whom she bore ten children, whose names correspond to the names of other òrìṣàs, such as Oṣumare (rainbow) and Ṣango. The oríkì (praise poems) of Yemọjá refer to her connection with Olokun and suggest that the Yorùbá in Africa assigned moral and physical characteristics and personality traits to Yemọjá that are comparable to those associated with her in Bahia:

> Queen of the waters who comes from Olokun's house
> She wears a dress of beads in the market
> She waits proudly seated, in front of the king
> Queen who lives in the depths of the waters
> She walks all around the city
> Displeased, she demolishes bridges
> She owns a copper rifle
> Our mother of the tearful breasts. (Verger 1981b, 191)

The phrase "tearful breast" is a metaphor for the leaking of milk from the swollen breasts of a nursing mother and signifies the characteristics of nourishment and nurturance associated with Yemọjá. The emphasis on large breasts is ubiquitous.

Yemanjá/Yemọjá in Bahia

In the Yorùbá diaspora, and especially in Bahia, Yemọjá is polythetic (Barnes 1989, 12–13)—that is, she is named and defined through a combination of features and meanings rather than through one monotypic attribute. A very popular deity, she is known variously as Yemanjá, Yemọjá, Iemanjá, Iara (water nymph of the indigenous Indians), and Senhora (madame or lady). Her images are also disparate and multiple. For some she is a mermaid with long, flowing hair, with the torso of a human and the lower body of a fish (fig. 4.3) For others, she is Nossa Senhora de Conceição da Praia—Our Lady of the Immaculate Conception of the Beach, a version of the Virgin Mary depicted standing atop the heads of angels with long, cascading black hair, pure white skin, wearing a gold or silver crown, and clothed in embroidered blue and white velvets and laces (fig. 4.4). A popular chromolithograph used by candomblé initiates and the general populace alike portrays Yemanjá as a glamorous princess or queen, dressed in blue and rising out of the blue sea, sheltered by a blue sky (plate 20).

Fig. 4.3. Aluminum foil mermaid called Yemanjá; decorating the Yemanjá Restaurant, Sugar Loaf, Rio de Janeiro, 1980. Photograph by author.

Ilê axé initiates understand Yemanjá as a beneficent mother figure, a general protectress, and a goddess of all saltwater, as in Africa, whose *àṣẹ* is localized in starfish and seashells that sit openly on the altar (plate 5) or in ocean or river stones housed in blue porcelain basins. In Brazil each deity is honored weekly on the day dedicated to him or her. Yemanjá's sacred day for *osse* (weekly or monthly veneration) is Saturday. On that day she is prayed to and may be offered her preferred foods—duck, mutton, and delicacies prepared from a base of white corn, oil, salt, and onion.

Attributes of Yemanjá

In Bahia an assortment of features delineate the *àṣẹ* of Yemanjá, features expressed in seven types of the goddess:

Yemowo—wife of Oxalá (Obatala—deity of creation) who rests in a lake in the interior far from the ocean and likes jewels and luxurious clothes

Fig. 4.4. Sculpture of Nossa Senhora de Conceição in a procession after a High Mass celebrating her holy day, December 8, in Salvador, Bahia, Brazil. Photograph courtesy of Arquivo Bahiatursa, Salvador, Bahia, Brazil.

Iyamasse—mother of Xango (Shango, deity of thunder and lightning and former king of Oyọ)

Olossa—lake into which the rivers drain

Yemanjá Ogunte—married to Ogum Alagbede and is aggressive and often violent

Yemanjá Assabá—limps, constantly spins cotton, is willful and sometimes dangerous (plate 21)

Yemanjá Assessu—lives in soiled, turbulent waters and is very headstrong and formidable.

Bahian oral literature featuring Yemanjá combines many of the above attributes:

> The youngest and most beloved wife of Oxalá is Iemanjá [Yemanjá/Yemojá], identified with the Virgin Mary. Voluptuous, she is represented with vast breasts and large, sexually potent buttocks. As

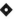

she also lives in the waters near Oxalá, Iemanjá's colors are [crystal] white and [light] blue. She is well loved among women, especially the stout ones. . . . [While] Oxum is believed to live on the surface of the waters, and Nanan in depths, Iemanjá lives in the middle.

Although Iemanjá possesses some of the caprices of feminine vanity, she does not have the same [extravagant] requirements of Oxum. She is especially docile and tractable, complacent and accommodating, and causes gentle breezes on fishing trips and tranquility within the family. . . . Even though she is confused with European or indigenous [Indian] myths, she does not have the voluptuousness of the mermaids or the perversity of the *iaras* [mythological river sirens]. (Seljan 1973, 26)[5]

Many personality traits of the goddesses conform to the mythical attributes of Yemanjá and her variants and thus Yemanjá may be considered an archetype. The composite portrait of Yemanjá is of a goddess/initiate who is alternately obstinate, yielding, inflexible, adaptive, protective, passionate, courageous, haughty, and sometimes arrogant; possesses a keen sense of rank and hierarchy and commands respect; is fair but formal; is a devoted friend and frequently puts friendships to test; finds it difficult to forgive an offense and rarely forgets the wrong. The goddess/initiate is preoccupied with others, is maternal, and serious. Despite the fact that vanity is not a salient trait characterizing Yemanjá, her initiates love luxury, ostentatious blue-and-white, or sea-green textiles, and costly jewels. They prefer sumptuous lifestyles even if their everyday circumstances do not permit them such luxury.

Axô Yemanjá: Sacred Symbols

In Bahia, sacred art objects, dance, ritual, and trance are the fundamental means used to commune with the gods and manipulate the sacred. Yemanjá manifests herself in her *adoxu* or *olorixá* (generic terms for all initiates able to experience possession trance; mediums) during the rituals and *matanças* (sacrifices) held in the Yemanjá shrine preceding the public festivals of the *ilê axé candomblé* Nagô. During these private ceremonies, slight rearrangement of the initiates' clothing signify their states of possession trance.

In the *ilê axé*, public festivals known as *xire* are arenas for splendid displays of art. In Ilê Axé Opô Afonjá—the *candomblé* I researched most thoroughly—these *xire* began when the *olorixás* leave the Casa de Xango (principal shrine house) and, led by the head priestess, proceed single file to the *barracão*. At other times, at a pre-designated hour, the *olorixás*

proceed from their homes to the *barracão*. At the ritual leader's signal, they immediately form a *roda* (circle) and dance counterclockwise as the drummers and singers *tirar cantigas* (sing the triad of specific songs for each deity to elicit the possession trance). At this juncture, the initiates wear elaborate *roupa de barracão* in the appropriate colors to signify the *olorixá*'s connection with the *orixá* who "owns their heads."

Once the initiate enters into the trance of his or her *orixá*—the *transe pesado* (or deep trance), the initiate's actions and behavior are believed to be those of their deity. The initiate's clothing is rearranged to signify the trance and they dance for a while in the center of the *roda*. They are then led backward into a back room of the *barracão* where they are dressed in the elaborate, expensive, and sumptuous formal ritual apparel reserved for use only by those who are in the deep trance of their deity. The initiate then reenters the dancing space backward, led either by the head priestess or her assistant, who constantly rings the *agogo* (the silver-colored ritual bell believed to inaugurate and continue the trance state). In this state, the initiate is believed to be the *orixá* incarnate and so reenacts the myths and the *axé* of his or her deity for the benefit of all present. When Yemanjá danced in the *barracão*, I was struck by the common sight of spectators and initiates eagerly awaiting her embrace. She accomplished this by opening her arms widely and closing them tightly around the recipient, touching the initiates' chest with the left, then the right shoulder. I could not ascertain the significance of the gesture beyond the fact that recipients believed that the *axé* of the *orixá* was transferred to them (Nivalda, 1983, personal communication).

The accoutrements (*axô* Yemanjá) Yemanjá wears and holds syn-thesize African and European elements which have symbolic functions (plate 22). This formal ritual ensemble conceptually recalls Yemanjá's status as a queen in Ṣaki, Nigeria, as recounted in the *odù* above. The ensemble varies only slightly for different *candomblés* and fundamentally consists of a silver-colored metal crown (often fringed with beads), bead necklace(s), blouse, skirt, fan, crown, sword, heavily starched under-skirts, silver-colored metal bracelets, armlets, and skirt bangles.

The crown (*adé*) is the object most closely associated with the authority of Yorùbá kings and female regents treated as male in West Africa, and is an important attribute of Yemanjá as well as other *ayabás* (female *orixás*) in Bahia. Yemanjá's metal crown probably recalls male Yorùbá royal symbols transposed symbolically to a female goddess. The *adé* represents Yemanjá's sovereignty over the sea and, according to some

initiates, all water. (The crown appears in Europeanized versions of
Yemanjá such as Dona Janaina, who is so popular on Bahian chro-
molithographs.) Images of Nossa Senhora de Conceição de Praia syn-
cretized with Yemanjá also wear similar crowns. (The Catholic crown
may refer to the Virgin Mary as a "queen" among all women; Padre
Oliveira, Oct. 1981, personal communication, Bahia, Brazil) The use
of the crown by the incarnated *orixá* Yemanjá may also refer to the
earthly interpretation of Yemanjá as queen and wife of the king of Ṣaki.
This would, however, be a free African Brazilian adaptation of a male
Yorùbá symbol. The fringe of tiny crystal beads that often character-
izes Yemanjá's crown is symbolic of water and serves to veil the face
of the *orixá*. Similar fringes are found on the beaded crowns of Yorùbá
kings. According to Thompson: "the crown incarnates the intuition of
the royal ancestral force, the revelation of great moral insight in the per-
son to the king, and the glitter of aesthetic experience. . . . Indeed, the
prerogative of beaded objects is restricted to those who represent the
gods and with whom the gods communicate: kings, priests, diviners,
and native doctors" (1972, 227–29). In this context, the beaded veil may
both indicate the presence of the supernatural and visually communi-
cate social and political rank. Only those Yorùbá kings who can trace
direct descent from Odùduwà (now worshiped as an *òrìṣà*) may wear the
beaded fringed veil, a symbol of supernatural kingship. Only incarnated
orixás wear the *adé* Yemanjá, as it symbolizes the force and royalty of
the spiritual presence. According to Mellor (in Thompson 1972): "the
beaded crown with veil is the essential sign of kingship." In *candomblé*
Nagô the only *orixás* who wear beaded veils are Oxalufon (Obatala in his
aspect as father of all *orixás* and rightful king of Ilé-Ifè), Yemanjá (queen
of Ṣaki and mother of other *orixás* except Loko, Omolu, and Oxumare),
and Oxum (queen of river, freshwater, and fecundity in her role as *iyami
àjé*, or witch) (Verger 1981b, n.p.). These three are linked more deeply
with mythical royalty and power than any other *orixás* in the pantheon
except for Xango, and the beaded fringed veil may symbolize the special
relationship between sovereignty, civil influence, and spiritual power.

 The fan (*abèbè*) of silver-colored metal is another important at-
tribute of Yemanjá, and is received at the completion of the initiation
to the level of *ebomin* (seven or more years after initiation as Iyawo). It
refers to her beauty and status as the cherished younger wife of Oxalá.
Although I did not find round fans in actual use in Ibara (site of the
Yemọjá shrine in Abeokuta), fans are mentioned in a verse from the

ancient literary corpus of Ifá divination as a symbol of Yemọjá (Thompson 1983, 7). In Africa, Yemọjá's power to bring peace and coolness to the world is expressed by the back-and-forth movements of the *abẹ̀bẹ̀*. Bahian initiates use the *abebe* Yemanjá in ritual dances in movements recalling the motion of waves to expel negative forces (dos Santos, n.d., 94). The *abẹ̀bẹ̀* and *adé* are kept on the altar for Yemanjá when not in use. The *ilêke* that Yemanjá wears invoke the cool transparency of water and are worn by initiates in single strands as daily insignia of the *orixá*. Twelve-strand or sixteen-strand necklaces are worn for festivals. Crystal and white metals such as silver symbolize the clarity and surface reflections of water—the natural element associated with Yemanjá—and her calm, virtuous moods.

The *saias* are made of expensive material and are reminiscent of the skirts worn by wives of slave masters, the types of skirts depicted in many eighteenth- and nineteenth-century illustrations of European and American dress (Debret 1840). This mode may have survived as a cultural memory or may have been copied by the Bahian upper-class wives or the mulata mistresses of slave owners and apparently appropriated by Africans as early as 1859 for festival and *candomblé* use. According to the illustrations, slaves and liberated blacks wore different styles of skirts.

The *saia* Yemanjá is made of six meters of cloth and decorated with rosettes, tiers of ruffles, flowers, and ribbons, in the manner of eighteenth- and nineteenth-century models. The extreme fullness is achieved by using two or more petticoats—*anaguas*—made of thin muslin (*murin*) edged with a border of lace ten or more centimeters wide. These petticoats are heavily starched using a technique employed by the slaves who did this work for their mistresses. This starching technique was handed down from mother to daughter by descendants of slaves and today is used solely within the confines of *candomblé* (Tia Clarisse, Ebomin of Omolu 1982, personal communication, Salvador). The starching process is time-consuming and difficult. In the *candomblé* where I lived, only two women knew how to starch "properly"; neither too much, leaving the *anagua* stiff, nor too little, leaving the petticoat limp, which is considered *feia* (ugly). The *anaguas* were individually starched in a large black iron pot over a wood fire built in the courtyard of the *adoxu*'s house. Chunks of starch were dissolved in boiling water and then the water was stirred vigorously to prevent lumping. The *anagua* was thoroughly immersed, pulled out with a heavy stick, and suspended

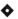

over the pot to cool before being wrung out to remove the excess starch. After drying on the grass in the sun, the petticoat was ironed, an arduous job requiring much pressure because of the stiffness.

In 1983 the usual price for starching one *anagua* varied from 1,000 to 1,500 cruzeiros, a costly sum considering that the minimum wage at that time was only 20,000 cruzeiros per month, the equivalent of $35.00. All initiates who could pay or barter for the service had their petticoats starched because it was a sign of beauty and prestige. The more bouffant the *saia* became by using many petticoats, the more beautiful it was considered to be (Ọdẹbwa, *adoxu* of Oxossi 1982, personal communication, Salvador). The petticoats were carefully put on and taken off and were worn as frequently as possible before being restarched, often until they were noticeably dirty. The pleasing aesthetic effect of the *orixá*'s skirt (*saia de orixá*) was partly or strongly dependent upon its fullness.

The blouse (*blusa*) of the *axô* Yemanjá is called *bordado* after the embroidery that embellishes it. Cut-and-drawn thread floral patterns are painstakingly embroidered along the edges in a very slow and tedious process. The cost of this garment varies according to the intricacy of the design, ranging from fifty dollars for a simple design to three hundred dollars for a blouse or skirt entirely covered with *bordado*. Liturgical vestments made using this technique are highly prestigious and are worn by the *orixá*, the *iyalorixá*, the *iyakekere*, or high-status *ebomin*. I have known women to save for a year or more to purchase one piece of *bordado*.

The two scarves (*ojá*) follow an African antecedent when worn wrapped on the head. Wrapping the *ojá* around the upper torso and tying it into a big bow on the front of the chest appears to be an indigenous innovation; When used for the *axô* or *roupa de orixá* I know of no African or European prototypes for this style. The chain at the waist of the *axô* Yemanjá and the metal symbols hanging from it are called *pinca* (*iba* in Yorùbá). *Pinca* are earned only after the seven-year ritual marking the transition from *iyawô* to *ebomin*. Silver-colored objects signify Yemanjá and brass- or gold-colored objects represent Oxum, while copper or copper-colored pieces are reserved for Yansan. Initiates believe that the metal's color reflects the nature of the *orixá* represented: Yemanjá—cool; Oxum—warm; Yansan—hot (Dona Hilda 1981, personal communication, Salvador; Pai Crispim 1982, personal communication, Salvador). All of the silver-colored items on the *pinca* Yemanjá

are symbols of Yemanjá's favorite possessions: combs, fans, mirrors, slippers. These may be given to her as gifts during the annual transclass and ethnicity festival, Presentes de Yemanjá.

The silver-colored sword (*espada*) represents an aspect of Yemanjá called Iya Tanan, which is venerated at Ilê Axé Opô Afonjá. This *orixá* is believed to reside in wells two hundred feet or deeper. Iya Tanan is symbolized by green crystal beads in Afonjá. I have not seen green crystal used as a color symbolic of Yemanjá anywhere else except in the *egún terreiro* ritually linked to Afonjá, on Itaparica Island. According to the head priestess of Afonjá, this variation of Yemanjá comes from the Grunci (probably the Gurunsi of Upper Volta) nation, the reputed ethnicity of Iyá Oba Biyi, the first ritual head of Afonjá. Iya Tanan is characterized by a personality that suddenly alternates between hotheaded aggressiveness (symbolized by the sword), suggesting a warrior aspect, and coolness, gentleness, protectiveness, and motherliness (symbolized by the fan, implying her more feminine aspect). Yemanjá Iya Tanan is regarded in Afonjá as mother of all *orixás* not borne by Nanan. In this capacity she must be invoked along with Oxalá during all phases of initiation, especially those involving evocation of trance, creation of a new being, and the relearning of routine tasks and behaviors (*quintanda* or *panan*). As important as Yemanjá is in African Brazilian religion and pan-Brazilian culture, there are very few people in whom she chooses to manifest, whereas there are a great number of initiates for *orixás* such as Òogún, Yansan, and Oxossi. There are usually only one or two *adoxu* Yemanjá in any *candomblé,* and mediums of this type are sometimes actively recruited.

In the shrine of Yemanjá in Afonjá, the residence of Yemanjá Iya Tanan is symbolized by a round well rim 36.22 inches high and 60.24 inches in diameter, made of cement and encrusted with cowries and seashells. It is located in the Ilê Yemanjá (house of Yemanjá—two rooms adjoined to the northern facade of the Casa de Oxalá containing that *orixá*'s shrine). The proximity of Yemanjá's shrine to that of Oxalá may symbolize their mythical relationship as wife and husband and as mother and father of most *orixás.* Although several *orixás* may be placed together on the same altar in the same building, I know of no other architectural shrines each dedicated to single deities juxtaposed in this way.

Participants in private weekly rituals and sacrifices at the Iya Tanan shrine must be initiates. During the ceremonies, they remain in the outer

room, kneeling with their heads resting on their hands. The only persons allowed into the inner shrine are the *iyalorixá*, her assistant, the *axogún* (men who perform the sacrifice),[6] *ebomin* Yemanjá, and the manifested *orixá* Yemanjá. The inner room (the actual shrine area) is where Yemanjá's favorite fowl—duck and guinea hen—is sacrificed. Here, divination with kola nuts (*obi;* an African fruit cultivated in Bahia) is also performed. *Osse* and *matanças* are performed at 5 or 6 A.M. on the day of the great annual festival. Spiritually, these rituals are very important since they activate and redistribute the *axé* Yemanjá.

Festivals for Yemanjá

In Brazil festivals and rituals for Yemanjá take place in both sacred and secular arenas, and in many instances these spheres overlap. In the sacred context, religions of both African and Luso-Brazilian derivation honor Yemanjá on February 2 and December 8, respectively.

The most important African-derived Yemanjá ritual takes place on the relatively isolated island of Itaparica, high on a remote hill known as Bela Vista. The primary participants in the nonpublic portion of this ritual are priests of Ilê Agboulá (*oje*) who care for the *egún* and their wives, children, and other relatives. Spectators who are loosely affiliated with the ancestor society, or who are present on the beach by coincidence, participate in the public segment.

About two weeks before the public festival for Yemanjá, the *oje* perform an *osse* to Baba Bakabaka, one of the patron ancestors of Ilê Agboulá. This is done in order to obtain permission to hold the festival observances for Yemanjá at the appropriate sacred sites. During the day on February 2 the *egún* of Yemanjá (plate 23), distinguished by the color blue and other visual attributes, makes an appearance in order to bless the presents previously assembled in the festival building. After dancing for about an hour, the *egún* exits to its sacred shrine. Next, initiates dressed in white liturgical costumes make their way singing and dancing down the hill to the sea in a long procession accompanied by drummers. The initiates carry baskets with gifts, food, and floral offerings on their heads. After crossing the length of the beach several times, singing the praises of Yemanjá and invoking her presence, the initiates, drummers, and *egún* priests begin to board the boats that will carry them and their presents out to sea where they will make contact with Yemanjá. The gifts are deposited on the third wave. If several Yemanjá initiates are possessed by trance, that is interpreted as an indication that Yemanjá

is satisfied with her presents and will bestow blessings and protection on her worshipers during the coming year. When the boats return, the crowd follows the initiates, the incarnated *orixá* Yemanjá, and the other participants to a small church where they dance until dusk. The festival ends when the trances are lifted from the initiates.

In the city of Bahia, Yemanjá is worshiped on December 8—the Roman Catholic holy day of Nossa Senhora de Conceição, the patroness of Bahia, fishermen, and business enterprises (fig. 4.4). The adoration of Yemanjá has evolved into national proportions. On this day, after an early mass, a huge procession parades through the streets with the image of the saint. A few days before this, the area around the church dedicated to this saint, which was painstakingly built with Portuguese stones and tiles, and the Mercado Modelo (a craft market and tourist attraction) are decorated with colorful lights and streamers in much the same manner as for Carnaval or other popular, profane festivals. Hundreds of temporary wooden shacks bearing names of the *orixás* (e.g., barraca Yansan) or Christian proverbs serve as bars and eateries for the thousands of people who participate in this street party called *festa de largo*. (A characteristic of Bahia that attracts tourists from all parts of Brazil and other countries is this coincidence of street festivals with annual religious holidays, masses, and processions of saints.)

Even though the visual images are European, the participants I interviewed considered themselves to be honoring both the Virgin Mary and Yemanjá. According to Pierre Verger (1981a, 74), a German traveler documented this syncretism as early as 1859:

> A small procession came out of the Church of Nossa Senhora de Praia on December 8, causing great excitement among the passersby especially because of the blacks [in the procession] who produced the most unique impression. It [was] a great day [for] the people [of] color. The black men and women enthusiastically danced in front of the church and in the streets. . . . [It was] an original, genuine African picture. I was unable to force myself to refrain from looking at [the] black women . . . some perfect beauties from the Costa da Mina [the area along the African coast, including Nigeria, Ghana, Republic of Benin]. Some of them exquisitely carved in basalt, in complete negligence, with the bust seminude on one side, splendidly erect, rounded . . . flexible shapes of a brilliant black, many with bare shoulders. They displayed rich necklaces of coral, genuinely African, with gold decorations, around their black necks. Many of these wore thick gold chains adorning their waists and their elbows. It appears

to me, however, that the majority of them were carefully dressed in a manner consisting of a turban wrapped around the head, a heavily embroidered white scarf, a finely embroidered shirt, and a pleated, fringed, full round skirt.

This eyewitness account is important because it documents the early association of Africans with Nossa Senhora de Conceição and suggests that a symbolic association between the Virgin Mary and Yemanjá existed in Bahia well before 1888, when slavery was abolished. Further, it shows that the prototypes for the *roupa de axé* were already in use: *saia rodada, pano da costa,* and *ojá.* It seems likely that the African participants were both slaves and freed blacks. The present-day festival is remarkably similar to the 1859 event described above. The participants are still predominantly of African descent. The crowds are intense, the music is deafening, and the revelry and samba dancing last until dawn

The largest and grandest secular festival for Yemanjá is the annual one which takes place on February 2 in Rio Vermelho in Salvador. Although this day is technically reserved for Nossa Senhora das Candeias (syncretized with Oxum), it has been taken over by the devotees of Yemanjá, with the justification that because Yemanjá is the queen and ruler of all water, she should also be honored on this day. Even though it is primarily secular, this festival includes a genuine *candomblé* religious ritual, a semireligious presentation of gifts by thousands of devotees on the beach, and a huge secular street party.

Before 5 A.M. on the festival day, there is a private ritual offering to Yemanjá by *adoxu* or *olorixá* from different *candomblés* (fig. 4.5). The *ebo* of boiled white corn mixed with clear vegetable, olive oil, or palm oil and onion is considered the favorite food of Yemanjá in the *ilê axé.*[7] A temporary structure built of wooden posts and wide palm leaves houses the drummers and some of the initiates who sing Yemanjá's praises and dance in an attempt to evoke her presence. In a small white house near the rocky shore, fishermen clear space for the thousands of individual gifts to be taken from their temporary structures, placed in large wicker baskets (*cestas*) in the white house, and finally, taken out to sea. As the sun rises, a long line of devotees begins to form. Some of the devotees go directly onto the rocks or into the water to pray and offer their individual gifts (plate 24).

This annual ritual can be said to transcend all class and racial barriers. The secular Presentes de Yemanjá festival has even attained national

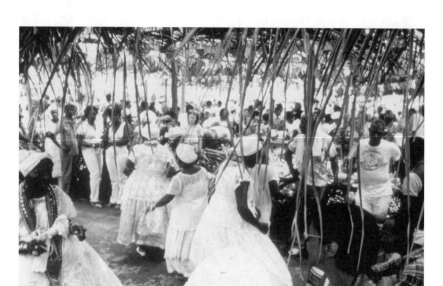

Fig. 4.5. Candomblé ritual preceding the Presentes de Yemanjá festival held in Salvador, Bahia, Brazil, on February 2. Photograph courtesy of Arquivo Bahiatursa, Salvador, Bahia, Brazil.

significance. The reasons for this phenomenon may derive from the amalgamation of the African goddess Yemojá with an aspect of the Virgin Mary. Most of the upper- and middle-class individuals I interviewed while they stood in line to offer gifts supported this conclusion: the devotees believed they were giving gifts to and obtaining blessings from both entities. Each gift thus served a dual purpose and reaped double spiritual benefits. Offerings included any feminine articles that a woman might desire: perfume, special soaps, face powder, flowers (fig. 4.6), ribbons, mirrors, and combs. Some offerings were extremely elaborate floral arrangements set in baskets with dolls. I even saw a boat made entirely of flowers with a toy doll (representing Yemanjá) on top. Notes of thanks or specific entreaties for help from Yemanjá accompanied all the offerings. The most common requests were solicitations (*pedidos*) for spiritual aid with matters of health and well-being and with problems regarding children, employment, and love.

Fig. 4.6. Flowers for *orixá* Yemanja, São Gonçalo do Retiro, Salvador, Bahia, Brazil, 1998, Photograph by author.

In Nigerian shrines or other sacred spaces, the goddess Yemọjá is simultaneously represented by natural objects, wooden sculptures (fig. 4.7), and human containers (plate 25), but in Bahia, Yemanjá has been actualized in only one wooden sculpture to my knowledge (fig. 4.8). She is presently represented most often by natural objects such as stones or conch shells but most importantly by a human medium, who when in possession trance and incarnating Yemanjá temporarily functions as a living artistic creation or sculpture (see plate 22).

Yemọjá has remained a powerful spiritual force throughout the centuries on the African continent and in the African diaspora. Her images are many: in Africa, they include *axé*-imbued sculptures, beaded necklaces, bracelets, human bodies in trance, and natural objects such as river stones. In contrast, in Brazilian *ilês axés*, Yemanjá's visual repertoire

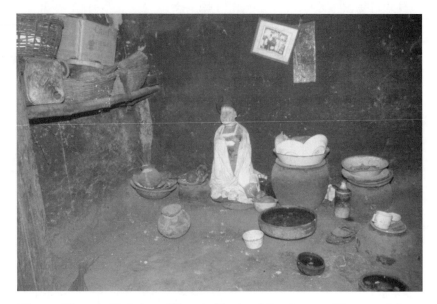

Fig. 4.7. Household shrine of Yeṃojá, Ibadan, Nigeria, 1983. Photograph by author.

consists of African-derived sculptures, natural objects, ancestor mas-querades, and humans in trance wearing liturgical vestments and carry-ing implements. Outside the *ilê axé*, among the general Brazilian pop-ulace, Yemanjá is represented simultaneously by chromolithographs of Dona Janaina—a crowned woman dressed in blue and walking on the blue sea, by silver and polychrome mermaids, and by forms of the Cath-olic Virgin Mary.

The power of Yemọjá/Yemanjá has, despite her changing image and ritual, remained steady and pervasive. In contemporary Bahia she is no longer venerated as an enchantress, but she is still regarded as queen, mother, protectress, and provider of fertility. Because of its geographical spread and diachronic depth in the New World, I think it safe to assume that the veneration of Yemọjá, along with its accompanying myths and rituals, formed an important part of the cultural baggage of Yorùbá slaves in the transatlantic slave trade. Especially in Brazil, the concep-tually African worship of Yemọjá and its associated art objects have not

Fig. 4.8. African Brazilian
sculpture for Yemanjá.
Courtesy of the Verger
Institute, Salvador, Bahia,
Brazil.

only continued but have, in many instances, invaded the beliefs, prac-
tices, and imagery of the dominant white social strata. This system and
its manifestation of the continent and in the African diaspora provides
intriguing opportunities to investigate issues surrounding the imbrica-
tion of cultures, continuity, and change as embodied in creative prac-
tices, their resultant products, myth, and ritual. Finally, the art objects
associated with Yemọjá worship are also extremely valuable as historical,
social, and political documents of the conceptual and material interpen-
etration of the diverse cultures they encode.

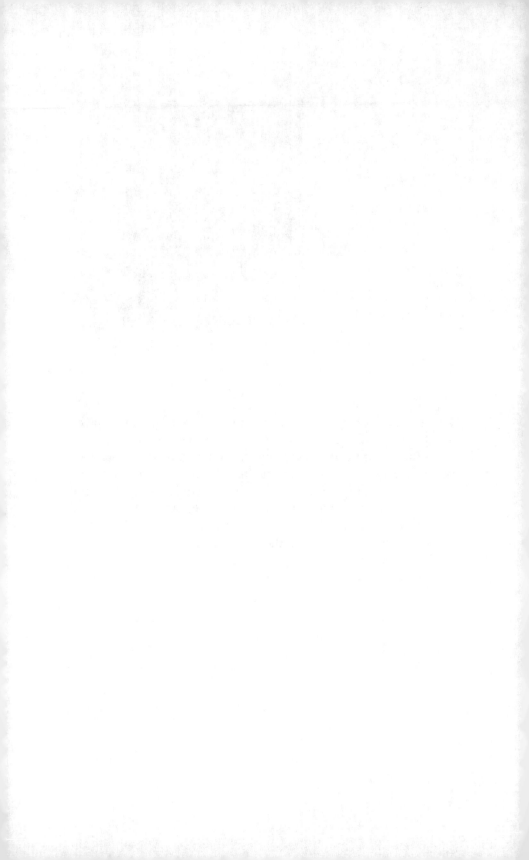

Ancestors, Gender, Death, and Art

Candomblé Nagô has resisted attempts to exoticize, folklorize, and commercialize it. Its superficial categorization into two broad divisions—the worship of *egún* and the worship of *orixá*—has tended to obscure its essential character. In Bahia this ideological separation is emphatically asserted by *egún* priests and devotees and is upheld by anthropologists such as Juana dos Santos: "The society of the Òrìṣà and the society of the ancestors are two completely different entities. There are two discrete liturgical practices, two discrete priesthood organizations, and two discrete locations" (1976, 103).[1] This theoretical position is contradicted by actual practice; my field research in Bahia revealed that connections exist between the *egún* and the *orixá* and that these are expressed through ritual, music, oral literature, movement and dance, and visual art. When dealing with the dead, a further distinction between male and female ceremonial is apparent. By discussing the history, structure, symbology, and art of the ancestor society in Bahia in this chapter, I hope to elucidate Yorùbá-derived religious practices and emphasize their interconnectedness with *orixá* veneration and gender issues. This chapter will examine (1) the origin, function, organization, and art of the *egún* society of male ancestors located on Itaparica Island and (2) the funerary ritual (*àxèxè*) and art for the predominantly female initiates in African Bahian religion or even in the Ilês Axés.

Ilê Agboulá—Organized Veneration of Male Ancestors

Although I visited a ceremony for the *egún* at Ilê Aṣipa in Salvador (July 2000), the most well known *egún* society holds its rituals in Ilê Agboulá. This *terreiro* is located high on a remote hill in an area called Amoreiras (mulberry trees) on the island of Itaparica located in the state of Bahia, twenty kilometers across the bay of Salvador (plate 26). The island is the gathering place and permanent residence for the chief officials (validated by the community at large) of this African Brazilian predominantly male association, which has been compared to a Masonic order (Bastide 1978a, 137; dos Santos 1976, 118–19). Most of the men belong to a permanent community that sustains itself by fishing and live in the lowlands of the island in an area known as Ponta de Areia (corner of sand). Before about 1970, this area was somewhat isolated from Salvador except for a few members of the upper middle class who vacationed there, maintaining houses for this purpose. The vacationers represent a fluctuating population effectively linked to the island by an efficient and fairly inexpensive ferryboat system, and the more expensive but faster catamaran service. Within the last decade, they have implemented a slightly more expensive system using one or two catamarans, which make a journey in twenty minutes while the ferryboat still takes an hour. There is now a marked class distinction.

The permanent population in Ponto de Areia is made up of the religious or biological descendants of Eduardo Daniel de Paula, founder of the society for *bàbá-egún* (father ancestors). Even though members are drawn from both sexes and cyclical private and public ceremonies require the sustained participation of women, the most important secrets of the society are controlled by men. One of its primary functions is to invoke powerful deceased members who, through a complex series of rituals, have been prepared for embellished cloth creations called *axô egún* (clothing of the ancestors). Contacted through daily, weekly, and monthly private rituals and elaborate semiannual public festivals, these ancestors take an active interest in the well-being of the families and friends offering advice and *axé* (fig. 5.1).

Some scholars believe that the origin of the ancestor society on Itaparica Island can be traced to the first Yorùbá slaves to arrive from Nigeria and Dahomey during the transatlantic slave trade (Bastide 1978a, 137; dos Santos 1976, 118–19). This is likely despite the abrupt and brutal

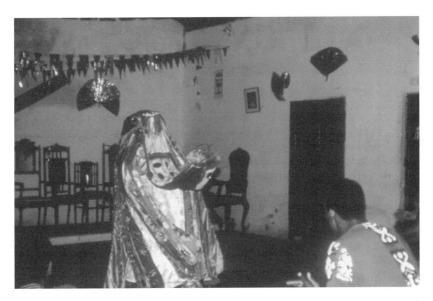

Fig. 5.1. Community member receiving *axé* from an elder ancestor *(egún agba)* in a festival, Ilê Agboulá, Itaparica, Bahia, Brazil, 1982. The *atori* (palm staff) symbolically separates the sacred space of the deceased from the space of the living. Photograph by author.

nature of slave capture, because physical belongings are unnecessary to generate the *spirit* of an ancestor (Lawal, May 2000, telephone conversation). S. O. Babayemi, a Yorùbá scholar, *egúngún* lineage member, and longtime participant in *egúngún* rituals stresses the physical aspect of interacting with an ancestor. In his 1980 publication (1–4, 25) he described in detail the close connection of ancestor veneration to family lineages in Nigeria, relating that *egúngún* function either individually, in the interest of their particular families, or collectively, in the interest of the community. When they function collectively, they transcend family and lineage alignments. When necessary, *egúngún* were invoked individually or collectively on the graves of the ancestors (*ojúoori*), the family shrines (*ilé run;* fig. 2.5), or the community grove (*igbàlẹ̀,* more commonly known in Bahia as *'bale*). The ancestors were invited to physically

visit the earth through masquerades referred to as *egúngún* or *àrá òrun* (inhabitants of heaven; fig. 2.6). Many community *egúngún* led their citizenry in wars or performed other social, political, and ritual functions.

I found that in contemporary Africa, lineage *egúngún* are maintained in a shrine in the main house of the compound (fig. 2.5) and are assumed to be accessible, active participants in their extended families' lives. Also enshrined are the cloaklike garments used to corporealize these ancestral spirits, sixteen cowries for *erindinlogun* divination, a bundle of branches (*iṣan* or *atori*) that symbolizes the ancestors and is used to control them during periodic public rituals, skulls of sacrificed animals, and secret materials that women are not allowed to see (Alapini Egúngún 1982, personal communication, Ilésà, Idasa compound). This array of shrine furnishings probably also existed among the Yorùbá during precolonial times; new *egúngún* shrines and ritual items could have been created by enslaved Yorùbás by invoking the spirits of the ancestors into new symbols.

The *Egun* society in Bahia may be more plausibly traced to enslaved Africans or African Bahians, possibly of Yorùbá descent, though it may have been nourished by those engaged in intercontinental trade. Free black merchants regularly traveled between Bahian and African ports such as Whydah in Dahomey and Lagos in Nigeria. As many as ninety-one such trips were documented for 1848 (Verger 1981a, 229). It is possible that these same merchants were able to trace their families in Africa and locate their domestic ancestral shrines. Ritual objects and the ritual knowledge needed to maintain old shrines and install new shines to invoke the ancestors could easily have been imported along with related material items. This hypothesis is lent further weight by data concerning these merchants that Nina Rodrigues collected in the late nineteenth and early twentieth centuries. In 1905, approximately seven years after slavery was abolished in Brazil, Nina Rodrigues interviewed an elderly African Bahian who had spent considerable time in Africa (1935, 156). This informant told him that in Africa the souls of the spirit world had a fraternity (i.e., the *egúngún* society) in which the initiated could participate, and that the souls materialized and promenaded about the city at will. The informant further asserted that he was unable to divulge any of the secrets to Nina Rodrigues because of the threat of severe punishment that could be inflicted through magic.

The earliest documented *egún* society and temple in Bahia is Terreiro Vera Cruz, founded around 1820 on Itaparica by an African named

Uncle Serafim (dos Santos 1976, 119). Dos Santos mentions four other important temples established in Bahia after 1820: Terreiro Mocambo (ca. 1830), founded on the Mocambo plantation; Itaparica, founded by an African named Marcus Senior; Terreiro Encarnação (ca. 1840), founded in the neighborhood of Encarnação by João-dois-metros, a son of Uncle Serafim; and Terreiro Tuntun (ca. 1850), founded in Tuntun village, an old African settlement, by Uncle Marcus, the son of Marcus Senior (dos Santos 1976, 118–19). At the time I conducted my research in the 1980s, there were only two *egún* temples in Bahia—both on Itaparica—and informants claimed these were the only ones in Brazil.[2] These were Ilê Oya, a direct spiritual descendant of Terreiro Tuntun, founded in 1925 in Barro Branco by Roxinho, and Ilê Agboulá, founded by Eduardo Daniel de Paula in the first two decades of the twentieth century (Bastide 1978b, 137; dos Santos 1976, 118–19). Within the past decade, two additional Egun temples were founded on the mainland in Salvador by Didi Dos Santos and Julio Braga. I participated in and/or observed ceremonies at three of these centers of ancestor worship but am more closely connected to Ilê Agboulá.

At Ilê Agboulá, *egún* are presented collectively by the trunk of a sacred tree 'roco (*iroko* in Yorùbá) or *gameleira*. This tree trunk (*opa koko*), rooted in the earth near the public dance space of the *terreiro*, symbolizes the link between the ancestral spirits and the force or spirit contained in the earth (*onile*). In this aspect, the *egún* are saluted collectively by uttering *asà* (in Yorùbá a memorial held in remembrance of the deceased). They are individually represented by secret objects and holes in the earth into which blood sacrifices, bits of food, and palm oil are placed to activate and honor them. *Egún* are also represented by thinly carved wood branches known as *ixan*. *Ixan* are cared for and most frequently wielded by priests belonging to the lower grade (*amuixan*) who accompany the cloth incarnation of the ancestor. They use the branches to demarcate the *egún*'s sacred space and prevent his garments from touching the living.

The ritual head of the society is the *alagba*, the organizer and leader of the private and public *egún* rituals and ceremonies. The political head, the *alapini*, is often a titular, symbolic leader. (In West Africa, an *alagba* heads local ancestor societies or organizations, while an *alapini* heads the intercity or intervillage ones.) Currently, the *alapini* on Itaparica Island is Domingo dos Santos—affectionately known as Seu Domingo—a direct descendent of Daniel de Paula (plate 27).

Next in the hierarchy are the *oje*, male priests responsible for invoking the *egún* in the *ìgbàlẹ̀*. *Oje* may also wield the *ixan* during ceremonies (plate 28), but they do so only after passing the lower *amuixan* initiation level. Men do not usually attain this important post until they reach their late forties or early fifties. An *oje* who is responsible for one or more *axô egún* is known as a caretaker (*zelador* or *atoke*). *Axô egún* normally belong to the family of the *zelador* responsible for calling the ancestor or ancestors to dance in the appropriate vesture. These ensembles conform in height to the deceased man they symbolize (plate 29). They are stored in a tiny, windowless room usually isolated from, but sometimes adjoining, the family *orixá* shrine. By draping them over a small platform fixed without wrinkling, *axô egún* are kept in good repair and are replaced by the community whenever the *egún* makes such a request during the public ceremonies. All vestments and implements used in the *egun* society must be made in seclusion by ritually prepared egun priests, *ojes*, and according to ideology no women may touch the items.

Two broad categories of ancestral spirits can be distinguished on the bases of seniority, ritual preparation, and power: *egún aparaaká* (fig. 5.2) and *egún agba* (plate 30) (1982, July 23, 1998, personal communication, Seu Domingo, Itaparica). Each is associated with a specific type of cloth ensemble (Jan. 1982, personal communication, Seu Domingo). *Aparaaká* (also referred to as *alaaporiyo* by dos Santos 1981, 182) are newly deceased spirits who for various reasons have been unsuccessful in achieving the status of *egún agba*. These newly deceased spirits can neither see nor speak. Cloth ensembles for *aparaaká* are generally flat and rectangular, with a wooden bar supporting the upper edge of the costume. The bar remains rigid when the spirit dances in movements consisting primarily of bending from side to side and gliding back and forth with arms outstretched. Made of white (for the most recently deceased), dark green, dark blue, or black cotton, the *aparaaká*'s simplicity of form and absence of embellishment reflect its lower status. *Egún aparaaká* are greatly feared because as unprepared souls they are generally violent or malicious. On the other hand, the senior ancestors—*egún agba*—are stable, controlled, and beneficent when properly and consistently respected. Their material manifestations—elaborate cloth constructions—make a great visual impact.

The *axé* of the ancestors is housed in the *ilê awo* (house of secrets) in the area of the *barracão egún* (public dance domain for the ancestors),

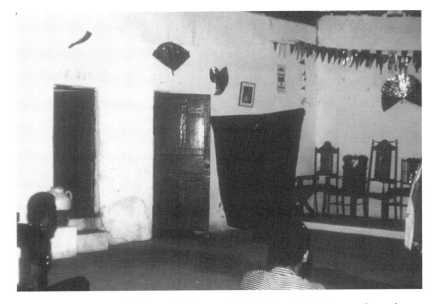

Fig. 5.2. *Egún aparaaka* (a newly deceased spirit signaled by its unadorned, rectangular black or blandly striped vestments). Ilê Agboulá, Itaparica, Bahia, Brazil, 1982. Photograph by author.

where only the *egún* and their priests can move about. This building has a floor of beaten earth in order to facilitate direct contact with the sacred energy of the earth deity—Onílè—and with the force of the ancestors, who are believed to issue forth from the earth. The structure divides the areas where the symbols and *axé* of the *egún agba* are venerated from the antechamber where the priests conduct the majority of the private rituals of their association.

The *barracão*, where the principal part of the public ceremonies takes place, is the largest area in a *terreiro de egún*. It is divided into two main areas (fig. 5.3). The most interior section is also the most sacred zone, where the ancestors dance and often remain for long periods during the nightlong ceremonies. Only the *ojes* are allowed to move in and out of this sacred space and even then only when they are participating in a religious activity. During a public festival, one of the family members of an ancestor may be called by the *egún* to enter briefly into this

space for a specific reason. During that time, an *oje* must accompany the individual. The remainder of the inside of the *barracão* is reserved for spectators' use and is separated by gender—men must remain on the right side, while women remain on the left. This separation of gender within sacred space is especially marked during festivals because it is important to separate the world of the living from the world of the dead.

In addition to functioning as the most important channel through which the essential link with powerful ancestors is maintained, public *egún* festivals are entertaining events that provide abundant occasions for the exchange of news and gossip and the renewal of family and social contacts. Men sit on the wooden benches arranged in rows on the right side of the public entrance to the *barracão*. The women and children sit or lie on straw mats on the left side. During intermission, this rigid spatial separation is dissolved, and men and women share strong, sweet coffee and food while exchanging news and critiquing and discussing the beauty of the *egúns* and the festival.

The literature and African Brazilian religious ideology notwithstanding, my observance of and participation in many festivals indicate that there is at least a visual and symbolic link between the *egún* and the *orixá* of the deceased male ancestor immortalized by the *egún*.[3] The connection is most apparent in the *axô egún* (1982, personal communication, Seu Domingo, Itaparica), as they represent powerful men of important families—*egún* priests, who are specially prepared for incarnation. The *axô egún* immortalize the *egún agba* through elaborate, brightly colored multimedia creations of expensive materials such as beads, fringe, mirrors, and cowrie shells. The cloth panels that hang from the square or rounded *ori* ("head" in Yorùbá) of the *axô egún* are often referred to as *abala*. Under the *abala* is a cloth tunic lined with fine cotton that has appendages for covering the arms. The *egún* sees and speaks through the *imbe*, a small rectangular piece of netting covered with bead fringe. In plate 31, which illustrates Baba Xango (*bàbá*, Yorùbá for *father*, is frequently used to address *egún*), a face panel (*oju*) of red velvet trimmed at the chin with brass bells appears immediately below the netting. Three round mirrors are attached in the positions of eyes and mouth, and the panel seems to represent the face of the deceased ancestor. Just below is the *bante*, a long apron that serves to identify the individual *egún*. Imbued with sacred ingredients, ritual herbs, and leaves, the *bante* is thought to contain his *axé*. (The *bante* must undergo a ritual to neutralize its force if it leaves the sacred confines of Terreiro Ilê Agboulá.)

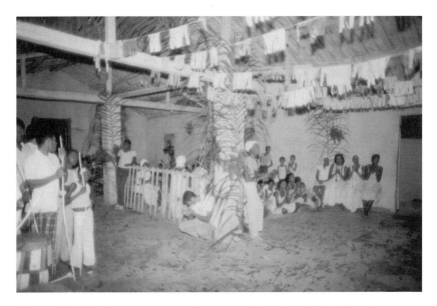

Fig. 5.3. Division between men and women during the festivals for the ancestors—women on the left and spiritual side. Ilê Agboulá, Itaparica, Bahia, Brazil, 1982. Photograph by author.

Each *bante* is distinguished by a unique configuration of symbols composed of beads, cowries, or mirrors. Since the *bante* I observed were completely different for each *egún*, it is my impression that they serve as its personal signature (as an individual's *odù* is a metaphor for his or her signature/personality). For example, in plate 30, the arrangement of cowries (belonging to the founding line of Ilê Agboulá and once used in *egún* rituals) suggests a skeletal structure and may, along with the face, function as a portrait of the ancestor to whom this masquerade refers. Most Bahians strongly believe there is only empty space beneath the vesture and that only the force of the ancestor activates the *axô egún*.

Each *egún agba* also has its own special manner of speaking, voice type, music, songs, mode of dancing, and Yorùbá society name. The *egún* manner of dancing involves much whirling and twirling, movements that emphasize the flash and brilliance of mirrors and metallic cloth. These descriptors, combined with the *bante*, identify the ancestors to

the spectators. Up to ten different *egún* may dance in one night during a weeklong festival, and these are enthusiastically critiqued and discussed by the spectators. All the costumes I observed (about forty) used velvet for the main panels and the crown. Velvet in Bahia is extremely expensive and prestigious and therefore is the preferred textile. Brightly colored cotton and synthetic brocade panels with strong floral designs complete the costume. A family combines its resources to provide the most beautiful ensemble possible. *Axôs* Egun are renewed or cleaned when requested by the *egún*. At an annual ceremony at Ilê Oya Ponda (Nov. 2, 1981), one *egún* berated his descendants for not replacing his tattered *axô* with a new, better-fitting one. One also asked me to pay for the dry cleaning of his cloth ensemble, which I did. At the end of the annual festival for Baba Agboulá, held September 7 and 8, 1998, I was asked to help purchase a new *asô* for another elder *egún*.

Although the Yorùbá concern for beautiful status-laden materials has been noted for Nigeria (Wolff 1982, 66; Borgatti 1983, 32), I found nothing to indicate that the Bahian community attached group prestige to individual family *egún* mixed media crreations. Instead, individual significance and prestige were based on the total aesthetic effect of the ensemble or *axô*. The degree of intricacy and skill of the dance steps were an indispensable part of the total evaluation.

At some point in the ceremony all *agba egún* carry a fly whisk (*erukere;* fig. 5.4), symbolizing supernatural and ancestral power. The *erukere* is treated with a ritual herbal liquid and made of horse or bull hairs attached to a hollow carved wooden handle usually containing ground bones of sacrificed animals, medicinal leaves, and other ingredients containing *axé*. *Egun* priests believe the *erukere* controls spirits in the forest and in heaven. In the same manner that the *xaxara* of Omolu/Obaluaiye represents earth and tree spirits, the fly whisk represents spirits of animals and ancestors.

The *erukere* is an important emblem of Yansan (the *orixá* of tempests and favorite wife of Xango) and may signify a covert female aspect of the overtly male *egún*. An *erindinlogun* verse cited by Guilhermino (1989, 22) explains how Oya became known as Iyansan ("mother of nine children"; in Yorùbá *iyá* means mother, and *mesan* is the number nine). This praise name of Oya has become the *orixá*'s dominant name in Bahia, where she is commonly called Yansan or Iyansan. In her aspect as Yansan 'Bale or the quality who deals mostly with rituals associated with death and egún ("mother of the nine children" of the collective

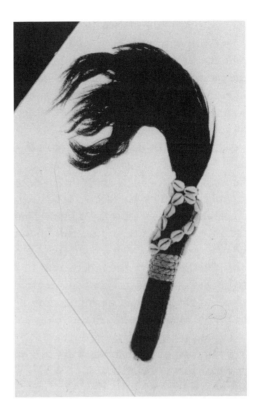

Fig. 5.4. *Erukere* used by the *egún agba*, symbol of Yansan, mythical mother of Egun. Collection of the Fowler Museum of Cultural History, University of California, Los Angeles.

egún shrine), she is the only female *orixá* allowed to enter the sacred male precinct of the *'bale*. This privilege is attributed to Yansan's status in Bahia as the actual mother of Egún. She is colloquially known as the "queen of the cemetery":

> Oya was the wife of Ogun and was not able to have any children. . . . [S]he consulted a Babalawo who revealed that she could only have children by a man who possessed her violently. And it was thus that Ṣango took her. Oya had nine children by him. The first eight were born mute. Once again Oya went to consult the Babalawo who told her of Igúngún or Egún, who was not mute, but could only speak with an inhuman voice (dos Santos 1981, 121).

According to one informant, the *erukere* held in the right hand sym-
bolizes the relationship of Egún with Yansan 'Bale (Oje Oluide, Feb.
1981, 1982, 1998, personal communication, Seu Domingo, Itaparica). In
the sacred dance of Yansan 'Bale, the *orixá* uses two *erukere,* one held
in each hand, and waves them in sweeping semicircular motions, her
widespread arms slightly above waist level. This motion is believed to
dispel souls and negative forces.

Like the *egún agba, orixás* are identified by costume color, hand-
held ritual implements, music, dance steps, voice, and greetings. In plate
16, for example, which illustrates incarnated *orixás* at an *ilê axé* during
a public ceremony based on Yorùbá religious practices, Xango can be
recognized in two aspects. Xango Alafin (second crowned *orixá* from
the left side), the god in his youthful manifestation as the king of Old
Òyó, is symbolized by the colors red (or rose) and white, a bifurcated ax
blade, and a gold-colored metal crown. Xango Airá (to Xango Alafin's
right) is the elder manifestation, identified by an all white costume and
silver-colored crown. The connections between gods and ancestors can
be most clearly discerned in the colors and ritual instruments associated
with their incarnations.

In each of the many *axô egún* I observed, the beaded fringed veil
was in colors associated with a specific *orixá.* (In my interviews it was
always the *orixá* who was the *eleda,* "master of the head" of the deceased.)
In addition, the dominant colors of each costume closely corresponded
to those of a particular *orixá.* For example, as discussed in chapter 4,
the *axô orixá* Yemanjá displays the color blue associated with the *orixá*
Yemanjá (plate 23). (Blue and white are also worn by the deity's devotees
and priests in both Nigeria and Bahia.) (fig. 5.5) The *axô egún* possesses a
ritual name as well, Amoromitodo, which in the *egún* and the *orixá* soci-
eties refers to Yemanjá. The ensemble was made by an *egún* priest based
on my drawing of an *egún* Yemanjá I saw dancing in the 1982 Presentes
de Yemanja, an annual public festival during which gifts to the deity
are presented in the water. Each *egún* holds a liturgical instrument that
symbolizes a certain link with the honored *orixá:* as noted, in the case
of Bàbá Yemanjá, a fan is usually carried in the right hand while danc-
ing. The beaded fringed veil refers to two aspects of the deity: Yemanjá
Asaba, characterized by crystal clear beads, and Iya Tanan, characterized
by translucent green beads. Furthermore, although the *egún* have their
own dance style, music, greetings, words of praise, and other characteris-
tic ritual behavior associated with *orixás* are frequently used for *egún.* For

example, I heard "odo iya" ("mother of the river") used as a greeting for the manifested *egún* Yemanjá in *candomblé* Nagô Egun. When I asked a participant which *orixá* was the "owner" or master of the head of Baba Amoromitodo. I was told it was Yemanjá (*filha-de-Ogun*, 1982, personal communication). Etymological analysis of the word *amoromitodo* also suggests evidence of a connection to Yemanjá, though the meaning of the whole has been forgotten. *Omi* means *water* in Yorùbá, and the initiate names of the Yemọjá society devotees begin with or incorporate this word. *Odo* means *river,* the home of Yemanjá. In Nigeria I frequently heard the words *àwòyó* (and *amoro* in praise of Yemọjá; Ìyá Oni Yemọjá, Omileye, 1983, personal communication, Ibara district, Abeokuta), but I have not been able to find out what they mean.[4]

Once one realizes that almost every *oje* is also a member of the *orixá* society, the hypothesis of a visual and spiritual link between the gods and the ancestors is not surprising. According to the *alagba egún* of Ilê Agboulá (now Alapini) and his brother, an *oje*, one must be initiated into *candomblé* Nagô *orixá* before one can be initiated into *candomblé* Nagô Egún (1982, personal communication, Seu Domingo and Flaviano dos Santos, Itaparica).[5] The close relationship that an individual priest had with his personal *orixá* would not be severed by death but would be immortalized through his *axô egún* and aspects of ritual, including dance, praise names, and songs. A critical examination of actual practice clearly dispels the articulated ideology asserting a complete separation between the gods and ancestors in the African Bahian society of the dead.

The Role of Women in the *Egún* Association, Ilê Agboulá

Although African Bahians frequently emphasize that women have no place in the *egún* society, as in Africa the importance of the feminine energy is clearly demonstrated through myths associated with the society. One example is a story taken from a divination verse known as *odù-eji-ologbun,* well known in Ilê Axé Opô Afonjá and Ilê Agboulá:

> In the beginning of the world, the woman intimidated the man and manipulated him with her little finger. This is why Oya [more commonly known in the Afro-Brazilian religious societies by the name of Yansan] was the first to invent the secret or the masonry of the *egúngun* in all its aspects. In this manner, when women wanted to humiliate their husbands, they organized a meeting in a crossroad under the direction of Yansan. She was already there with a huge monkey that she

had tamed and prepared with appropriate clothing at the foot of a tree so that he would do whatever Yansan decided by means of a switch [or branch] which she secured in her hand with the name of *işan* [*ixan*]. After a special ceremony, the monkey appeared and fulfilled his role according to Yansan's orders. This took place in front of the men, who fled, terrorized because of this apparition. Finally, one day, the men decided to take measures in order to terminate the shame with which they continually lived under the dominion of women. They then decided to go to Orunmila [the *orixá* of the Ifá oracle] in order to consult Ifá so they could know what they could do to remedy such a situation.

After they had consulted the oracle, Orunmila explained to them everything that had been happening and what they should do. As a result, he ordered Ogun to make an offering of roosters, clothing, a sword, and a used hat in the crossroads at the foot of the specified tree before the women had their meeting again. Said and done, Ogun arrived quite early at the crossroad and fulfilled orders. Afterward, he put on the clothing and hat and secured the sword in his hand. Much later, during the day, when the women arrived and began to meet in order to celebrate their habitual rituals, a terrifying form suddenly appeared. The apparition was so terrible that the most important of the women, that is, the one who was in front, Yansan, was the first to run away. Thanks to the force and the power she possessed, she disappeared forever from the face of the earth. In this manner, since that era, the men dominated the women, and they are the absolute owners of the cult. They prohibited and will always prohibit women from penetrating the secret of every society of the masonic type. (dos Santos 1976, 122–23)

Although women are forbidden to know the "deep" secrets of the *egún* society, their participation is important and even indispensable. Each *egún* ceremony I attended over a period of two years began with the singing and dancing of wives and female relatives of Ilê Agboulá members. The women first performed a *pade* (ritual offering of *cachaça*, manioc meal, and palm oil for Exu) so that the ceremony would run without mishap. The *pade* was followed by a small *xire* (summoning of the *orixá* in hierarchical order, similar to *candomblé* Nagô practice), and each *orixá* was honored by three songs. Only then could the ancestors be summoned and sung for. Chants for *egún* are generally led by and responses sung by women (although men join in); chants are enthusiastically and loudly accompanied by vigorous hand-clapping. The lively participation of the women is important for the *egúns'* pleasure, and it is strongly believed that the *egún* provide spiritual blessings and benefits when they are content. I have witnessed many admonitions and complaints by the ancestors when the zeal of the women's performance

lessened five or six hours into the ceremonies, which begin at 10 P.M. and last until dawn. Women are also responsible for cooking the solidified corn gruel (*acaçá*), abara, and other ritual foods preferred by the *egún*. Offerings of flowers, money, wine, palm oil, kola nuts, and bitter kola nuts are arranged by the women in a little room to the left of the main dancing area in the *barracão* and are delivered to the *amuixan* along with written requests (*pedidos*) sent by devotees. These in turn are delivered to the *oje*—the only men allowed to confront the *egún* in the *'balę*. When the *egún* come in to dance and communicate with the living, they usually summon women to the sacred dancing space first, in hierarchical order, according to the status conferred by their duties. The *egún* show personal concern for the welfare of the devotees, inquiring after family members and offering advice and solutions to problems.

The two most important titles for females in the *egún* society in Bahia are *iyá egbę* (mother or leader of the female society; fig. 5.5), and *iyá monde* (translation unknown). The *iyá egbę* is in charge of all the female society officials and is responsible for delegating duties and responsibilities to other women. She is the first woman who receives any information or requests relative to the sect, and her major role is to fulfill the desires of the *egún* as indicated through divination. (This is usually in the nature of preparing cooked sacrifices.) The *iyá egbę* is the first woman to be greeted by the *egún* during the public ceremonies by virtue of her status and her age (which is usually considerable). The *iyá monde* has charge of all female devotees and serves as an intermediary between these women and the *egún*. The *iya monde* transmits requests, messages, thanks, and prayers to the *egún* from the female community. She also usually leads the ritual songs sung by the women for the *egún* (1982, personal communication, Seu Domingo, Itaparica).

Àxèxè, Funeral for Deceased *Adoxu:* Art and Ritual

Female ancestors are not immortalized by cloth masquerades in the same way the ancestors of males are immortalized in the *egún* association. However, ancestors of females and male *olorixás* are represented and worshiped collectively. The *egún* of *adoxu* (initiates in *candomblé*) are localized in pots or holes in the ground after proper ritual preparation. These ancestral shrines are maintained in a special windowless structure known as the house of the dead (*ilê saim* or *ilê ibo aku*). There is such a structure on the grounds of every *candomblé* Nagô *terreiro*, placed well away from personal houses and other shrines, designated for the conse-

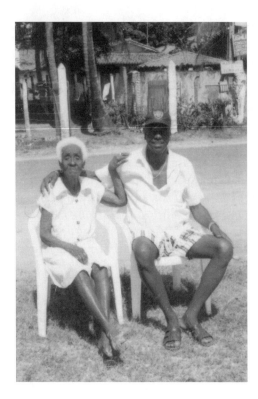

Fig. 5.5. *Ìyá ẹgbẹ egún,* head of the women officials of the *egún* society, with male head *alapini egún,* Seu Domingo. Ilê Agboulá, Itaparica, Bahia, Brazil, 1998. Photograph by author.

crated symbols and liturgical paraphernalia of the *orixás.* This physical separation may have fostered the ideology of distinct compartmentalization of *egún* and *orixá.* The house of the dead is usually painted white and has a large wooden cross stuck into the earth in front of it. It is one of the sacred places visited and saluted during any public festival for the *orixá* involving processions leading out of the *barracão* and around the grounds of the *terreiro.* The *ilê saim* consists of two connecting rooms. On the walls of the first room are photographs of deceased female members of the *candomblé* who were ritual leaders or who had distinguished themselves in some way during their lifetimes. In the inner room, at a distance from the only entrance, are clay pots covered with white cloth containing symbols of the deceased. Offerings of *acaçá,* palm oil, and popcorn are placed on the floor. According to dos Santos (1976, 104–5),

collective altars known as *ojubọ* consist of a round sticky mass of material placed in a large dried gourd shell (*cabaça*). The *cabaça* is a symbolic replacement for a human body (Pai Crispim, Nov. 1982, personal communication, Salvador). There is a separate *ojubo* for the collective ancestors of male and female *adoxu*.

In order to reestablish equilibrium after the death of an initiate, it is necessary to perform a seven-day funeral ceremony following the actual physical burial. The object of this ceremony (*àxèxè*) is to dispatch the soul of the deceased and receive instructions regarding the proper disposal of the ritual objects and apparel belonging to the initiate. *Candomblé* dress of white muslin (*roupa de ração*) is worn throughout the ceremony. It may be used only for funerary purposes and cannot ever be combined with any other costume (fig. 5.6). It is kept in a designated location and is always washed separately. The costume elements are combined in ways to symbolically distinguish communications addressed to the *egún* of the deceased *adoxu* from those directed to the *orixá*. The *pano da costa*, normally worn around the torso and secured under the arms in ceremonies for the *orixá*, is always worn around the shoulders, covering them completely whenever the soul of the deceased or any other *egún* is confronted. This ritual uniform is completed by the protective braided strands of raffia palm known as *contra-egún*, worn on the upper portion of each arm.[6] On the last night of the *àxèxè*, fresh raffia strands are placed on the wrists for added protection during the part of the ceremony held near the *ilê saim*. A cross is drawn on the forehead, hands, and feet with white chalk (*efun*) imported from Nigeria. The total costume functions as a protective covering (*fechamento*), sealing the body from the negative influences of the deceased that are freely moving about. Before dressing for the ceremony, all participants are required to take a ritual herb bath, completing the protection of the body against destructive forces. The bath contains herbs and leaves of potent *orixás* such as Yansan—the mother of Egun and the only *orixá* who can confront death (*ikú*)—or Omolu, who is also linked with death.

Nina Rodrigues provides the earliest published description of the *àxèxè* ritual:

> There does not exist in this city a person who has not encountered one of these enormous groups of African Negroes who, along with their descendants and friends, are coming out of a church where they have ordered a mass to be prayed for their deceased. The group is so special

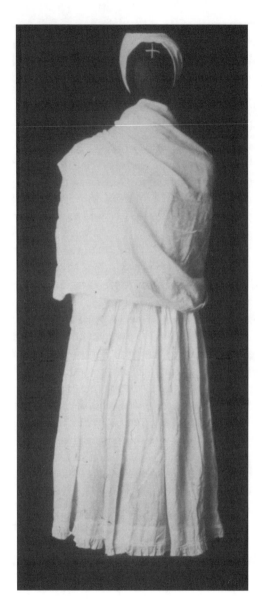

Fig. 5.6. Ritual candomblé dress of white muslin (*roupa de ração*) worn throughout the *axexe* ceremony. This clothing may be used only for funerary rituals and is never combined with any other costume. It is washed and stored separately from other ritual clothing. 1984. Photograph by Richard Todd.

that it forcibly arrests one's attention. From here, they immediately proceed to a funerary *candomblé*, the importance of which depends on the economic resources of the family. The *candomblé* lasts one or two days; they dance in it and make sacrifices to the soul of the deceased and to the *orixás*. It is frequently on this occasion that the destiny of the *orixás* and the ritual objects and apparel of the deceased is given. One *pai de terreiro* [head priest] of a famous temple, knowing himself to be without descendants, had requested that after his death part of the ornaments of his shrine should be exposed on a sacred tree in the neighborhood and the other part, together with his *orixá*, should be thrown into a nearby river. After a great funerary *candomblé*, late in the night, his disciples, or daughters in saint [*filhas-de-santo*], went to fulfill his last request. But, [since] the tide was still high, it was lucky that the pieces were thrown on the beach and remained uncovered in the damp sand in the morning. A friend of mine ordered them collected, and having washed some of them, sent them to me. I offered them to the museum of the faculty of Legal Medicine, where they are to be currently found. ([1895] 1935, 155)

The ritual currently lasts from three to seven days, depending on the status of the deceased individual. In July 1982 I participated in a ceremony that lasted seven days. It was performed for an *ẹbomin* of the *orixá* Ogun (*filha-de-Ogun*) who had been initiated in Bahia at Afonjá but had resided in Rio de Janeiro for some twenty years before her death.

The ceremony took place in the anteroom (*sala*) of the Casa de Oxalá. During certain portions of the ceremony all the windows as well as the door (which were lined with fresh raffia palm fronds [*mariwo*]) remained closed. The ceremony began after sunset with a *pade* Exu performed by an *ẹbomin* of Omolu/Obaluaiye. All persons attending the first night of the *àxèxè* must attend the remaining nights or the *axé* of the ritual will be broken. For this reason, many initiates do not attend the first night, preferring the fifth, sixth, or seventh, which include the most important and elaborate portions of the ceremony. The flexibility suggests that the situation may yield to expediency.

A candle and a large empty calabash representing the deceased were placed in the center of the room along with a container of water, a container of *cachaça*, and a dish of manioc flour (*farinha*). The candle was lit, and a bit of water from the bottle was poured onto the floor by a male initiate (usually an *oje* from Ilê Agboulá Egún society). The *oje* touched each small pool of water with the index and middle finger of his right hand and tapped them on top of the left hand, which he had formed

into a fist. Then the *iyalorixá* prostrated herself before the open door—saluting the spirit of the deceased—passed two coins (*moeda*) over her body, and danced three times counterclockwise around the candle and the calabash. Each initiate (nearly all were *ebomin*) followed the same procedure in hierarchical order. During this time, songs relating to death and to the safe departure of the soul were sung. Afterward, all the objects on the floor were taken to the house of the dead. Participants removed the *pano de costa* from their shoulders and wrapped it around their torsos, a gesture signifying the end of the portion of the ceremony dealing with the spirits of the dead and the commencement of the portion dealing with the *orixá*, who were greeted, praised, and sung for, with special songs being sung for the deceased *Orixá*. The focus of the ceremony then returned to the deceased, signified by taking the *pano da costa* from the torso and once more placing it upon the shoulders. Again, dances and chants for the deceased were performed. This ceremony lasted six hours, though it can be as short as four hours or it can last the entire night. The total process described above was repeated throughout the first five consecutive nights.

On the sixth night, cooked food, kola nut, and live chickens were placed on the floor along with the calabash and lighted candles. This night, several *oje* from Ilê Agboulá were also in attendance. After performing the ritual of the first five days, a possessed initiate of the *orixá* Yansan 'Bale seized the calabash and rushed out of the Casa de Oxalá up the incline to the house of the dead (*ilê saim*). The *oje* each took one or more of the chickens and the food and followed the *orixá*. The remaining initiates and relatives of the deceased tied fresh strands of raffia palm around their wrists. Everyone filed out and took a position near the *ilê saim*. They then sang, paying homage to the deceased and to her *orixá* Ogun. Meanwhile, the *oje* were invoking one of the *egún* from Ilê Agboulá, who later danced. The spirit of the deceased also manifested in the form of a long white rectangular cloth masquerade in the style of *aparaaká* that is reserved for brief representations of the deceased during *àxèxè* rituals. The spirit of the deceased spoke in a high-pitched voice and danced behind the white cross in front of the house of the dead, subsequently communicating to the *oje* regarding the disposition of her ritual paraphernalia. The *axé*, which had been removed from her head shortly after death and wrapped in cloth, was placed next to her. Ritual objects were wrapped in a package (*erù*) and disposed of in the

forest by the *oje*. Afterward, everyone returned to the Casa de Oxalá and completed the songs to dispatch the soul of the deceased.

On the seventh day, at 8:00 in the morning, the *axexe* participants dressed in white Western-style clothing and attended a mass for the deceased in a small church in Barroquinha. In the afternoon the group returned to the *terreiro,* changed back into the ritual dress, and began the *pade.* The chants for the spiritual incorporation of the deceased into the collective shared force of the *terreiro* ancestors (*asa*) were completed. Finally, a communal meal was shared in the Casa de Oxalá, and the anteroom was swept and washed with water as an act of purification.

The *àxèxè* ritual marks the spiritual death and funeral that takes place after the physical death and burial of the *adoxu.* The white ritual costume worn for the *àxèxè* simultaneously protects the body and functions as a visual symbol of the ritual, clearly separating it from other *candomblé* ceremonies. The protection of the body against hostile souls and negative spirits is begún by the herb bath and completed by the garments and *contra-egún.* The color white signifies the link with the creator god Oxalá, who is responsible for creating a new human being during initiation. Oxalá must therefore be symbolically present after death at the burial, a presence expressed by the semiotics of the *àxèxè* ensemble.

In sum, rituals and art forms associated with death in *candomblé* Nagô are broadly divided into male and female categories. A further distinction may be made between the existence of stable, organized, predominantly male associations concerned with propitiating and interacting with the *egún* on a daily basis, and an infrequent ritual ceremony performed after the death of an *orixá* initiate. The art forms functioning in African Bahian rituals for death reflect the contrast between the stable *egún* society and the occasional *axexe* ritual. Material manifestations of the *egún* are elaborately embellished (or not), according to the rank and the *orixá* of the deceased. The *egún agba* ensembles are made of luxurious materials combined to reflect the individuality of each ancestor. Newly deceased spirits of lower status are restricted to simple, unembellished styles.

Àxèxè rituals primarily involve females, but deceased male *olorixás* also are honored by *àxèxè.* The ritual costume is white and symbolizes the association of the ritual with Oxalá (Obatala). One element of the *àxèxè* costume (the *pano da costa*) signals changes in the ritual: worn on the shoulders (fig. 5.6), it completes the *fechamento*—the ritual closing

of the body necessary for protection against death; worn on the torso, it reflects involvement with the gods. The art forms involved in the death rituals discussed abtove combine with liturgical vestments and implements of the *orixá* to complete an artistic and symbolic system of the microcosm of *candomblé* Nagô.

 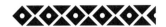

Contest of Cultures
Imagery and Rituals for Twins in Bahia

The veneration of twin births in Brazil is a choice example of Geertz's theory that "social interchanges among peoples . . . lead to interchanges of values and behaviors" (1960, 355; in Barnes 1989) and illuminates the far-reaching, transclass, ritual and artistic impact of the Yorùbás on mainstream Brazilian society.

Beje are conjoined with the extremely popular Catholic "twin" saints Cosme/Cosmas and Damião/Damian or Crispim and Crispiniano, originally brought to Brazil by Portuguese Roman Catholic missionaries during the colonial era. In Brazil, the Catholic ritual and imagery associated with these saints (fig. 6.1) were gradually transformed by traditional Yorùbá religious ritual and sculpture (plate 32) associated with the deity of twin births, Ìbejì.[1] As a direct result of intensive cross-cultural contact, the visual imagery associated with Cosmas and Damião in Europe evolved from representations of adult to late adolescent men to young boys (plate 33). They became affectionately known as "the little boys" (*os meninos*) and served as the focus of a ubiquitous domestic feast. Moreover, in place of the Catholic High Mass commemorating their holy days in Europe, popular Brazilian culture has implemented the Caruru, a party that takes its name from the salient African-derived delicacy served there. The Brazilian *caruru* is made of very finely chopped okra, shrimp, palm oil, onion, and other spices. It is habitually served with black-eyed peas cooked with palm oil, sugar cane, and banana and

with other foods specially linked with Yorùbá rituals for the *òrìṣà* Ìbejì and for special births in general.

The homage to Cosme/Cosmas and Damião/Damian in Bahia simultaneously continues according to the basic European Roman Catholic tradition. There is a special church dedicated to these saints in the neighborhood (*bairro*) of Liberdade, where they are depicted as adult men. The entire month of September is dedicated to Cosme/Cosmas and Damião/Damian, beginning with special daily novenas and culminating with a mass and a procession of their images on September 27, their holy day. The images in this church and procession are of adult men, as in Europe. Only in the popular realm can we distinctly perceive the influence of traditional Yorùbá religion.

I would argue that a process I call the "Yorùbánization" of the Brazilian Roman Catholic celebration, hagiography, and iconography associated with Cosme/Cosmas and Damião/Damian occurred as a result of the *Ìbejì* ritual and imagery brought by enslaved Yorùbás to Brazil. One arena in which such a cultural exchange could easily have taken place is the domestic environment, in which those who could afford it employed African nannies, or *babas,* to rear their children (this continues today). Undoubtedly, these African women socialized their young charges in the Yorùbá belief system and etiquette.

Ìbejì in Ketu, Republic of Benin

Ketu is an ancient Yorùbá kingdom claiming a direct link with Ilé-Ifè, the spiritual center of all Yorùbá-speaking peoples.[2] According to the Ketu king lists cited to me by Kabiyesi Oba Adetutu, the then *alaketu* (King) of Ketu, the kingdom was founded in about 1405 A.D. by the first son of Oduduwa (1981, personal communication, Ketu, Benin). Originally, Ketu was part of a single culture area with all the other Yorùbá kingdoms. Between 1895–1906, Ketu was divided in half between Nigeria and Dahomey by French and British colonials (Asiwaju 1976, 9). The town of Ketu is about sixty miles west of Abeokuta, Nigeria, and sixty miles north of Porto-Novo, Benin. Because of its isolation, Ketu has escaped much of the modernization and Westernization that characterizes Nigeria; a significant portion of the traditional Yorùbá religion (*isin òrìṣà*) and associated art production remains intact. I found many parallels in esoteric ritual and art between Ketu and the Quetu sects of the Bahian *candomblé* during several short visits and two extended stays between 1981 and 2001.

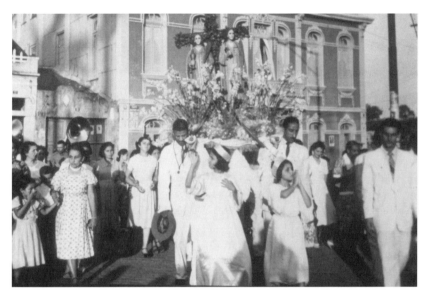

Fig. 6.1. Catholic procession for Cosme and Damião, Salvador, Bahia, Brazil. Date unknown.

In Ketu all twins are regarded as gifts from Olodumare (God). Their veneration transcends social, religious, and age boundaries. Muslims and Christians as well as traditional religionists honor living *ìbejì* with miniature pots for each twin (fig. 6.2). These pots are known as *kolo-kolo* in Ketu and *kologbo* in Nigeria. In Brazil *kologbo* is also associated with *ìbejì* pots (1982, personal communication, Seu Vicentio, Salvador).

Homage is universally paid among the Yorùbá to deceased *ìbejì* by small wooden ritual sculptures called *ère ìbejì*, which function as conventionalized portraits and surrogates for the deceased twin (fig. 6.3). In Ketu *èla ìbejì* is the name most commonly given to these figures carved from the sacred Ire tree, which is ritually linked to twins (Ètu Òbe [Cool Knife] 1981, personal communication, Ketu, Benin). The word *ela* means one half or part of something regarded as a unit or inseparable whole (Tayewo Olofeyin, Ijabo, 1981, personal communication, Ketu, Benin).

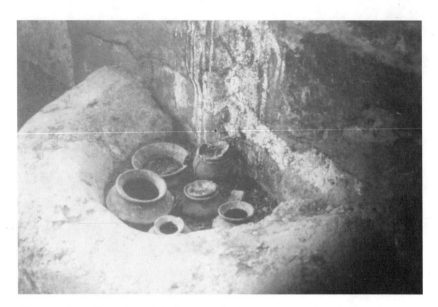

Fig. 6.2. Altar for twins with clay pots for living twins and sculptures for deceased twins. Ketu, People's Republic of Benin, 1983. Photograph by author

In Ketu, as in other parts of Yorùbá country, *ìbejì* are the objects of special and sustained ritual attention from birth. According to Baba Ẹjire, who is a twin, father of twins, and head of Idena district: "Immediately [after] the *ìbejì* are born . . . some of the soil will be taken up . . . and be used to make *ojúìbejì* [the shrine for twins]. . . . You must take some of the bedding or soil stained with the birth blood because of the children's *iwaye*, the star under which they were born" (1981, personal communication, Ketu, Benin).

Ifá divination is the next ritual to be performed at birth, or shortly after the twins' birth. It is the way to learn "to whom the *ìbejì* came." The individual to whom twins "come" must also always be a twin—although it is unimportant whether they are male or female. Usually a highly respected elderly person in the community receives this honor. Diverse appellations such as *atowa, oluwo ìbejì,* and *olu ìbejì* signify this special rank. The "owner" of the twins customarily performs the other rituals held for twins shortly after birth and supervises the construction

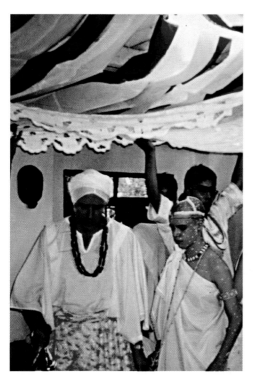

Plate 1. Initiate, Candomblé Casa das Aguas, Itapevi, São Paulo, Brazil. Photograph by Reginaldo Prandi.

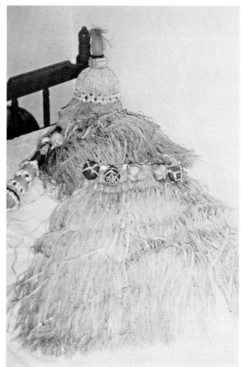

Plate 2. Ritual clothing for Cavungo, the Bantu *inquice* (deity) who is similar to the Yorùbá *orixá* Omolu. Bahia, Brazil, 1998. Photograph by Rogério Lima Vidal.

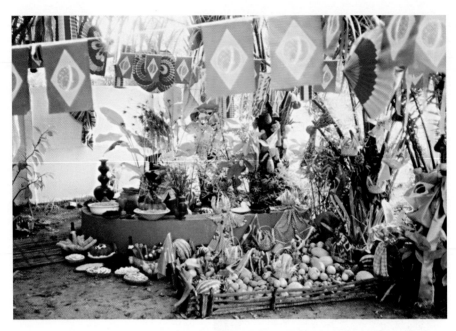

Plate 3. Active Caboclo shrine during a festival; Bantu Candomblé headed by Tata Lembaraji, Bahia, Brazil, 1998. Photograph by Laércio Sacramento.

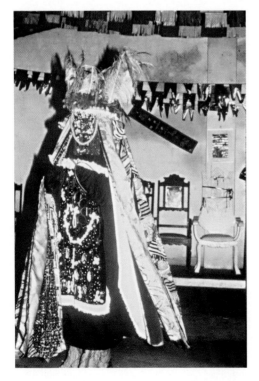

Plate 4. The *egún agba* called Baba Caboclo who incorporates and honors the collective ancestral energies of the indigenous Brazilian Indians. Baba Caboclo is identified by the feather headdress signifying "Indianness" and the yellow and green colors of the Brazilian national flag. Ilê Agboulá, Itaparica, Bahia, Brazil, 1988. Photograph by author.

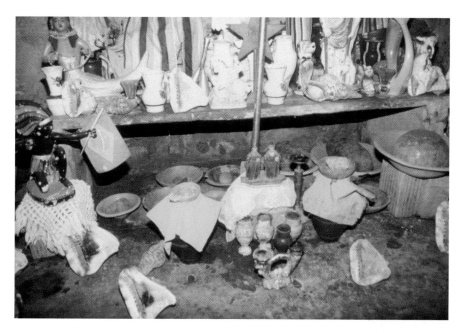

Plate 5. Pai Crispim's interior shrine room during nonfestival interval. Key objects and implements, such as conch shells, embody Yemanjá's *axé*. Ceramic, clay, and porcelain pots and dishes contain the stones and bits of iron, brass, or lead representing the natural essence of the *orixás* Ogum, Oxum, and Oxalá, respectively. Salvador, Bahia, Brazil, 1986. Photograph by author.

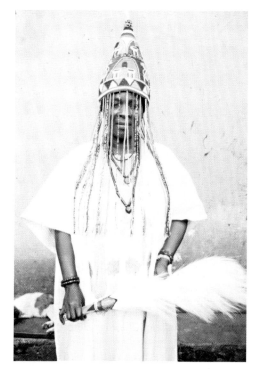

Plate 6. The female regent of Igbole dressed in official crown and male clothing for royal duties. Ekiti, Nigeria, 1991. Photograph by author.

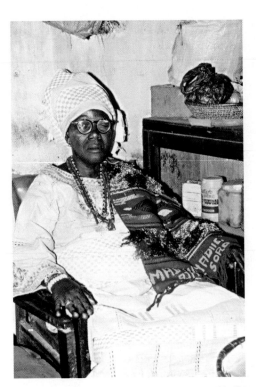

Plate 7. Chief Ajayesoro wearing Ògbóni cloth insignia on her shoulder. Ilé-Ifẹ̀, Nigeria, 1991. Photograph by author.

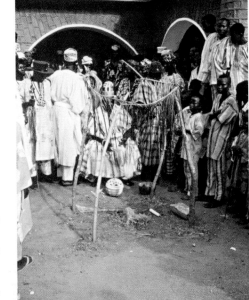

Plate 8. Ceremony for the current *araba* (king or head of Ifá priests), as part of a long series of installation rituals, invoking the male and female principles of the carved calabash, which signifies the Yorùbá universe. Ilé-Ifẹ̀, Nigeria, 1991. Photograph by author.

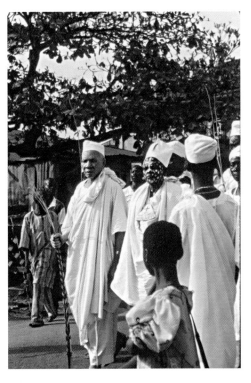

Plate 9. Obatala priest—albino people are sacred to the *òrìṣà* Ọbàtálá; Yẹyẹlòrìṣà, chief female priestess of the Obatala shrine and a medium for Obatala, Ilé-Ifẹ̀, Nigeria, 1991. Photograph by author.

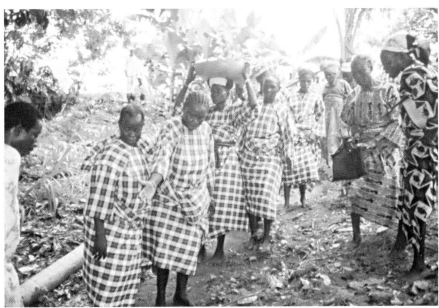

Plate 10. Procession by the *ẹgbẹ* Yemọjá (Yemọjá Society) to the sacred Ogun River—abode of the *òrìsà* Yemọjá, Ibara district, Abeokuta, Nigeria, May 23, 1983. Photograph by author.

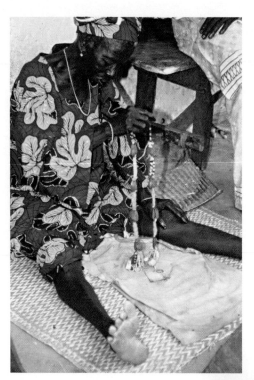

Plate 11. *Iyanifá* ʻFawenda Mọpelola, Ọ̀yọ́, Nigeria, 1991. Photograph by author.

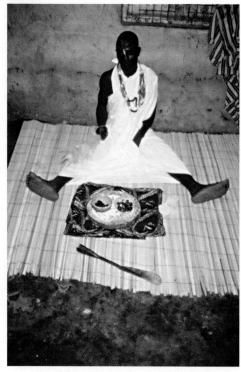

Plate 12. Male Ifá initiate with sixteen palm nuts in a calabash on a divining tray *(atẹ)*, Abeòkuta, Nigeria, 1991. Photograph by author.

Plate 13. *Roupa de axé. Camizu, saia, ojá,* and ritually prepared beads symbolizing the initiate's link with Yemǫjá. Photograph courtesy of the Fowler Museum of Cultural History, University of California, Los Angeles.

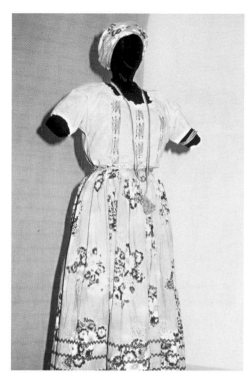

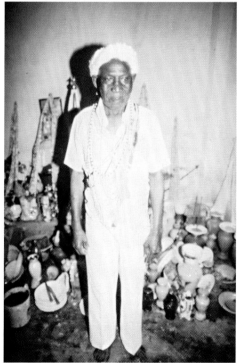

Plate 14. The late Pai Crispim, *babalorixá* of Ilê Axé Terreiro Omolu-Xapaná, Jardim do Lobato, Salvador, Bahia, Brazil, 1982. He is wearing the *sǫkoto* and *fila* worn by men. He is standing in his shrine *(ojúbǫ)*, which has been activated for ritual. Photograph by author.

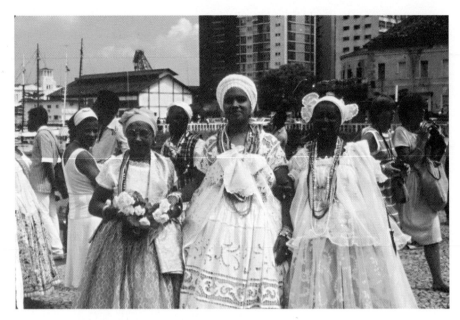

Plate 15. Elements of dress signifying different initiate status during the public phase of the Presentes de Yemanjá at the shores of the Atlantic Ocean, lower city (*cidade baixa*). This ritual is held after the ceremonial cycle for the female *orixás* by members and affiliates of Ilê Axé Opô Afonjá, São Gonçalo do Retiro, Salvador, Bahia, Brazil, 1982. A recent initiate *(iyawô)* is in the middle and an *iyalorixá* (Òsunlade from Brasilia) is to the right. Photograph by author.

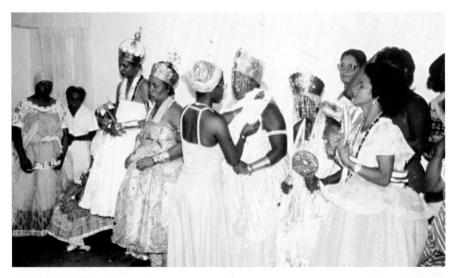

Plate 16. Line of *orixás* awaiting their turns to dance during the *xire* in the *barracão*, Ilê Axé Babaluaiye of Dona Hilda, Curuzu, Salvador, Bahia, Brazil, 1981. Photograph by author.

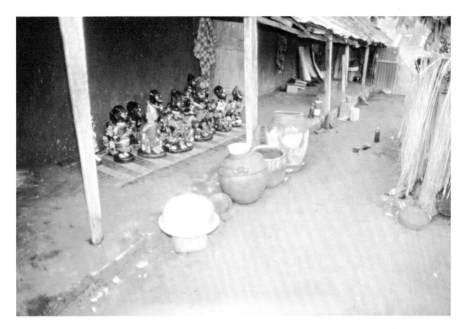

Plate 17. Group of sculptures embodying the sacred force of Yemọjá owned by the initiates of the *egbe* Yemọjá. They are gathered together on the veranda of the inner community Yemọjá shrine during the annual festival to await sacrifice and reempowerment. Ibara quarter, Abeokuta, Nigeria, 1983. Photograph by author.

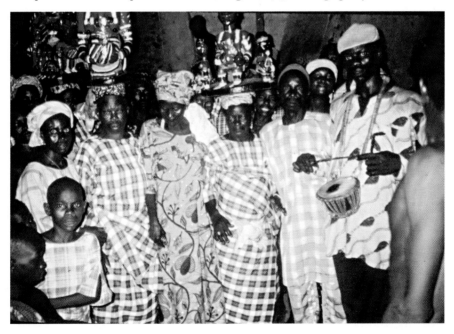

Plate 18. Images embodying the sacred force of Yemọjá returning from a procession in the shrine district, Ibara quarter, Abeokuta, Nigeria, 1983. Photograph by author.

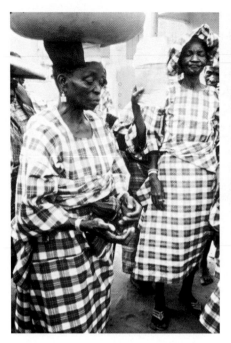

Plate 19. Initiate incorporating the sacred force of Yemoja during a procession in the shrine district, Ibara district, Abeokuta, Nigeria, 1983. Photograph by author.

Plate 20. Chromolithograph of Yemanjá, 2000. Photograph by author.

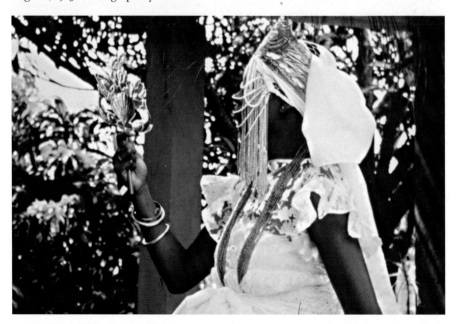

Plate 21. *Orixá* Yemanjá Assabá, Candomblé Casa das Aguas, Itapevi, São Paulo, Brazil. Photograph by Reginaldo Prandi.

Plate 22. Axô Yemanjá ensemble for the incarnated *orixá* Yemanjá. Photograph courtesy of the Fowler Museum of Cultural History, University of California, Los Angeles. Photograph by Richard Todd.

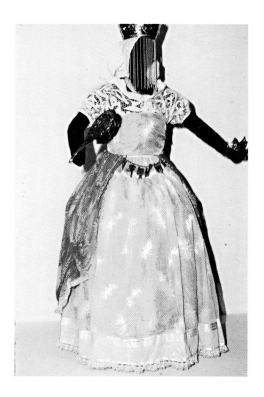

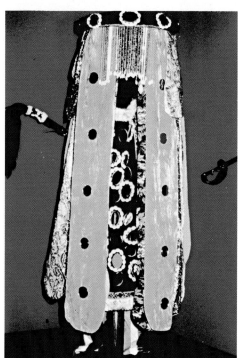

Plate 23. *Egún* of Yemanjá, Ilê Agboulá, Itaparica, Bahia, Brazil. Reconstruction sewn by *oje* (*egún* priest Flaviano) from a drawing by the author during attendance at the Presentes de Yemanjá festival, 1983. Photograph courtesy of the Fowler Museum of Cultural History, University of California, Los Angeles.

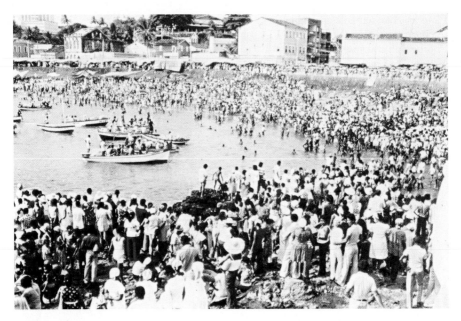

Plate 24. Devotees entering the water to deposit their gifts in the Atlantic Ocean during the Presentes de Yemanjá festival. Photograph courtesy of Arquivo Bahiatursa, Salvador, Bahia, Brazil.

Plate 25. Òlòrisà Yemọjá, Ibara, Akeokuta, Nigeria. 1983. Photograph by author.

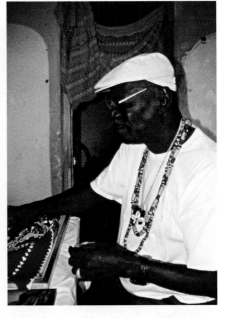

Plate 26. Alapini Domingo, head of the *egún* society—Ilê Agboulá—in his personal shrine where he receives clients for spiritual work or sixteen-cowrie divination, Itaparica, Bahia, Brazil, 2000. Photograph by author.

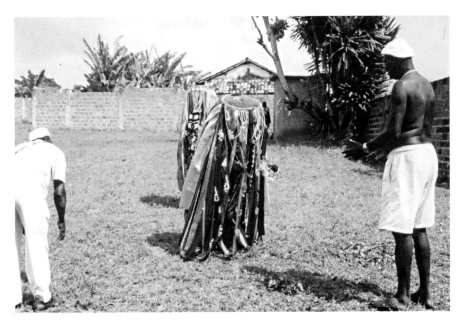

Plate 27. *Egún agba* during daylight portion of annual festival held in September for Baba 'Boula, founder of Ilê Agboulá, the society for the ancestors, with Alapini Domingo dos Santos, Itaparica, Bahia, Brazil, 1998. Photograph by author.

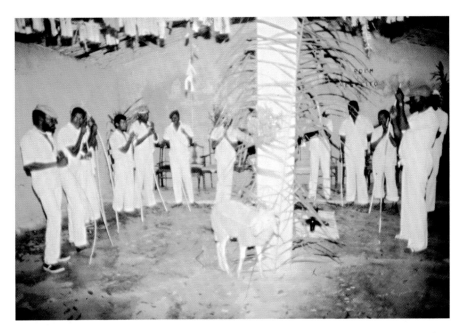

Plate 28. *Oje* during a festival, Ilê Agboulá, Itaparica, Bahia, Brazil, 1982. Photograph by author.

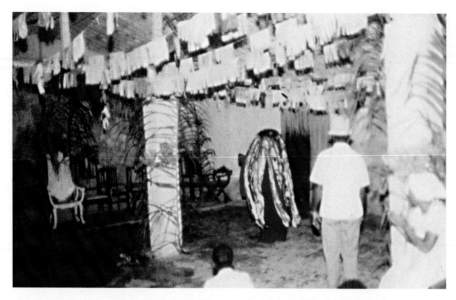

Plate 29. *Egún agba.* Ilê Agboulá, Itaparica, Bahia, Brazil. Photograph by author.

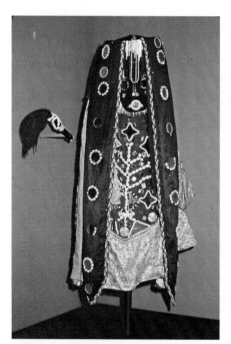

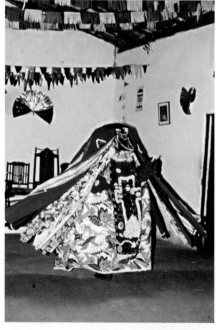

Plate 30. *Egún agba.* Collection of the Fowler Museum of Cultural History, University of California, Los Angeles.

Plate 31. *Egún agba,* Baba Xango, Ilê Agboulá, Itaparica, Bahia, Brazil, 1982. Photograph by author.

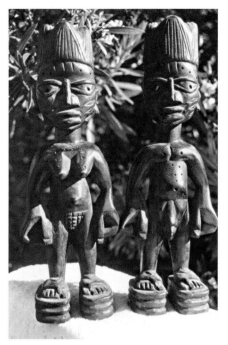

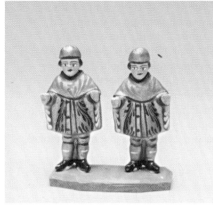

Plate 33. Tiny sculptures for Cosme/Cosmas and Damião/Damian representing them as little boys. Date unknown. Collection of the Fowler Museum of Cultural History, University of California, Los Angeles.

Plate 32. *Ère ìbejì,* 1999. Photograph by author.

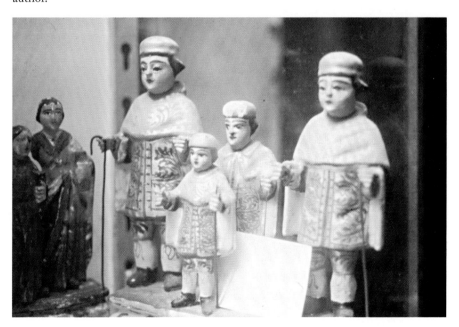

Plate 34. Sculptures representing Cosme/Cosmas, Damião/Damian, Idowu/Dou, and Alaba. Probably dating to the late nineteenth or early twentieth century, these figures were photographed in the museum of Catholic Convent of Carmo, 1982. They demonstrate an iconographic Yorùbá influence on Luso-Brazilian depictions of Catholic saints. Photograph by author.

Plate 35. Household shrine with a chromolithograph of Cosme and Damião forming the core of the shrine in a middle-class household on the annual Catholic holiday for these saints. A connection with Candomblé is signified by the remains of sacrifice topping the bowls of *caruru* (special food for twins), 1982. Photograph by author.

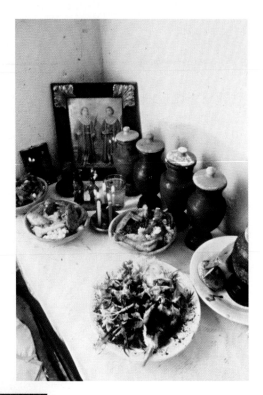

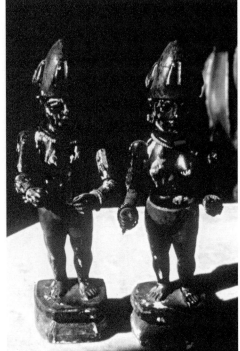

Plate 36. Wooden *ibejì* carvings probably made in Brazil around the late nineteenth century. The articulated arms on these figures place their construction in Brazil rather than Nigeria, where twin figures are carved from a single piece of wood. Salvador, Bahia, Brazil, 1982. Private collection. Photograph by author.

Fig. 6.3. *Ìyá ìbejì* with a living twin holding his *ère ìbejì*. The child after twins, called Idowu, is held in the mother's arms. Ketu, People's Republic of Benin, 1982. Photograph by author.

of the shrine for *ìbejì* (*ojúìbejì* in Ketu and *ojúbọ ìbejì* in southwestern Nigeria; fig. 6.4). On the third day after birth, the *babaláwo* comes to the *ìbejì* household to perform the divination known as *ẹta*. At this time, taboos for the twins and their mother (*iyá ìbejì*) will be determined and the *odu* of each twin will be decided. During the *ẹta* the exact number of *kolo-kolo* will be used; one remains at the *ìbejì* household shrine while the other goes to the shrine at the *olu ìbejì's* house (Baba Ẹjire, 1982, personal communication, Ketu, Benin; Anna Sijuwade, Falọsade, 1982, personal communication, Ketu, Benin).

Because *ìbejì* "bring their names from heaven" the Ketu Yorùbá do not hold a special naming ceremony. Tayewo, Tayelolu, or Tẹtẹdẹ is given to the firstborn twin of the first set of twins in Ketu, whether

Fig. 6.4. Anna Sijuwade pouring palm oil at her *ojúìbejì* (literally "face" of twins, or altar) as an offering to her living twins, Ketu, People's Republic of Benin, 1983. Photograph by author.

they are male or female: Kehinde (as among the southwestern or central Yorùbá) is given to the second born of the first set of twins.

In Ketu there are special sets of names for subsequent twin births to the same parent: for the second set, the name of the firstborn is Owoyi if female and Ẹdun if male. Ẹdun is also the Yorùbá name for the red Colobus monkey, an animal believed to be sacred to *ìbejì*, probably because of its characteristic twin births. Its flesh is *ewọ̀* (taboo) for *ìbejì* and their families (Pa Akan 1981, personal communication, Ketu, Benin). Akan is the name given to the second twin, whether male or female. The child born after twins is known as Idowu, while the child born after Idowu is named Alaba (Tim Mulero 1982, personal communication, Ketu; Adegbola Fagbayi 1982, personal communication, Ketu). These last two names are extremely important in analyzing the Yorùbá-Brazil connection and support my theory that Yorùbá twin

veneration transformed and thus Africanized the Brazilian rituals for Cosme/Cosmas and Damião/Damian.

The *ojú-ìbejì* shrine is the key point of contact with the *asé* of the *òrìsà Ìbejì* and serves as the focus of domestic rituals for both living and deceased twins. The *kolo-kolo* containing clear water and pulverized leaves sacred to Ibéjì (e.g., *ewe tètè, ewe dundun*, and *ewe tatalaiye*) are replenished at regular intervals. These pots (representing the living twins) receive a taste of all the special foods cooked for Ibéjì, especially beans and palm oil, as do any *ela ìbejì* (pots representing the deceased twins) that may be housed in the shrine. This special water kept in the *kolo-kolo* is considered to be *èro* (a cooling or calming antidote) for the twins when they are *gbóna-gbóna* ("hotting," meaning sick or feverish). It is often given to the twins to drink or mixed in palm oil and rubbed on their bodies as a protective device. Both the *kolo-kolo* and the *ela ìbejì* are usually kept inside the *ojú-ìbejì* and covered with a cloth (preferably white) when not in use (Bàbá Ejire 1982, personal communication, Ketu, Benin).

The rituals for Ìbejì are known as Ètutu in Ketu and Caruru in Bahia; the offerings made to them are similar to the offerings made to the other *òrìsàs*. Ritual foods include *obi abata* (four-lobed kola nut), *ataare* (alligator pepper), *orogbo* (bitter kola), and *oti* (native gin or schnapps). In addition to these, foods special to *ìbejì* are always used: *èwa ewe* (black beans), *èwa sein* (black-eyed peas), *isu* (yam), *elegede* (long, large yellowish orange squash), *agbado* (corn), *ògede* (banana), and *èko* (solidified white corn gruel). These foods are served in an *igba* (large calabash) or indigenous clay dishes. A little of these foods is placed on the twins' tongues and on the rims of the *kolo-kolo* or in the mouths of the *ela ìbejì*. The rest is shared among the family and guests, especially the children, whose presence is required for a successful *ìbejì* offering (Ìyá Egbeìbejì 1982, personal communication, Ketu, Benin).

The key points to remember about correspondence between imagery and ritual for twins in Africa and in Brazil are:

1. *Ela (ere) ìbejì* are conceptual representations of actual twin infants or children who died and were commemorated by wooden sculptures.
2. Special names are given to twins: Idowu to the child born immediately after twins, and Alaba to the child born immediately after Idowu.

3. All *ibejì* rituals (including the annual sacrificial feast) in their full traditional form include foods made with black-eyed peas and palm oil, sugar cane, yam, banana, corn, four-lobed kola nut, and bitter kola.

4. Songs or special chants are sung during the ritual, while the food is eaten and shared with the *ibejì* (living twins) and the *ela ibejì* (sculptures representing deceased twins). The participation of small children is an indispensable segment in the party or offering.

European Reverence of Cosmas and Damian

In Roman Catholic hagiography, Saints Cosmas and Damian are variously recorded as either Arabian twins or brothers close in age who were martyred during the time of the Roman Emperor Diocletian (284–305) for their refusal to worship "pagan idols" (Tabor 1969, 54; Holweck n.d., 159–60; David-Danel 1958, x, xi, xii, 8, 10, 20, 24–56). They were physicians by profession and were renowned for their miraculous cures and free services. Many legends arose regarding their invincibility, owing to unsuccessful attempts by non-Christians to drown and stone them. They were finally beheaded. During the Renaissance, they became the patron saints of the Medici merchants and bankers of Florence, Italy. Later, throughout Europe, Cosmas and Damian became the patrons of surgeons, chemists, physicians, and others associated with the medical profession. Churches were erected in Europe to Cosmas and Damian and claim to contain relics of these saints. The celebration, on September 27, usually involves a High Mass, a veneration of the relics, and inclusion in the Vatican Vectors (a general litany for many saints) on that day.

European iconography in various countries, including commonplace imagery in France, Portugal, Italy, Germany, and Spain, invariably depicts these brothers as young men, at the moment they were martyred. Moreover, they are always shown together and dressed in the type of clothing physicians wore during the Middle Ages: long, flowing robes, capes lined in ermine or other fur, and black caps. Their images in wood reliefs, oil and gesso painting, and sculptures depict them in some act of healing or in some historical circumstance leading to or including their martyrdom. Cosmas and Damian's attributes of scalpel and ointment container are prominently displayed. Their most famous miracle, and

the most frequently depicted, is the "miracle of the black leg," which illustrates their successful grafting of a black man's leg onto the body of a cancerous or gangrenous white man.

To my knowledge, only in Brazil (and especially in the state of Bahia) are Saints Cosmas and Damian (there known as Cosme and Damião) represented as little boys, or less frequently as adolescents, in popular culture. They are objects of an elaborate and popular domestic ritual practice that transcends socioeconomic class distinctions and incorporates foods of Yorùbá derivation or concept. (Elsewhere in Brazil, toys and candies and other sweetmeats are also given to these saints and to all the children present at the rituals.) Although the Yorùbá names for twins (Táyéwò, Táíwò, Tètèdé, Kẹ̀hìndé, and so on) have been lost in Bahia, the names of Idowu (retained in Brazil as 'Dou) and Alabá have been retained. And only in Bahia in the context of African Brazilian religion (especially of Ketu influence) have 'Dou and Alaba been linked to Cosme and Damião and this link conceptualized in art. Plate 34 illustrates a cluster of four figures tentatively dated to the late eighteenth or early nineteenth centuries and housed in the museum of the Catholic Convent of Carmo. These depict four little boys, two larger ones side by side in back of two smaller ones, all affixed to the same plinth. The priest/caretaker told me that these figures, made of carved, painted, and gilded wood, represented Cosme, Damião, 'Dou, and Alaba (though he was unaware of the connotations of the latter two names). When I showed the photographs of this image to initiates of *candomblé* Nagô, the images were consistently identified as Beje, 'Dou, and Alaba.

It seems reasonable to propose that through the centuries of close contact between African Brazilians and Portuguese Brazilians, the Brazilian version of the European Catholic ritual practice of Cosmas and Damian was Yorùbánized. The most likely historical avenue (besides the domestic arena earlier discussed) through which this aspect of West African Yorùbá culture was disseminated is slavery and the Catholic brotherhoods or other fraternal societies. Other possible historical avenues of transmission include demographic changes. By the nineteenth century, blacks outnumbered whites. Black influence on Portuguese heritage was facilitated through the intimate domestic, familial interaction between the African Brazilians who filled most service positions and the Portuguese families for whom they worked. Further, the increasing numbers of middle-class intellectual or artistic whites participating in

African Brazilian religions in recent decades may have contributed to the contemporary popularity of the ritual practice of Cosme and Damião in Bahia.

Íbejì Ritual and Imagery in Brazil

In Bahia, Catholic Saints Cosme and Damião are conjoined with *ère*- or *èla-íbejì*. This fusion operates on visual, ritual, and behavioral levels in both African Brazilian and Portuguese Brazilian spheres of the society and therefore cuts across class lines. In Bahia I found the common denominator of *íbejì* ritual to be the ceremony known as the Caruru. Furthermore, the ceremonial procedures of the Caruru appear to vary, in accordance with socioeconomic class level, in the degree to which they follow West African Yorùbá *íbejì* ritual. In other words, the closer the association with Ilê Axé or African Brazilian religion, the greater the attention paid to correct ritual process. This is in turn exemplified in a greater observable degree of African correspondence. In contrast, the higher the socioeconomic class (with its European values), the less African correspondence observable.

In Bahia, Caruru is a *festa*, often in the form of a huge sacrifice, to honor or please *beje*. Carurus are given for various reasons: as fulfillment of a promise made to the "twin saints" Cosme and Damião or Crispim and Crispiniano for solicited or unsolicited aid, to celebrate the birthdays of actual twin children (*gemeos*), and to celebrate the holy days of Cosme and Damião or Crispim and Crispiniano (Oct. 25; plate 34).

Caruru also refers to a kind of stew primarily made of okra and commonly served in Nigeria with *amala* (a glutinous dried-yam flour mixed with boiling water and cooked). The difference is that in Nigeria only okra, salt, and water are used in the preparation of the dish, whereas in Bahia, rich quantities of dried shrimp, ground peanuts, onion, and copious amounts of palm oil are added to the minutely chopped okra. *Caruru* is normally cooked in a huge pot, as it is always meant to serve an enormous crowd (above all, children). Besides the main dish, the traditional Caruru party will include foods made with beans and palm oil (*acaraje, abara*) as well as black-eyed peas and black beans (noted as special *íbejì* foods in Ketu). Other necessary foods are plantain or banana fried in palm oil, African yam and corn, candy (*raspadura*), and a drink (*arua*) made of sugar cane.

In *candomblé* Nagô, *beje* are assigned a place after their mythological mother, Yansan, in the hierarchy of *orixás*. According to the chief

priestess of Afonjá, an *adoxu* of Yansan cares for, dresses, and feeds the *íbejì* images kept in the major shrine of the temple grounds, the *ilê* Xango (Mâe Stella, in the Ilê Axé Opô Afonja, Sept. 1981; 1998, personal communication). The sacred day of *beje* is Wednesday, and on this day their shrine is cleaned and the food and water replenished. The special domain of *beje* includes the custody of pregnant women and children, the bringing of good luck, and "opening roads" (i.e., removing obstacles). *Beje* may have their own shrine or they may be honored in a general shrine for other *orixás* (plate 5). The *assento* (material seat for *beje*) usually contains attributes associated with Cosme and Damião (e.g., a metallic scepter and quill or ointment box); African elements (kola nut and bitter kola), tiny clay bowls or vases of water, and plates of varying sizes and number. After they have been properly consecrated, these objects contain the *axé* of *beje*. *Íbejì* ritual within the *candomblé* consists of a weekly ritual and a more elaborate celebration on or near their annual Catholic holiday. Parents of twins often make more regular offerings to *beje* (plate 35), and *candomblé* members frequently honor 'Dou and Alaba (but always in relationship to *beje*). In this case, extra dishes, candles, and foods are added to the altar.

Style and Images

The figurative images of *íbejì* in Brazil (Beje, Cosme and Damião, Crispim and Crispiniano[3]) can be divided into two major stylistic divisions: first, the images that derive their forms and iconography from European prototypes but depict little boys, not adults; second, those that conform to West African Yorùbá prototypes in form and iconography but which are "Brazilianized" because they combine in one single image distinct stylistic peculiarities commonly found in varying ethnic regions of the Yorùbá (plate 32 and fig. 6.3). I photographed one very rare and important pair of sculptures that are clearly *íbejì* but appear to have been made in Bahia (plate 36), as the use of articulated arms for *íbejì* sculptures are unknown to me and other scholars of Yorùbá arts in Nigeria.

These images differ greatly from the "official" images of Saints Cosme and Damião found in the only church dedicated to them in Bahia. The officials of the church denied that the saints had anything to do with "that paganism" when I asked them about Caruru for Cosme and Damião. After the mass for these saints that I attended, however, many of the worshipers distributed hard candies (*queimados*) to children

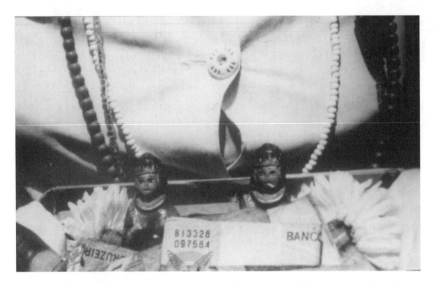

Fig. 6.5. Ilê Axé member carrying Cosme/Cosmas and Damian in a shoebox and collecting alms on their holy day much in the same manner as Yorùbá mothers of *ìbejì* carry their sculptures or living twins to the market to collect alms in Nigeria. Salvador, Bahia, Brazil, 1981. Photograph by author.

inside the church. Candy and money were distributed liberally to the hordes of hungry children waiting outside the church. Many others strolled around the area requesting alms or donations while carrying rather worn, tiny images of Cosme and Damião in a box (fig. 6.5).

The ritual and imagery associated with Íbejì, the deity for twin births and twin children in West Africa, and the amalgamation of this twin ritual practice with that of Cosme and Damião in Brazil reveal how Yorùbá traditional religion transformed Portuguese Brazilian visual and ritual forms. Further reinforcing this conclusion that Yorùbá twin ritual and imagery influenced popular Catholicism is the fact that the European mode of ritual and iconography inherited from Portugal continues to exist (in its almost "pure" European prototypical form) alongside the African mode.

Although the popular ritual of the "twin saints" retained elements of its European heritage (e.g., holy days and the celebration of mass), the

West African Yorùbá elements appear to be predominant. Even though this system has been erroneously attributed to Bantu influence (Castro 1978), the data clearly prove its basis in the Yorùbá system of ritual and imagery for *ibejì*. This is illustrated by the idea that twins are special and bring good luck through proper ritual attention; the retention of the concept and nomenclature of 'Dou and Alaba as linked to twins; and the continued preparation of traditional Yorùbá foods special to twins, especially beans and palm oil. Although many of the images in the ritual are Caucasoid, the *òrìsà* involved conceptually is Íbejì.

The most striking impact can be seen in the visual transformation of Saints Cosme and Damião and Saints Crispim and Crispiniano from adult men to "little boys." Since no European parallel has yet come to light, this transformation can be convincingly attributed to the Yorùbánization of this Portuguese Brazilian ritual practice.

Conclusion

Bahians are fond of saying that "Brazil's umbilical cord is buried deep in Africa" (Domingo dos Santos, July 1998, personal communication, Itaparica). I would go even further to avow that the religious and artistic umbilical cord of many African Brazilians is buried deep in Africa and is especially connected to Yorùbá beliefs and practices. The wider Brazilian society strongly models American, French, Portuguese, and other European-derived values and lifestyles. Within this frame, descendants of Africans are overwhelmingly relegated to socially, politically, and economically peripheral sites and roles. In contrast, Yorùbá-derived African Brazilian religion can be understood as a conscious mode of resistance to stratification and separation. The sacred is manipulated through artistic and religious expressions to provide adaptive responses that empower some African Brazilians to reconstruct their social and cultural identities according to a fundamental African conceptual model. Active and sustained participation in the sacred encourages viable, attainable goals and lifestyles.

Essentially, each *ilê axé* (temple or *candomblé*) functions as a microarena that while distinct from the wider society often operates parallel to it because of the fluid movement of the devotees from one domain to the other. In the *ilê axé* the salient objectives are to maintain harmonious relationships with the *orixás* who are perceived as forces controlling and affecting all aspects of life. This pervasive acceptance of

a traditional African worldview in a post-modern urban setting may be partially explained by the fact that these values and beliefs are transmitted from generation to generation. They are taught orally by parents who are themselves often uneducated according to the Western paradigms (as are the majority of African Brazilians) or in the community schools (e.g., *comunidade* Oba Biyi at Afonjá) that supplement secular Brazilian schools with the history, myth, music, and dances of the gods by means of a half-day curriculum. Although *candomblé* members may work in the outside world, most of their social and family contacts remain within the relatively closed minisociety of the *ilê axé*, thus ensuring continuation of traditions through generations. People remain in the system because it provides more satisfaction and psychic rewards than can be accrued in the wider Euro-American-oriented Brazilian society.

Ilês axés may be conceptualized as cultural responses to concrete social conditions that are essentially characterized by a cumulative cleavage along racial, social, and class lines beginning with enslavement and continuing after abolition in 1888 through the present. African Brazilians remain a marginalized, permanent underclass within the wider society. With the exception of the United Negro Front (active in the 1970s and 1980s), members of carnaval groups such as Ilê Aiye or Olodum, and a few of the *adoxu* I interviewed, African Brazilians generally appeared to be apolitical and apathetic in terms of accepting their socioeconomic conditions. It was impressed upon me that through manipulating the sacred they became proactive agents and continued to endure culturally.

Within the *ilê axé*, art plays a dynamic, essential role, giving substance to intangible ideas and beliefs, and in the sacred space, art and ritual are inseparably intertwined. Costume and liturgical implements function in a recognized network of visual and symbolic configurations communicating mythological and historical information to the audience. Art also signals proper ritual behavior, social status, and trance within the *ilê axé* of *candomblé* Nagô by means of special combinations of costume elements. Although it may appear that the preoccupation with hierarchy and prestige (and their permutations in art forms) stems from the caste system of Brazilian society, I think it is more feasible to look for the roots of this attitude in the hierarchical, stratified Yorùbá society. Another possible explanation is the natural and universal tendency of humans to divide themselves into the powerful and the powerless and to symbolize these positions by means of art forms. An

additional important function of art within the *ilê axé* is entertainment. Since few have time or money for the distractions of movies, plays, concerts, and other secular activities available to Portuguese Brazilians, art fulfills this need for diversion and functions as an aesthetic pageant or theatrical display.

The final key to understanding the multifunctional nature of Yorùbá ritual art in Brazil can be found in the concept of linking spiritual rewards with material offerings, which are viewed as sacrifices. African Brazilian, Yorùbá-derived ritual art in the *ilê axé* perpetuates the religion and codifies, materializes, and exemplifies intangible links with the *orixás* and the ancestors, the nuclei of the religion. African Bahian ritual and art (especially that of the Yorùbá) have profoundly affected aspects of Brazilian national consciousness and Portuguese Brazilian Catholic ritual and imagery. This is demonstrated by the national, public veneration of Yemanjá (amalgamated with the Virgin Mary, culminating in the annual festival on February 2) and the domestic ritual veneration of twins (amalgamated with Cosme and Damião).

In sum, Yorùbá-derived African Bahian religion and ritual art provide tangible vehicles for the preservation of beliefs, myth, ideas, and sociohistorical and other cultural values. Because they have conceptual and formal origins in Africa and are thus often in conflict with the wider European-American orientation of Brazilian society, Yorùbá-derived religion and ritual art can also be interpreted as a political statement of cultural resistance. The strategy of manipulating the sacred by institutionalizing ritual art, African beliefs, and religious practices in the *ilês axés* has been critical to African Brazilians' ability to counter oppressive social, political, and economic forces.

Notes

All translations from Portuguese to English are my own unless otherwise noted.

1. In addition to artistry, core elements of Yorùbá sacred rituals, music, songs, dance, ceremonial language, mythology, and philosophy are based on general mental frameworks carried with the enslaved Yorùbá-speaking peoples when they were brought to Brazil from Nigeria and the Republic of Benin (at that time, the Kingdom of Dahomey). All of the above are maintained and practiced in Bahia, Brazil, in religious communities called *candomblés* Nagôs (Cahn-domm-lay Nah-gohz), which will be discussed in detail in chapter 2.
2. See also Collins 1990.
3. German-Indian anthropologist Kirin Nayaran (1993) describes similar conflicts.
4. "Ọ̀yọ́ Returns" refers to a symbolic rebuilding in the United States of Old Ọ̀yọ́, capital of the Ọ̀yọ́ Empire formerly located north of Ilorin, in northeastern Nigeria. Old Ọ̀yọ́ was regarded as the political seat of the Yorùbá peoples, the spiritual seat being situated in the town of Ilê Ife. Old Ọ̀yọ́ was destroyed in the 1800s and moved to its present location south of Ilorin, in southwestern Nigeria—approximately one hundred kilometers from Ibadan. It is now referred to simply as "Ọ̀yọ́."
5. Previous single-authored publications or anthologies have generally not been concerned with in-depth investigations of one single culture or genre of artistry. Instead, they have deployed sweeping survey, overview, or descriptive approaches that although important and valuable, traverse disparate African diaspora cultures within each individual book (Murphy 1988, 1994; Thompson 1975, 1983, 1993).
6. That my project takes a unique approach has been confirmed by several extensive bibliographic computer searches and by my consultation of a major published bibliography on Africa and its diaspora (Gray 1989). Drewal and Driskell (1989) have made impressive contributions toward the study of con-

temporary African Brazilian art. Other noteworthy contributions are recent anthologies *Beads Body and Soul: Art and Light in the Yorùbá Universe* (1998), edited by Drewal and Mason et al.; *Santeria Aesthetics in Contemporary Latin American Art* (1996), by Arturo Lindsay, and *Sacred Arts of Haitian Vodun* (1995), edited by Cosentino et al.

7. See Bastide 1960, 1978a, 1978b; Carneiro n.d., 1948, 1981a, 1981b; dos Santos, n.d., 1962; dos Santos, 1976; and Verger 1954, 1957, 1980, 1981a, 1981b.

8. I have been informed of a more recent edition of Landes's *City of Women* published by the University of New Mexico Press that *does* include photos.

9. For publications that address the theme of African-derived art in Brazil, but from quite disparate standpoints, see do Prado Valladares 1969a, 1969b, 1976; Barata 1941, 1957, 1966; Bastide 1968; Carise 1975; and Nina Rodrigues 1904.

10. Macumba is the generic name for African Brazilian religions in Rio de Janeiro. Although these are eclectic, many are heavily based on Yorùbá ritual; they are widely confused with Umbanda, even by scholars.

11. See Van Gennep 1961 and Turner 1967 for their use of the word *limen* (root of liminality), connoting the physical and symbolic "threshold" between sacred and secular spheres/worlds.

12. I am grateful to Awise 'Wande Abimbola (1997, telephone conversation) for giving me the Yorùbá appellation to describe my method, which I formerly termed "meta-ethno-aesthetic."

13. On modernism, see Tagg 1989 and Harvey 1995.

14. "Naõ basta descrever os ritos ou citar os nomes das divinidades; é preciso também compreender o significado dos mitos ou dos ritos."

15. I am not at liberty to divulge many details or reveal secrets about fundamental rituals; I clearly distinguish my own ideas and interpretations from those of my collaborators.

16. I published a monograph based in part on my Ph.D. dissertation in 1984 as an exhibition catalog for an exhibit on African Brazilian art I co-curated with the late Daniel Crowley for the University of California, Los Angeles, Museum of Cultural History. It is my understanding from Doran Ross, director of the Fowler Museum, UCLA, that the monograph was very much in demand and is now out of print.

CHAPTER 1

1. Pai Crispim, Seu Domingo, Dona Hilda (1982, personal communication, Salvador), verified by personal attendance and participation in Macumba and Umbanda in 1981 in Rio de Janeiro.

2. "[Uma] realidade multifacetada"; this study was Dantas's master's thesis in social anthropology (1982). Revised in 1987 for publication, the work is an important critique of Brazilian scholarship on *candomblé* Nagô (Yorùbá-derived/models) and the social construction of notions of Africa by Brazilian intellectuals and African Brazilian practitioners. The value of this publication is diminished, however, by its central focus on only one *candomblé*. Also known

locally as a Xango, the *terreiro* of Santa Barbara Virgem was located near Bahia in Laranjeiras, Sergipe, in northeastern Brazil. Dantas's study would have been strengthened by situating her analysis in or comparing her field investigation to the neighboring state of Bahia, which she acknowledges as the origin of the socially constructed "hegemonic *nagô* model," dispersed as early as 1896.

I am grateful to Anibal Mejia, my former graduate assistant, for a synopsis of this and other publications. I used Mejia's summaries to help me distinguish the books most germane to this study and those which thus merited a more technical transcription.

3. *Kandombele* means "an African musical presentation or festival" (Castro 1976, 144). Castro's dissertation is essentially a dictionary tracing the etymology of words used in African Bahian religions.

4. The word *Umbanda* originally derives from a Bantu term designating a form of religion. In Brazil, the religion Umbanda evolved into an eclectic form of "religião limpa" [clean religion, one without the blood sacrifices characteristic of African Brazilian *candomblés*]. The Umbanda ceremonies I attended in 1981 in Rio combined Yorùbá *orixás*, Kardecist Spirits, Caboclo energies, and the forces of "pretos velhos"—souls of enslaved Africans [ancestors]. The first center of Umbanda was founded in Rio de Janeiro ca. 1920 (Prandi 1991, 48).

5. The *Hippocrene Practical Dictionary for Portugues/English* (1989) defines *terreiro* as "an open terrace (for drying coffee beans, etc.); place where voodoo rites are practiced." The original quote reads: "Terreiro. . . . O conjunto das pessoas que sob a chefia de um pai out mae-de-santo formam um grupo de culto" (Dantas 1988, 261).

6. Use of the Yorùbá language is critical to the expression of status through ritual knowledge. This has been illuminated by *candomblé* priest Ruy do Carmo Povoas (1989).

7. The prefix "Luso" refers to Portuguese ethnicity and is usually employed in linguistic discussions. For example, Anglophone means English-speaking, Francophone means French-speaking, while Lusophone" means Portuguese-speaking. I am using "Luso" to refer to Brazilians whose ancestry is obviously European or at least "white." Although perhaps conceptually problematic to North Americans, in Brazil skin color is closely connected to economic class, privilege, and social mobility.

8. The *orixás* Xango and his head wife, Yansan, are often interchanged with Santa Barbara because they all carry swords and are associated with war and the diverse hues of the color red.

9. "Contemporanemente, o *candomblé* foi descoberto pela classe média e por turístas, autoridades, políticos e artistas em busca de prestigio, revelando o terreiro como algo fascinante e 'diferente,' além de fonte não só de apoio moral e religioso mas, principalmente, estético."

10. Ketu was formerly located in the area divided into Nigeria and Dahomey by European colonials who partitioned Africa during the 1884 Berlin Conference.

11. "Da exaltação da África mítica e de sua herança cultural reificada, tal como

ocorreu no Nordeste, confina o negro brasileiro a um gueto cultural isolado da corrente da vida e da sua posiçaõ na estrutura da sociedade, ocultando-se as desigualdade atraves da enfase nas formas simbolicas de integração."

12. In Dantas's opinion, this construction/collusion occurred as early as 1896 with Nina Rodrigues's work and has been carried on through recent scholarship.

13. This same usage of the term "political" is prevalent in Marxist or cultural materialist analyses of art, as in Nicos Hadjinicolaou's *Art History and Class Struggle* (1978).

14. The term *iyalorixás* derives from Yorùbá, one of the major languages spoken and written in Nigeria and the Republic of Benin. Ìyá means "mother" and in this sense can be translated as caretaker or ultimate authority, similar to the notion of CEO in the Western sense. *Orixá* is the Brazilianized version of *òrìsà*.

15. See also dos Santos 1976 and Omari 1984.

16. "Ela comporta uma ideia de progresso que não e simplesmente o da evolução espiritual, o desenvolvimento médiunico da umbanda. Nos meios do *candomblé*, desenvolvimento emplica accesso a postas altos na hierarquia, a que se chega atraves da obrigação ritual. E isso significa prestígio, pois mesmo fora dos espaços religiosos o *candomblé* tem sido um religião reconhecidamente com maior grau de legitimade que a umbanda."

17. Gege is a linguistic corruption of Ewe. The Ewe-speaking peoples are found in Ghana where they exhibit cultural affinities with the Aşante. There are also clusters of Ewe speakers in the Republic of Benin where there are cultural linkages with Fon speakers. Since *vodu* is a Fon term for divinity, it is entirely possible that the term and the ritual to which it refers were brought to Brazil by enslaved Ewes from Dahomey. An interesting note on the cultural interchange that existed among Africans on the continent is the fact that the Fon borrowed heavily from Yorùbá traditions (for example, the *vodu Gu* is analogous to the Yorùbá *orixá* Ogun, the deity ruling war, ironworking, hunting, and the forest).

18. The striking Yorùbá hegemony in Brazil may be attributed to the great number of slaves of this ethnic group brought to Brazil in several contingents prior to the mid-nineteenth century (Verger 1981a, 55; Nina Rodrigues [1905] 1977, 107).

19. The most frequent mode of African Bahian ritual representation of Exu is by means of a conical clay form. This image varies in height from three inches to approximately four feet, with the eyes, nose and mouth made of cowrie shells. There are sacrificial materials inside and out. Another frequently encountered image of Exu is a horned, iron humanoid figure with a long tail, probably a result of the Catholic syncretization of Exu with the devil (a phenomenon that also occurs in West Africa).

Each initiate, ancestor, and *orixá* has a personal *exu* that must be propitiated first in any ritual. The *exu* serving the *terreiro* as a whole is frequently housed outside near the gate entrance in a separate shrine (e.g., at Lobato). In others, Exu has a separate shrine within the temple grounds proper (e.g., at Afonjá, where it is located next to the Xango shrine).

20. *Barracão* in Portuguese is defined as a shanty or roughly built dwelling. In *candomblé*, the name refers to a large room or hall where the principal public or semipublic ceremonies take place. In Yorùbá-derived *candomblés* the *barracão* is also known as *abassa*.

21. "Mae Aninha, Eugenia Ana dos Santos (1869–1938), who was Bahian, was initiated in 1884 in Salvador by Maria Julia of the Casa Branca, Engenho Velho. (When Maria Julia was initiated, the African Bamgbose Obitiko [brought from Ketu to Bahia by Marcelina Obatossi] participated in the rituals.) [Marcelina and Bamgbose were two important founders of Bahian *candomblé* whose names are always the first called when sequences in ritual songs invoke past priests and priestesses.] When Aninha left Casa Branca do Engenho Velho, she stayed for some time in the Bahian *terreiro* of Tio Joaquim, a priest of Pernambucan origin. In 1910 Aninha separated from Tio Joaquim and founded the Center of Santa Cruz do Ilê Axé Opô Afonjá in Salvador [in 1918]. According to the research of Auras and Santos 1983, Aninha passed part of her religious life in Rio de Janeiro where she was active in intense sacred activity with a group of Bahian families living in Rio near Pedra do Sol. Aninha founded the [still active] Rio de Janeiro branch of Axé Opô Afonjá" (Prandi 1991, 42–43).

22. This usage was confirmed by Annette Bird through whom I had sent a present to the *iyalorixá* of Afonjá. On Bird's return, she indicated her unsuccessful attempts to telephone Mãe Stella, being repeatedly told that she was not at home but at the *roça*, shrine area (1984, personal communication, Venice, California).

23. Because Ọ̀ṣunlade was gregarious and expansive, by virtue of our almost continuous, close association, this fortunate situation presented me with the opportunity to be privy to significantly rich and substantial data.

CHAPTER 2

1. According to Samuel Johnson *History of the Yorùbás* (1921), there exist legends and myths featuring female kings in the states of Ilé-Ifẹ̀ and Old Ọ̀yọ́.

2. Whereas the term *ojúbo* is used to refer to an altar for an *òrìṣà* and *ìgbàlè* to refer to the altar for the *egúngún* encased within architectural forms (Lawal, May 2000, telephone conversation), the actual architectural structures housing these altars are often referred to generically as *ilé àṣẹ* (literally, the house or home of *àṣẹ*).

CHAPTER 3

1. I am grateful to Rowland Abiodun, Babatunde Lawal, Olabiyi Yai, and Bayo Ijagbemi for Yorùbá exegeses that facilitated my analysis of the African Brazilian material.

2. *Ilê axé* is coterminous with *terreiro;* it comprises temple buildings and grounds, as well as beliefs, behaviors, practices, and objects associated with Yorùbá-derived religions in Brazil.

3. "Double-voiced" is a term employed by Henry Louis Gates, Jr. in his *Signifying Monkey: A Theory of African-American Literary Criticism* (1988). Although Gates used the term to refer to the double heritage of African American literature, in the sense that it contains both African and hegemonic Anglo-American elements "double-voice" is applicable to visual and performing arts as well. Indeed, as early as 1906 W. E. B. Dubois noted in *Souls of Black Folk* that this "sense of two-ness . . . double-consciousness of being . . . both . . . American and Negro" was endemic in the black American's psyche.

 In other recombined components, indigenous Indian or Caboclo design elements are evident (an example is the Egún caboclo discussed in chapter five).

4. While the Yorùbá blouse (*bùbá*) has been characterized by wide sleeves in recent decades, sleeve length and styles have varied in recent times as well as through the centuries.

5. I am grateful to Maria José Barbosa for bringing this reference to my attention.

6. The *òjá* (baby sash) and *gèlè* (head tie) are distinguished from each other by the Yorùbá in contemporary times, although they may be used interchangeably (Lawal, May 2000, personal communication). *A Dictionary of the Yorùbá Language,* published and reprinted from 1968 through 1983 in Nigeria by University of Ibadan Press, defines *òjá* as head tie, sash, belt, and girdle.

7. Yansan is the African Brazilian name for Oya, the Yorùbá goddess who rules the Niger River and tornadoes and is one of the wives of Xango. Yemanjá is the designation for Yemojá, goddess of the Ogun River, mother of other *orixás,* and in charge of maternal love and fertility. Oxum (Òsun) is the goddess of the Òsun River, another of Xango's wives and in charge of fertility, sensuous love, and beauty. Oxossi (Osoosi) is the god of hunting and a former king of Ketu (Mae Stella, Pai Crispim, 1983, Salvador da Bahia, personal communication). Obatala (Oxalá) is a god of the Igbo people, the indigenous inhabitants of Ilé-Ifè. Obatala was later incorporated into Yorùbá mythology to honor the original owners of the land (Idowu 1962, 71–75).

8. This complex of objects is commonly known as *assento* or *assentamento,* seat or foundation in Portuguese.

9. That this tendency predates the transatlantic slave trade is clearly seen in the bronze and terra-cotta art forms of ancient Ilé-Ifè.

10. These individuals are also known as *filhas-de-santo,* or daughters of the saint, or *filhos-de-santo,* sons of the saint.

CHAPTER 4

1. The data presented here are based on extended research periods of approximately three and one-half years in Brazil spanning 1980–83, 1986, 1990, 1998, 2000, and 2001; a year and a half in Nigeria from 1980–1983, 1986, and 1991; and three months in the Republic of Benin (1982–83).

2. The river Ogun should not be confused with the deity Ògún who is the god of iron, blacksmiths, motorists, and war.

3. In the translation, I have attempted to remain as close to the spoken rhythm of the chant as possible, with only slight editing.

4. The first quote was collected by Thompson from a Gẹ̀lẹ̀dẹ́ priest in Lagos and his second reference was also from a Gẹ̀lẹ̀dẹ́ priest based in Ibara quarter, Abeokuta.

5. *Candomblé* Nagô mythology considers Yemanjá to be the mother of all *orixás* except the children of Nanan. This is explained by a myth in which Aganju (Yemanjá's son) sexually molests her. While running away, Yemanjá trips and falls, giving simultaneous birth to many *òrìṣà* and to the Ogun River in Nigeria (Nina Rodrigues [1896] 1935, 222–23)

6. Women cannot shed blood through the ritual act of sacrificial killing in either Africa or Brazil.

7. This recalls the *ègbo*—mashed white corn mixed with white oil—a favorite food for Yemọjá in Ibara district, Abeokuta, Nigeria.

CHAPTER 5

1. Dos Santos's assertion of a strict separation between gods and ancestors in African Brazilian religion contrasts with the situation in many parts of the Yorùbá in Africa, where *egúngún* is thought to be an *òrìṣà* as well as a deceased ancestor (Obadẹrin Egúnjobi, 1981, personal communication, Ketu, Benin; Táíwò A. O. Nipado, 1982, personal communication, Ileṣa; Babayemi 1980, 1–4, 25).

2. Since that time, I have received reports that other *terreiros* to honor the ancestors have been founded in Bahia, as well as in Rio de Janeiro (Anibal Méjia, Adoxu Oxum, personal communication, Tucson, AZ). My daughter and I attended a ceremony for the *egún* in July 2000 at Ilê Aṣipa, located in the outskirts of Bahia and headed by Didi Dos Santos.

3. While *egúngún* rituals entail ancestor veneration, some *òrìṣàs* are considered ancestors (Lawal, May 2000, telephone conversation).

4. *Àwòyó* translates as a physical thing that brings joy and contentment when viewed (Lawal 1996, 39).

5. There is a close spiritual link between the *candomblé* Nagô *orixás* of the Ilê Axé Opô Afonjá of São Gonçalo do Retiro in Bahia and the *candomblé* Nagô Egún of Ilê Agboulá in Itaparica. The exact nature of this link is unclear. According to Flaviano dos Santos (a male *orixá* initiate and now head of his own *candomblé*, who holds posts in both *terreiros*), in order to participate in *egún*, one must also be initiated into the cult of the *orixá* (Oct. 1982, personal communication, Itaparica). The connection may go back to the late Mãe Senhora, world-renowned head priestess of the *candomblé* dedicated to the deity Afonjá (warrior manifestation of Xango) and cofounder of Ilê Axé Agboulá.

6. The same simple type of uniform is worn for all internal ceremonies dealing with birth, death, rebirth, and renewal; only the placement of the *pano da costa* varies. The absence of embellishment symbolizes the essential core of "pure" human existence, stressing natural rather than social or man-made elements.

CHAPTER 6

1. Since there are many excellent studies published on *ìbejì* in Nigeria, the data presented in this chapter is restricted to new information collected by the author during field research in Ketu, Republic of Benin, 1981, 1982.
2. Because of the important role Ketu plays in African Bahian ritual and art (Omari 1984, 16, 17) this chapter emphasizes data for *ìbejì* derived from that area.
3. The most in-depth information I was able to collect on Saints Crispim and Crispiniano is that they are shoemakers and are always shown together. They are apparently particular to Brazilian hagiography.

Glossary

Abará
Special food of Yansan and Egun prepared as Acaçá (see below) but made with black-eyed peas, ground shrimp, salt, and palm oil.

Abiān
First-level candidate for initiation.

Acaçá
A semi-firm pudding made of ground white corn, cooked in boiling water without salt or sugar, and wrapped in fresh banana leaves. After it has cooled, it is removed from the leaves and served (as a special food imbued with sacred power) to most of the Orixás, the ancestors, and initiates.

Adé
Among the Yorùbá, a conical beaded crown with a beaded veil and birds attached to its pinnacle. Traditionally signifies direct descent from Oduduwa, a creator deity and the first king of Ilé-Ifẹ. In Brazil, refers to any Orixá's (deity) or Egun's (ancestor) crown.

Adoxu
Initiate wearing a cone-shaped mass (*oxu*) of sacred white chalk and herbs consecrated by his/her Orixá. Also the cone that is placed on the initiate's head while the *axé* cuts heal. Never worn again after the Orunko ceremony where the initiate's Orixá pronounces his/her name publicly for the first time.

Agogo
Cone-shaped ritual bell attached to a handle and made of silver or silver-

colored metal. Used by the head priest/priestess and his/her first assistant to call the Orixás and invite them to participate in rituals or to incorporate in the initiates' heads. May be also used to sustain trance.

Aiyé
The physical, terrestrial world.

Ajibonã (Jibonã)
Also known as a little mother (*mãe pequena*). May be assigned to one or two initiates who are undergoing the ritual ceremonies of Iyawo. Responsible for caring for the novices—bathing, feeding, dressing, teaching, and punishing them. Because they are present during all phases and sacrifices of the initiation performed by the Iyalorixá, a lifelong bond is formed that may not be broken.

Alagba
High priest in the Egun society.

Alabá
Name of a child-spirit that accompanies Cosmas, Damian, and 'Dou. When there are four figures, Alabá is signified. Among the Yorùbá, Alabá is born immediately after Idòwú and receives the same attention bestowed on the twins (Ìbéjì) and Idòwú.

Alapini
Chief priest and spiritual head of the Egun society.

Axé (àṣẹ)
Vital and revitalizing power contained in nature in all sacred objects and acts connected with the Orixás, and existing in the heads of all full initiates. The ritual heads usually control or manipulate the collective *axé* and redistribute it during initiations and other rituals. Axé is believed to increase and decrease and thus must be ritually reinforced periodically. Axé is energized by blood, natural herbs, leaves, water, and other materials. Axé can also be spoken as an affirmation that translates as "so be it" or "that's right."

Àxèxè
Seven-day funeral ceremony of passage celebrated for deceased Ebomins

in which the participants wear special white muslim clothing that must only be used for death rituals. Also are worn palm fiber armbands called *contra-eguns* which protect the participants from the dead. The intention of the ceremony is to liberate the deceased's soul and escort it back to the point of creative spiritual origin. If the deceased was an important ritual leader, his/her soul may be ritually seated and regularly honored thereafter.

Axô (axo)
Clothing used within the precincts of the Ilê Aiyé.

Axogun
Male initiate responsible for performing the ritual sacrifices of animals for sacred ceremonies.

Ayaba
Feminine Orixá in Brazil; among the Yorùbá, Queen.

Babalorixá
Father of the Gods. Male title of the chief ritual administrator of the Orixás, Axé, and initiates of an Ilê Axé (Candomblé). Specially prepared and initiated for this leadership role. King. (In the summer of 2001, I noticed women ritual heads also being called by this title.)

Barco
Boat of initiates. Two or more individuals who are initiated and cloistered together. The metaphor of the boat refers to the voyage or transformation from uninitiated to Iyawo with all the knowledge, spiritual modification, and physical metamorphosis that process entails. The shared experiences ideally creates life-long ties.

Barracão
Large ballroom where public festivals take place. It is usually rectangular and may be roofed with tiles or palm leaves. It usually has a main door in the ceremonial room and ancillary doors for the kitchen area and the rooms where the Orixás' public ceremonial vestments are stored in trunks.

Bata

Insignia of those who have completed the ceremonies of the seven-year initiation. Consists of a short-sleeved, low-necked loose blouse which is worn over the skirt and extending several inches below the waist.

'Beje

Abbreviation used in Brazil for Yorùbá Ìbejì (twins). Also used to refer to Saints Cosme and Damião.

Caboclo

A general name given to spirits that embody indigenous Indian ancestors of Brazil.

Camizu

Blouse used by initiates called Iyawos (wives) with less than seven years of initiation or those who can not afford to graduate to the level of Ebomin by fulfilling the seventh-year initiation. Made with short sleeves, with a round neckline and worn inside the skirt. Those who have completed their seventh year initiation rituals may wear a *camizu* under the *bata* signifying their elder initiate status.

Candomblé

Site where African-derived deities are enshrined and ceremonies for them take place. Also colloquially, any public festival associated with African-Brazilian religions.

Candomblé Congo or Angola

Site where Central African/Bantu-derived deities are enshrined and ceremonies for them take place. Also colloquially, any public festival associated with Central African/Bantu religions. There is often assimilation of Nagô characteristics in clothing and characteristics of the deities, called Inquice or Inkice in Candomblé Congo or Angola. The head is usually a man and is called Tata-de-Inquice or father of the gods. The music is similar to contemporary Central African ritual music and the drums are beaten with the hands rather than with sticks as in Candomblé Nagô, producing a different sound.

Candomblé Nagô

Ilê Axés based on the religious and artistic archetypes derived from the

Yorùbá-speaking peoples of Nigeria and Benin Republic. A shortened form of Anago, a word for the Yorùbá used by Fon and Ewe speakers in Benin Republic.

Deka
Ritual performed for Ebomims who desire the position of Babalorixá or Iyalorixá and the right to open their own Ilê Axés. This ceremony constitutes the seven-year *obrigação*, validates their qualifications for the position, and transfers *axé*. Those receiving the *deka* commit themselves to the traditions and regulations of Candomblé Nagô. They receive the *axés* of their personal Orixás (previously housed in the collective shrine), beads signifying their new status, and sixteen cowrie shells to use for divination along with a sacred knife (*obe*) and other materials necessary to initiate others.

Dia de Orunko
Also called *Dia de Dar O Nome* (the day where the name is given [for the first time since cloistering for initiation]). Ceremony where the recent initiate's Orixá leaves the seclusion room to dance in public for the first time. Here the Orixá shouts and reveals his/her new name for the first time. This is the only instance where the Orixá of an Iyawo speaks.

Dobale
Masculine gesture of greeting and honoring the Orixás or the ritual heads by prostrating full length with the stomach touching the floor.

'Dou (Idowu)
Closely linked to twins as a third entity or companion. Present when there is a third figure accompanying Cosmas and Damian (Cosme and Damião; also called 'Beje). Among the Yorùbá, the child born immediately after twins is called Idòwú. In Brazil, Idòwú was abbreviated to 'Dou. 'Dou (Idòwú) receives the same foods and rituals that are performed for twins.

Ebomim
Initiate with more than seven years of initiation and who has completed the *deka* (the seven-year *obrigação*, or obligation, which is the next higher level initiation than Iyawo). It is from this class of initiates that an Iyálorixá may be selected to lead. Derives from the Yorùbá *egbon*

mi (elder relative). This class of initiates is distinguished by their use of a *bata*—short-sleeved, low-necked loose blouse which is worn over their skirts and extends several inches below their waists.

Egún/ Egúm

Spirit or soul of the deceased specially prepared to return to earth; ancestor; spirit of Death. Also, the collective deceased honored in separate shrines in certain Ilês Axes.

Ekede

Female who does not receive her Orixá in trance and undergoes a brief initiation. She is especially trained to take exclusive care of the entranced Orixás of the Iyawos and Ebomins. She dresses and undresses them during the *xire*, accompanies them so that they do not fall, and wipes the perspiration from their brows. She is trained to bring the Orixás out of their deep trances and into the brief, playful trance known as *ere*. She is often called *mãe* (mother) and may help the Iyalorixá with festival preparations. There are several Ekede active at any given moment and usually one ekede is assigned to care for one to three Orixás.

Erukere

A flywhisk made of cow- or horsetail hairs and used in Africa by kings, religious leaders, and chiefs. Used in Brazil by Yansan and Egun (ancestors).

Gèlè

Headties; a long, narrow piece of cloth.

Ìgbàle

Isolated sacred grove or space associated with deities or ancestors. Location where the *axê* of the Eguns is situated. Also known as 'Balé or Ilê Saim.

Ìbeji

In Brazil and Africa, the principal of duality represented by twins and regarded as Orixás and protectors of twins and multiple births. In Brazil, they are fused with Cosme and Damião (Catholic Saints Cosmas and Damian).

Ifá
Divination using sixteen palm nuts or the divining chain.

Iká (or Iká Òsi)
Feminine gesture of greeting and honoring the Orixás or the ritual heads by prostrating and turning first left, then right, before standing.

Ilê Agboulá
Locale where the society of priests revitalizes the *axé* of and holds public and private ceremonies for the Eguns (ancestors). Located in Bela Vista on the island of Itaparica, Bahia, approximately twenty kilometers by ferryboat or catamaran from Salvador. Currently headed by Alapini Domingo dos Santos of Ponto da Areia, Itaparica.

Ilê Axé
Initiate name for the locale where African-derived deities are enshrined and ceremonies for them take place. Synonymous with Candomblé. Also, interior shrine of a specific Orixá.

Inquice (Inkice)
Deities in Candomblé Congo or Angola.

Iya Kekere
Little mother, the second in command to the chief administrator of the Ilê Axé.

Iyalorixá
Mother of the Gods. Female title of the chief ritual administrator of the Orixás, Axé, and initiates of an Ilê Axé (Candomblé).

Ogan
A civil title awarded to men who are wealthy, famous, or distinguished and who are committed to support an Ilê Axé financially. They are chosen by the Orixá and suspended (lifted up) during a public ceremony or selected by the ritual head during divination. They undergo a minor initiation.

Ojá
Long narrow cloth used to wrap the head in a turban or to tie around the torso in a bow (for a Iyawo).

Oje
Initiated male priest of the Egun society.

Osse
Weekly, annual, or monthly offerings and/or sacrifices for a deity on his/her special day. The favorite foods and water are refreshed, and the shrine is cleaned. Afterwards, the Iyalorixá will divine with *obi* (kola nut) and music and songs played at major osse.

Pano da Costa
Rectangular cloth, plain or vividly striped, that forms part of the liturgical wear within the Ilê Axé and worn by Iyawos wrapped around the breasts, torso, and hips with the ends folded over each other in front of the body. Ebomins wear the *pano da costa* twisted around their waists, over their *batas*. Priestesses may wear it over their left or right shoulders. Formerly imported from Nigeria or woven in Bahia.

Terreiro
Group of land, properties, and houses where rituals, initiation, and religious ceremonies for deities take place.

Xire
The order in which the invocations to the deities are played and sung by the drummers, danced and sung by the initiates as they move in a counterclockwise circle known as a *roda*. This takes place at the beginning of private ceremonies or public festivals and the Orixás are sung for in a semihierarchical order, usually beginning with Ogun. (Exú is honored in the afternoons by a ritual called *pade*). Also means to play or have a good time, and public *xires* are very lively and gala affairs that complete a long day of internal preparatory rituals. In the *barracão*—the public ballroom—the *xire* officially begins when the Iyalorixá (or in her absence the Iya Kekere) enters, accompanied by her cortege. Then, the Iyawos and Ebomins begin to dance after first greeting the open entrance door; the sacred drums; the Iyalorixá, and finally the Iya Kekere.

Glossary of *Orixás*

The *orixás*, in order of hierarchical importance and ritual appearance in public festivals in Yorùbá or Bantu Candomblé, are Exu, Ogum, Omolu, Nanan, Oxumare, Oxossi, Logunede, Ossaim, Xango, Yansan, Oba, Oxum, Ewa, Yemanjá, Onile, Oxaguian, and Oxalufon (Pai Crispim, Salvador, Oct. 10, 1982, July 28, 1983, personal communication). I have organized the names of *orixás* here in alphabetical order for ease of reference.

Ewa
Rules the Yẹwa River in Ogun, Nigeria. Emotional, kind, devoted. Dances as if fighting defensively or molding a ball and throwing it upward. Holds a harpoon in her left hand and a sword in her right. Colors are red and yellow. Preferred sacrifices are white pigeon, guinea fowl. Preferred foods are sweet potatoes, fried bananas, ground corn. Syncretized with Joan of Arc. Ceremonial greeting is "Ri Ro!"

Exu
Rules all areas of the world without restriction. Serves as an intermediary between the gods, ancestors, and men. Each initiate, *egún*, and *orixá* has a personal Exu with a specific name and specific duties. Exu is the first deity to be propitiated in any ritual but does not incorporate in humans except in Bantu-derived Candomblés. Colors are red and black. Preferred sacrifices are black he-goat, black rooster. Preferred food and drink are palm oil, manioc flour mixed with palm oil (*farofa*), and plain white rum. Erroneously syncretized with the devil. Ceremonial greeting is "Tutu Laroye!"

Logunede

Hunter who is female during certain periods and male during others and is linked with the forest. Calm, refined. Dances with a bow and arrow (*ofá*) and fan in a modified hunter's dance. Colors are turquoise, blue, and crystal yellow. Preferred sacrifices are castrated bull (*oda*) and armadillo (*tatu*). Preferred foods are *axoxo* and black-eyed peas mixed with boiled eggs (*omolocum*). Syncretized with São Miguel Arcanjo. Son of Oxossi and Oxum Ponda. Ceremonial greeting is "Logun!"

Nanan

Rules water and is the eldest of all *orixás* linked with water. Austere, hard working, celibate. Dances rocking an *ibiri* (palm rib staff similar to the *xaxara*, or broom, of Omolu). Wears a nonbeaded, veiled cloth crown and bracelets made of raffia and cowries. Colors are dark blue and white. Preferred sacrifices are hen, nanny goat, guinea fowl. Preferred food is a starchy mass made with finely ground black-eyed peas (*andere*). Syncretized with Sant'Anna. Mother of Oxumare and Omulu. Ceremonial greeting is "Saluba!" Known also as Nana Buruku.

Oba

Rules over the Oba River. One of the wives of Xango. Timid, charming. Often dances covering her left ear. At other times, holds a sword in one hand and a small shield in the other. Colors are red and white. Preferred sacrifices are nanny goat, duck, guinea fowl. Preferred food is ground black-eyed peas wrapped in banana leaves and steamed (*abara*). Syncretized with Santa Catarina. Ceremonial greeting is "Oba Xiree!"

Ogum

Rules over all metal, especially iron, and war. Aggressive, bold, athletic. Dances in a warlike manner. Wears a special crown (*akoro*) and armor. Carries two metal cutlasses. Color is green or dark blue. Preferred food is feijoada. Syncretized with Santo Antonio. Mythical relationships vary from husband of Yemanjá Ogunte to son of Iyá Tanan and Yemanjá Assabá. Ceremonial greeting is "Ogunhe!"

Omolu

Rules smallpox, fever, and epidemic diseases. Secretive, stubborn, antisocial. Dances bent over very low to the ground. Carries a ritual broom and is covered with raffia. Color is black combined with white or red.

Preferred sacrifices are pig, rooster, he-goat. Preferred foods are popcorn (*agbodo*), finely chopped organ meats cooked with palm oil (*rampatere*). Syncretized with São Lazaro, São Roque, or São Bento. Known in Candomblé as OBALUAIYE, XAPANA, and SOPPONA. Son of Nanan. Ceremonial greeting is "Atoto!"

Onile
Rules the earth and does not incorporate in humans. Symbol is a large triangular mound of hard-packed earth. Preferred sacrifice is he-goat. Preferred food is palm oil.

Ossaim
Rules the *axé* in sacred leaves and medicines and is linked with the forest. Intuitive, elegant, sensitive, Dances rapidly in hopping, skipping movements, often on one leg. Carries an iron staff with seven or more points and a bird in the middle extending upward from the base. Color is mint green. Preferred sacrifices are he-goat, rooster. Preferred foods are black beans, manioc meal. Syncretized with São Benedito. Ceremonial greeting is "Ewe O!"

Oxaguian
Youthful aspect of Oxalá, the creator god. Dynamic, brave, warriorlike. Dances very actively and aggressively in a warrior mode. Holds a small shield in his right hand and a short thick staff in his left. Colors are periwinkle blue (as in *segi,* the tubular beads made in ancient Ife) and opaque white. Preferred sacrifices are guinea fowl, hen, she-goat. Preferred food is unsalted pounded yam. Syncretized with the adolescent Jesus Christ. Ceremonial greeting is "Epa!"

Oxalufon
Elder aspect of Oxalá. Rules birth and creativity. Tranquil, moral, inflexible. Dances in a very slow rhythm bent low to the ground in the manner of a very tired old man. Frequently covered by a white cloth (*ala*), the ends of which are held protectively by the other *orixás* manifested in the festival. Carries a multilayered staff (*paxoro*) and sometimes a fan. Color is opaque white. Preferred sacrifices are white pigeon, white hen, white goat. Preferred food is unsalted boiled white corn or unsalted pounded yam. Syncretized with the mature Jesus Christ. Father of all *orixás* and husband to Nanan and Yemanjá. Ceremonial greeting is "Epa Baba!"

Oxossi

Rules the hunt and is connected with the forest. Introverted, unstable, intellectual. Dances as an aggressive hunter pursuing and capturing game. May drop to the floor and pantomime moving through tall grasses. Wears two powder horns, holds a bow and arrow and one or two horsehair fly whisks. Color is turquoise blue. Preferred sacrifices are he-goat, pig, the head of a bull, rooster, guinea fowl. Preferred foods are boiled yellow corn slightly sweetened and mixed with coconut (*axoxo*), yams, and black beans. Syncretized with São Jorge. Ceremonial greeting is "Oke Aro!"

Oxum

Rules the Osun River in Oshogbo, Nigeria. Beautiful, vain, deceitful. Dances as if preening herself at a riverbank—looking in a mirror and adjusting her clothing and adornments. Dances in a rhythm called *ijexa*, holding her skirts up and on her tiptoes. Carries a fan. Colors vary from crystal yellow to opaque chartreuse. Preferred sacrifices are duck, hen, guinea fowl, nanny goat. Preferred foods are a mixture of black-eyed peas, onion, and shrimp (*omulucum*) and cornmeal mush mixed with honey and vegetable oil (*adun*). Syncretized with Nossa Senhora das Candeias. Youngest wife of Xango. If the *orixá* Oxum is manifested at the same time as Oba, a fight between the two usually ensues. Ceremonial greeting is "Ore Yeye O!" Known also as Oxun.

Oxumare

Rules the rainbow. Inquisitive, intelligent, artistic. Dances in a snake-like motion, often writhing on the floor, or dancing upright in a frontal march with hands alternating toward the ceiling and floor. Holds a metal snake in each hand. Colors are green, pink, yellow. Preferred sacrifices are he-goat, rooster, guinea fowl. Preferred food is boiled white corn mixed with coconut. Syncretized with São Bartolomeu. Son of Nanan. Ceremonial greeting is "Aro Moboi!"

Xango

Rules thunder and lightening. Formerly king (*alafin*) of Oyo, Nigeria. Proud, aggressive, stubborn. Dances rapidly to a rhythm called *bata* in a royal yet warriorlike manner. Holds a double-bladed metal or wooden axe (*oxe*) that is brandished from side to side. Colors are red and white. Preferred sacrifices are sheep, turtle, rooster. Preferred food is chopped

and seasoned okra topped with whole okras cooked with beef (*amala*) and served with round white yam balls. Syncretized with São Jeronimo. Husband of Yansan, Oxum, and Oba and son of Yemanjá. Ceremonial greeting is "Kawo Kabiesile!" Also known as Shango or Ṣango.

Yansan

Rules tempests and, in the aspect of Yansan 'Bale, rules cemeteries and the dead. Sensual, forceful, unfaithful. Dances rapidly from side to side with arms waving. Carries one or two fly whisks (*erukẹre*) and a sword. Colors are bright to earth red. Preferred sacrifices are nanny goat, hen, guinea fowl. Preferred foods are fried cake of ground black-eyed peas (*acarajé*) and cooked okra cut in circular rounds (*caruru*). Syncretized with Santa Barbara. Wife of Xango and mother of Egum. Ceremonial greeting is "Epa Hei!" Also known as Oya.

Yemanjá (also Yemọjá, Iemanjá)

Rules the Ogun River in Nigeria. Calm, serious, dignified. Dances in movements simulating waves: two or three steps forward and one backward. Carries a fan. Colors are crystal white and crystal blue or green. Preferred sacrifices are duck, guinea fowl, nanny goat. Preferred food is boiled white corn mixed with onion and oil. Syncretized with the Virgin Mary (Nossa Senhora de Conceição). Mother of all the *orixás* except Omolu and Oxumare. Ceremonial greeting is "Odo Iyá!"

References

Abimbola, Ogunwande. 1971. "The Yoruba Concept of Human Personality." In *La Personne en Afrique Noire*. Colloques Internationaux du Centre National de la Recherche Scientifique, no. 544: 73–89. Paris: Centre National de la Recherche Scientifique.

———. 1976. *Ifá: An Exposition of the Ifá Divination Corpus*. Ibadan, Nigeria: Oxford University Press.

Abiodun, Rowland. 1990. "The Future of African Studies: An African Perspective." In *African Art Studies: The State of the Discipline*, Symposium Publication. Washington D.C.: Smithsonian Institution Press.

———. 1994a. "Understanding Yorùbá Art and Aesthetics: The Concept of Àṣe." *African Arts* (July): 68–78, 102.

Abiodun, Rowland, Henry J. Drewal, and John Pemberton, eds. 1989. *Yorùbá: Nine Centuries of African Art and Thought*. New York: Center for African Art.

———. 1994b. *The Yorùbá Artist: New Theoretical Perspectives on African Arts*. Washington D.C.: Smithsonian Institution Press.

Ajuwon, Bade. 1984. "Myth and Principle of Predestination in Yorùbá Folk Culture." *New York Folklore* 10 (1–2): 89–98.

Akinjogbin, I. A. 1967. *Dahomey and Its Neighbors 1708–1818*. Cambridge: Cambridge University Press.

Apter, Andrew. 1992. *Black Critics and Kings: The Hermeneutics of Power in Yorùbá Society*. Chicago: University of Chicago Press.

Asiwaju, A. I. 1976. *Western Yorubaland under European Rule 1889–1945*. London: Longman.

Babayemi, S. O. 1980. *Egungun Among the Oyo Yoruba*. Ibadan, Nigeria: Board Publications.

Barata, Mario. 1941. "Arte Negra." *Revista da Semana* 62(20).

———. 1957. "A Escultura de Origem Negra no Brazil." *Brazil Arquitetura Contemporanea* 9:51–57.

———. 1966. "Le Noir dans les Artes Plastiques au Bresil." *SOPIE*.

Barber, Karen. 1991. *I Could Speak until Tomorrow: Oriki, Women, and the Past in a Yorùbá Town*. Washington D.C.: Smithsonian Institution Press.

Barnes, Sandra T, ed. 1989. *Africa's Ogun: Old World and New*. Bloomington: Indiana University Press.

Bascom, William, 1993. *Sixteen Cowries: Yoruba Divination from Africa to the New World.* Bloomington: Indiana University Press.

Bastide, Roger. 1960. *Les Religions Africaines au Bresil: Contribution a une Sociologie des Interpenetrations des Civilisations.* Paris: Presses Universitaires.

——. 1961. *O Candomblé da Bahia: Rito Nagô.* Trans. Maria Isaura Pereira de Queiroz. São Paulo: Companhia Editora Nacional.

——. 1968. "The Function and Significance of Negro Art in the Life of the Brazilian People." Colloquium on Negro Art, Dakar, Senegal. Proceedings.

——. 1978a. *African Religions in Brazil: Toward A Sociology of the Interpenetration of Civilizations.* Trans. Helen Sebba. Baltimore: Johns Hopkins University Press.

——. 1978b. *O Candomblé da Bahia (Rito Nagô).* São Paulo.

Biobaku, S. O., ed. 1973. *Sources of Yoruba History.* Oxford: Clarendon.

Bogatyrev, Petr. 1971. *The Function of Folk Costume in Moravian Slovakia.* Approaches to Semiotics 5. The Hague: Mouton.

Borgatti, Jean. 1983. *Cloth as Metaphor: Nigerian Textiles from the Museum of Cultural History.* Los Angeles: UCLA Monograph Series.

Braga, Julio. 1988. *O Jogo do Búzios: Um Estudo da Adivinhação no Candomblé.* São Paulo: Editora Brasiliense.

Bramly, Serge. 1977. *Macumba: The Teachings of Maria-Jose, Mother of the Gods.* Trans. Meg Bogin. New York: St. Martin's.

Brown, David H. 1996. "Toward an Ethnoaesthetics of Santeria Ritual Arts: The Practice of Altar-Making and Gift-Exchange." In *Santeria Aesthetics in Contemporary Latin American Art,* ed. Arturo Lindsay. Washington DC: Smithsonian Institution Press.

Carise, Iracy. 1975. *A Arte Negra na Cultura Brasileira.* Rio de Janeiro.

Carneiro, Édison. [1948] 1967. *Candomblés da Bahia.* 4th ed. Rio de Janeiro: Edições de Ouro.

——. 1981a. *Religões Negras.* 2nd ed. Rio de Janeiro.

——. 1981b. *Negros Bantos.* 2nd ed. Rio de Janeiro.

Castro, Yêda Pessoa de. 1976. *De L'integrations des apports africaines dans les parlers de Bahia au Bresil.* Ph.D. diss., Université Nacional du Zaire.

——. 1978. *Contos Populares da Bahia.*

Clifford, James. 1988. *The Predicament of Culture: 20th Century Ethnography, Literature and Art.* Cambridge, Mass.: Harvard University Press.

Collins, Patricia Hill. 1990. *Black Feminist Thought: Knowledge, Consciousness, and the Politics of Empowerment.* Vol. 2 of *Perspectives on Gender.* New York: Routledge.

——. 1991. "Learning from the Outsider Within: The Sociological Significance of Black Feminist Thought." In *(En) Gendering Knowledge: Feminists in Academe,* ed. Joan E. Hartman and Ellen Messer-Davidow. Knoxville: University of Tennessee Press.

Cosentino, Donald J., ed. 1995. *The Sacred Arts of Haitian Vodou.* Los Angeles: UCLA Fowler Museum of Cultural History.

Costa Lima, Vivaldo. 1967. "O Conceito de 'Nação' dos Candombles da Bahia." *Afro-Asia.* Salvador: CEAO.

―――. 1977. *A familia-de-Santo nos Candombles Jeje-Nagos da Bahia: Um Estudo de Relaçoes Intra-Grupais.* Tese de Mestrado em Ciencias Humanas, Universidade Federal da Bahia.

Courlander, Harold. 1973. *Tales of Yoruba Gods and Heroes.* Greenwich, Conn.: Fawcett.

Dantas, Beatriz Gois. 1988. *Vovo Nagô e Papai Branco: Usos e Abusos da Africa no Brazil.* Rio de Janeiro: Graal.

Dark, Philip. 1966. "The Ethno-Aesthetic Method." In *Essays on the Verbal and Visual Arts,* ed. June Helm. Proceedings of the Annual Spring Meeting of the American Ethnological Society. Seattle: University of Washington Press.

David-Danel, Marie-Louise. 1958. *Iconographie des Saints Medicins Cosme et Damien.* Lille, France.

Debret, Jean Baptiste. 1840. *Viagem Pitoresca e Historica ao Brasil desde 1816 ate 1831.* São Paulo.

Dipert, Randall R. 1993. *Artifacts, Art Works, and Agency.* Philadelphia: Temple University Press.

do Carmo Povoas, Ruy. 1989. *A Linguagem do Candomble: Niveis Sociolinguisticas de Integracao Afro-Portuguesa.* Rio de Janiero: Sindicato Nacional dos Editores dos Livros.

do Prado Valladares, Clarival. 1969a. "A Iconografia Africana no Brazil." *Revista Brasileira da Cultura* 1.

―――. 1969b. "O Negro nas artes plasticas." *Cadernos Brasileiros.*

―――. 1976. "Aspectos da iconografia afro-brasileira." *Cultura.*

dos Santos, Deoscoredes Maximiliano. N.d. West African Sacred Art and Rituals in Brazil: A Comparative Study. Unpublished Manuscript.

dos Santos, Juana Elbein. 1962. *Axé Opô Afonjá: Noticia Historica de um Terreiro de Santo da Bahia.* Rio de Janeiro: Instituto Brasileiro de Estudos Afro-Asiaticos.

―――.1976. *Os Nagô e a Morte: Pade, Asese e o Culto Egun na Bahia.* Petropolis: Editora Vozes.

―――. 1981. "O culto dos ancestrais na Bahia: O Culto do Egun." *Oloroorisa.* São Paulo: Agoa.

Drewal, Henry John, and David Driskell. 1989. *Introspectives: Contemporary Art by Americans and Brazilians of African Descent.* Exhibition Catalog. California Afro-American Museum, Los Angeles.

Drewal, Henry John, and John Mason. 1998. *Beads Body and Soul: Art and Light in the Yorùbá Universe.* Los Angeles: UCLA Fowler Museum of Cultural History.

Drewal, Margaret Thompson. 1992. *Yorùbá Ritual: Performers, Play, Agency.* Bloomington: Indiana University Press.

Eco, Umberto. 1985. "How Culture Conditions the Colours We See." In *On Signs,* ed. Marshall Blonsky, 157. Baltimore: Johns Hopkins University Press.

Ellis, A. B. 1894. *The Yorùbá-Speaking Peoples of the Slave Coast of West Africa.* London: Curzon.

Eyo, Ekpo, and Frank Willet. 1980. *Treasures of Ancient Nigeria.* New York: Knopf.

Fontaine, Pierre-Michel. 1985. *Race, Class, and Power in Brazil.* Los Angeles: Center for Afro-American Studies, University of California, Los Angeles.

Gates, Jr., Henry Louis. 1988. *Signifying Monkey: A Theory of African-American Literary Criticism.* New York: Oxford University Press.

Giddens, Anthony. 1994. "From *The Consequences of Modernity*" in Williams and Chrisman 1994.

Gray, John, comp. 1989. *Ashe, Traditional Religion and Healing in Sub-Saharan Africa and the Diaspora: A Classified International Bibliography.* Westport, Conn.: Greenwood.

Guilhermino, Sebastião. 1989. *Iansa do Bale: Senhora Dos Eguns,* Rio de Janeiro: Pallas Editora.

Hadjinicolaou, Nicos. 1978. *Art History and Class Struggle.* London: Pluto.

Harding, Rachel E. 2000. *A Refuge in Thunder: Candomblé and Alternative Spaces of Blackness.* Bloomington: Indiana University Press.

Harris, Marvin. 1956. *Town and Country in Brazil.* New York: Random House.

Harris, Marvin, and Charles Wagley. 1958. *Minorities in the New World: Six Case Studies.* New York: Columbia University Press.

Harvey, David. 1995. *The Condition of Postmodernity: An Inquiry into the Origins of Cultural Change.* Cambridge, Mass.: Blackwell.

Herskovits, Melville. 1966. *The New World Negro.* Selected Papers in Afro-American Studies. Bloomington: Indiana University Press.

Hobsbawm, Eric J., and Terence Ranger, eds. 1983. *The Invention of Tradition.* New York: Cambridge University Press.

Holweck, Rt. Rev. F. G. N.d. *A Biographical Dictionary of the Saints.* London.

hooks, bell. 1995. *Art on My Mind: Visual Politics.* New York: New Press.

Idowu, E. B. 1962. *Olódùmarè: God in Yorùbá Belief.* London: Longman.

Jameson, Fredric. 1994. *Postmodernism.* Durham, N.C.: Duke University Press.

Johnson, Samuel. 1921. *History of the Yorùbás.* London: Routledge and Kegan Paul.

La Duke, Betty. 1985. *Compañeras: Women, Art, and Social Change in Latin America.* San Francisco: City Lights Books.

Landes, Ruth. 1947. *City of Women.* New York: Macmillan.

Law, Robin. 1977. *The Oyo Empire: C. 1600–1836.* Oxford: Oxford University Press.

Lawal, Babatunde. 1970. Yorùbá Sango Sculpture in Historical Retrospect. Ph.D. diss., Indiana University, Bloomington.

———. 1996. *Gelede: African Art and Spectacle.* Seattle: University of Washington Press.

Lindsay, Arturo. 1996. *Santeria Aesthetics in Contemporary Latin American Art.* Washington D.C.: Smithsonian Institution Press.

Lody, Raul. 1987. *Candomblé: Religião e Resistencia Cultural.* São Paulo: Editora Atica.

Mercier, Paul. 1963. "The Fon of Dahomey." *African Worlds,* ed. D. Forde. London and New York: Oxford University Press for the International African Institute.

Mintz, Sidney, and Richard Price. 1992. *The Birth of Afro-American Culture: An Anthropological Perspecitve.* Boston: Beacon.

Morton-Williams, Peter. 1960. "Yoruba Responses to the Fear of Death." *Africa* 30 (1): 34–40.

Murphy, Joseph. 1988. *Santeria: An African Religion in America*. Boston: Beacon.
————. 1994. *Working the Spirit: Ceremonies of the African Diaspora*. Boston: Beacon.
Narayan, Kirin. 1993. "How Native is the Native Anthropologist." *American Anthropologist* 95:671.
Nina Rodrigues, Raimundo. [1896] 1935. *O Animismo Fetichista dos Negros Bahianos*. Rio de Janeiro: Civiização Brasileira, s.a.
————. 1904. "As Bela Artes nos Colonos Pretos [sic] no Brazil." *Kosmos* (May).
————. [1905] 1977. Os Africanos no Brasil. São Paulo: Companhia Editora Nacional.
Òjó, G. J. A. 1966. Yoruba Culture: A Geographical Analysis. London: University of London Press.
Omari, Mikelle Smith. 1984. *From the Inside to the Outside: The Art and Ritual of Bahian Candomblé*. Monograph Series No. 24. Los Angeles: Museum of Cultural History, University of California.
————. 1991. "Critique." In *African Art Studies: The State of the Discipline*. Washington, D.C.: Smithsonian Institution Press.
Pierson, Donald. 1942. *Negroes in Brazil: A Study of Race Contact at Bahia*. Chicago: University of Chicago Press.
Pollock, Griselda. 1988. *Vision and Difference: Femininity, Feminism, and Histories of Art*. New York: Routledge.
Prandi, Reginaldo. 1991. *Os Candomblés de São Paulo*. São Paulo: Editora Hucitec Editora Da Universidade de São Paulo.
Price, Richard and Sally. 1980. *Afro-American Arts of the Suriname Rain Forest*. Los Angeles: UCLA Museum of Cultural History.
Querino, Manoel. 1938. *Costumes Africanos no Brasil*. Rio de Janeiro: Civilazação Brasileira.
Ramos, Artur. 1935. *O Folclore Negro do Brasil*. Rio de Janeiro: Casa do Estudante do Brasil.
————. 1940. *O Negro Brasileiro*. São Paulo: Companhia Editora Nacional.
————. 1942. *A Aculturação Negra no Brasil*. São Paulo.
Rio, João do. 1906. *Religioes no Rio*. Rio de Janeiro.
Said, Edward W. 1994. *Culture and Imperialism*. New York: Vintage.
Seljan, Zora A. O. 1973. *Iemanjá: Mae dos Orixás*. São Paulo: Editora Afro-Brasileira.
Tabor, Margaret. [1908] 1969. *The Saints in Art*. Detroit: Gale Research.
Tagg, John, ed. 1989. *The Cultural Politics of "Postmodernism."* Binghamton, New York: State University of New York.
Thompson, Robert Farris. 1972. "The Sign of the Divine King: Yoruba Bead-Embroidered Crowns with Veil and Bird Decorations." In *African Art and Leadership*, ed. Herbert Cole and Douglas Fraser. Madison: University of Wisconsin Press.
————. 1975. "Icons of the Mind: Yorùbá Herbalism Arts in Trans-Atlantic Perspective." *African Arts* 8(30): 2–59.
————. 1983. *Flash of the Spirit: African and Afro-American Art and Philosophy*. New York: Random House.

——. 1993. *Faces of the Gods: Art and Altars of Africa and the African Americas.* New York: Museum of African Art.

Turner, Victor. 1967. *The Forest of Symbols: Aspects of Ndembu Ritual.* Ithaca, NY: Cornell University Press.

Van Gennep, Arnold. 1961. *Rites of Passage.* Chicago: University of Chicago Press.

Verger, Pierre. 1954. *Dieux d'Afrique, Culte des Orishas et Vodouns a l'Ancienne Cote des Esclaves en Afrique et a Bahia, la Baie de tous les Saints au Bresil.* Paris: Paul Hartmann Editeur.

——. 1957. *Notes sur le culte des Orisa et Vodun, a Bahia, la Baie de tous les Saints, au Bresil et a l'Ancienne Cote des Esclaves en Afrique.* Dakar: Institut Français d'Afrique Noire.

——. 1980. "Orixás da Bahia." *In Iconografia dos Deuses Africanos no Candomblé da Bahia.* Salvador, Bahia.

——. 1981a. *Noticias da Bahia: 1850.* Salvador, Bahia.

——. 1981b. *Orixás (Deuses Iorubás na Africa e no Novo Mundo).* Salvador, Bahia: Corrupio.

Wafer, Jim. 1991. *The Taste of Blood: Spirit Possession in Brazilian Candomblé.* Philadelphia: University of Pennsylvania Press.

Wagley, Charles. 1952. *Race and Class in Rural Brazil.* Paris: UNESCO.

Warren, Dennis, and Kwaku Andrews. 1977. *An Ethno-scientific Approach to Akan Arts and Aesthetics.* Philadelphia: Institute for the Study of Human Issues.

Westcott, Joan. 1962. "The Sculpture and Myths of Èshu-Elegbá, the Yoruba Trickster." *Africa* 32 (4): 337–54.

Williams, Patrick, and Laura Chrisman, eds. 1994. *Colonial Discourse and Post-Colonial Theory.* New York: Columbia University Press.

Wolff, Norma. 1982. "Egungun Costuming in Abeokuta." *African Arts* 15 (3): 66–70.

Yai, Olabiyi Babalola. 1994. "In Praise of Metonymy: The Concepts of 'Tradition' and 'Creativity' in the Transmission of Yoruba Artistry over Time and Space." In *The Yorùbá Artist: New Theoretical Perspectives on African Arts,* ed. Rowland Abiodun, et al. Washington D.C.: Smithsonian Institution Press. 107–115.

Additional Readings

Adams, Laurie Schneider. 1996. *The Methodologies of Art: An Introduction.* New York: Harper Collins.

Araujo, Emanoel. 1994. *Art in Afro-Brazilian Religion.* São Paulo: Camara Brasileira do Livro.

Bascom, William. 1980. *Sixteen Cowries: Yorùbá Divination from Africa to the New World.* Bloomington: Indiana University Press.

———. 1991. *Ifá Divination: Communication between Gods and Men in West Africa.* 2nd. ed. Bloomington: Indiana University Press.

Ben-Levi, Jack, et al. 1993. *Abject Art: Repulsion and Desire in American Art.* New York: Whitney Museum of American Art.

Bettelheim, Judith, and John W. Nunley. 1988. *Caribbean Festival Arts: Each and Every Bit of Difference.* Seattle: University of Washington Press.

Bickers, Patricia. *Vicious Circle.* Exhibition Catalog. Douglas Hyde Gallery, Dublin.

Birman, Patricia. 1995. *Fazer Estilo Criando Generos: Possessão e Differença De Genero Em Terreiros De Umbanda E Candomblé No Rio De Janeiro.* Rio de Janeiro: Relume Dumara.

Blier, Suzanne Preston. 1991. "African Art Studies at the Cross-Roads: An American Perspective." In *African Art Studies—The State of the Discipline,* 91–107. Washington, D.C.: National Museum of African Art, Smithsonian Institution.

———. 1993. "Truth and Seeing: Magic, Custom and Fetish in Art History." In *African and the Disciplines: The Contributions of Research in Africa to the Social Sciences and Humanities,* ed. Robert H. Bates et al., 139–52. Chicago: University of Chicago Press.

———. 1995. *African Vodun: Art, Psychology, Power,* Chicago: University of Chicago Press.

Boime, Albert. 1990. *The Art of Exclusion: Representing Blacks in the Nineteenth Century.* Washington: Smithsonian Institution Press.

Brown, David H. 1993. "Thrones of the *Orichas:* Afro-Cuban Altars in New Jersey, New York and Havana." *African Arts* (October): 44–59, 85–87.

Brown, Diana D. 1985. *Umbanda: Religion and Politics in Urban Brazil.* Ann Arbor, Mich. UMI Research.

Browning, Barbara. 1995. *Samba: Resistance in Motion.* Bloomington: Indiana University Press.

Carneiro, Maria Luiza Tucci. 1994. *History em Movimento: O Rascismo na History do Brazil: Mito e Realidade.* São Paulo: Editora Atica, S.A.

Cole, Herbert M. 1989. *Icons: Ideals of Power in the Art of Africa.* Washington D.C.: National Museum of African Art, Smithsonian Institution Press.

Conniff, Michael, and Thomas J. Davis. 1994. *Africans in the Americas: A History of the Black Diaspora.* New York: St. Martin's.

Cunningham, Patricia A., and Susan Voso Lab. 1991. *Dress and Popular Culture.* Bowling Green, Ohio: Bowling Green State University Press.

Derrida, Jacques, 1982. "Sending: On Representation." *Social Research* 49 (2): 294–326.

De Zegher, M. Catherine, ed. 1995. *Inside the Visible: An Elliptical Traverse of 20th Century Art.* Cambridge, Mass.: MIT Press.

Dissanayake, Ellen. 1988. *What Is Art For?* Seattle: University of Washington Press.

Fernie, Eric, comp. 1995. *Art History and Its Methods: A Critical Anthology.* London: Phaiden.

Foster, Hal. 1996. *The Return of the Real: The Avant-Garde at the End of the Century.* Cambridge, Mass.: MIT Press.

Gilroy, Paul. 1993. *The Black Atlantic: Modernity and Double Consciousness.* London: Verso.

Hall, Stuart. 1996. *Questions of Cultural Identity.* Thousand Oaks, Calif.: Sage.

———. 1997. *Representation: Cultural Representations and Signifying Practices.* Thousand Oaks, Calif.: Sage.

Harris, Joseph et al. 1996. *The African Diaspora.* Arlington: Texas A&M University Press.

Hemingway, Andrew, and William Vaughan, eds. 1998. *Art in Bourgeois Society, 1790–1850.* Cambridge, Eng.: Cambridge University Press.

Holbrook, Morriss B., and Elizabeth C. Hirschman. 1993. *The Semiotics of Consumption: Interpreting Symbolic Consumer Behavior in Popular Culture and Works of Art.* Berlin: Mouton de Gruyter.

Lash, Scott, and Jonathan Friedman, eds. 1996. *Modernity and Identity.* 4th ed. Oxford: Blackwell.

Lavin, Maude. 1993. *Cut with the Kitchen Knife: The Weimar Photomontages of Hannah Hoch.* New Haven: Yale University Press.

Leacock, Seth and Ruth. 1972. *Spirits of the Deep: A Study of an Afro-Brazilian Cult.* New York: Doubleday Natural History.

Lemelle, Sidney. 1994. *Imagining Home: Class, Culture, and Nationalism in the African Diaspora.* New York: Verso.

Matory, James L. 1994. *Sex and the Empire That Is No More: Gender and the Politics of Metaphor in Oyo Yorùbá Religion.* Minneapolis: University of Minnesota Press.

Mattoso, Katia M. De Queiros. 1992. *Bahia: Seculo XIX—Uma Provincia no Imperio.* 2nd ed. Rio de Janeiro: Editora Nova Fronteira.

Maw, Joan, and John Picton, eds. 1992. *Concepts of the Body/Self in Africa.* Verof-

fentlichun gen der Institue fur Africanistik und Agyptologie de Universitat Wien: Afro-Pub, Herausg.

Moxey, Keith. 1994. *The Practice of Theory: Poststructuralism, Cultural Politics, and Art History.* Ithaca: Cornell University Press.

Mudimbe, V. Y. 1994. *The Idea of Africa.* Bloomington: Indiana University Press.

Nascimento, Abdias do. 1980. *O Quilombismo: Documentos de uma Militancia Pan-Africanista.* Rio de Janeiro, Brazil: Vozez.

Nelson, Robert S., and Richard Shiff. 1996. *Critical Terms for Art History.* Chicago: University of Chicago Press.

Nooter, Mary H. et al. 1993. *Secrecy: African Art that Conceals and Reveals.* New York: Museum for African Art; Munich: Prestel Verlag.

Okpewho, Isodore et al., eds. 1998. *The African Diaspora: African Origin and New World Identities.* Bloomington: Indiana University Press.

Pollock, Griselda. 1993a. *Avant-garde Gambits 1888–1893: Gender and the Color of Art History.* New York: Thames and Hudson.

———. 1993b. *Vision and Difference: Femininity, Feminism and the Histories of Art.* 6th ed. Routledge: London.

Preziosi, Donald. 1989. *Rethinking Art History: Meditations on a Coy Science.* New Haven: Yale University Press.

———. 1992. *Equatoria.* New York: Routledge.

———. 1998. *Maroon Arts: Cultural Vitality in the African Diaspora.* Boston: Beacon.

Price, Sally. 1984. *Co-Wives and Calabashes.* Ann Arbor: University of Michigan Press

———. 1989. *Primitive Art in Civilized Places.* Chicago: University of Chicago Press.

Riserio, Antonio. 1981. *Carnaval Ijexa,* Salvador, Bahia: Corrupio.

Rubinstein. Ruth P. 1995. *Dress Codes: Meanings and Messages in American Culture:* Boulder: Westview.

Russell, Kathy et al. 1992. *The Color Complex: The Politics of Skin Color among African Americans.* New York: Anchor, Doubleday.

Scott, David. 1991. "That Event, This Memory: Notes on the Anthropology of African Diasporas in the New World." *Diaspora* 1(3):261–84.

Silva, Nelson do Valle. 1992. *Relacces Raciais no Brazil Contemporaneo.* Rio Fundo Editora.

Silverman, Kaja. 1983. *The Subject of Semiotics.* New York: Oxford University Press.

Smagula, Howard, ed. 1991. *Re-Visions: New Perspectives of Art Criticism.* Englewood Cliffs, N.J.: Prentice Hall.

Souza, Gilda de Mello e. 1987. *O Espirito Das Roupas: A Moda No Seculo Dezenove.* São Paulo: Editora Schwarcz.

Spitz, Ellen Handler. 1985. *Art and Psyche: A Study in Psychoanalysis and Aesthetics.* New Haven: Yale University Press.

Sterling, Susan Fisher. 1994. *Signifying: Photographs and Texts in the Work of Carrie Mae Weems.* Exhibit Catalog. Washington, D.C.: National Museum of Women in the Arts.

Vansina, Jan. 1984. *Art History in Africa: an Introduction to Method.* London: Longman.

Vogel, Susan et al. 1989. *Art/Artifact: African Art in Anthropology Collections.* 2nd ed. New York: Center for African Art; Munich: Prestel.

Walker, Sheila S. 1972. *Ceremonial Spirit Possession in Africa and Afro-America.* Leiden: Brill.

Index

Page numbers in italics refer to photographs.

bata, 46, 60, 61, 140, 142
Bate Folha, 14
'beje, 50, 111, 120, 121, 140
Bela Vista, 81
beleza, 43
bembe, xviii
Bird, Annette, 133n22
blood sacrifices, 1, 18
blusa, 79
boa aparencia, 9
Bogatyrev, Petr, 52, 57
Bogum, 14
boiadeiros, 15
bordado of the *axô* Yemanjá, 79
Braga, Julio, 93
branqueamento (whitening), 9
Brazil: abolishment of slavery in,
 3; political map of, *6;* Yorùbá
 hegemony in, 132n18. *See also*
 African Brazilian religion and
 sacred art, Yorùbá-derived;
 African Brazilians; Luso-Brazilian
 society
Brown, David, xxviii
bùbá, 134n4

cabaça, 105
Caboclo, 1, 140, Plate 4; *candomblés,*
 14–16; shrine, Plate 3
Caboclo do Mato, 15
cachaça, 15, 102, 107
camizu, 46, 47, 48, 140, Plate 13
candomblés Angola, 14, 16, 140
candomblés Congo, 14, 16, 140
candomblés Nagô *Egún*, 101
candomblé(s) Nagô *(ilê axés)*, 1–2, 35;
 African-derived pan-Brazilian
 constructions, 1, 7, 12; attraction
 of for white Brazilians, 3–4, 22;
 Bahian, 16–21; canons of, 21;
 as centers of cultural resistance
 and power, 8, 11–13; changes
 in, xxiii; closeness to the gods
 desired and highly valued in, 23;

clothing as the most important
 two-dimensional art form, xxv;
 concerned with maintaining "pure"
 African traditions, 5; defined, 2,
 140, 143; elite, 17; essential
 role of art in, 126–27; function
 as mutual aid organizations,
 24; group-orientation, 12, 23;
 hierarchy, 23, 57–63; initiations,
 13; land held in common, 24;
 lineage, 13; microarena of wider
 society, 125; as microcosms of
 "Africa," xxiv–xxv, xxix, 4–9;
 origination in Bahia, 1; *orixá,*
 101; as a physical site, 48, 133n2;
 priests/practitioners, xx; principles
 of barter and redistribution,
 12; prior to 1888, 3; privileging
 of verbal/nonverbal Yorùbá
 phraseology, 8; proletarianism,
 19; protocol in, 57, 59; in Rio
 de Janeiro, 1; as the *roça*, 51; in
 São Paulo, 1; separation between
 sacred and nonsacred areas, xxv;
 terreiros, xxxiii, 2, 17–21, 22, 48–
 49, 131n5, 133n2, 144; two broad
 divisions, 89; typology of, 13–16;
 urban or suburban phenomena, 17;
 as used in contemporary Bahia,
 xxix, 3; value placed on genealogy,
 22; values in, 21–25; worldview
 of enslaved Africans operative
 within, 8
candomblés Queto (Ketu), 16
capitalism, 23
Carise, Iracy, xxi, xxii
Carneiro, Edson, xx, 3, 5, 15, 21
caruru, 111–12, 117, 120, 149, Plate 35
Carybé, 21
Casa Branca, Engenho Velho, 22
Casa Branca, Vasco da Gama, 5, 17, 51
Casa de Culto, 2
Castro, Yeda, 2, 131n3
Catholic brotherhoods and sisterhoods,
 12, 119